Film and Video Production in the Cloud

With cloud applications and services now widely available, film and video professionals have all the tools they need to work together on centralized platforms and effectively collaborate across separate desktop, web, and mobile devices. In *Film and Video Production in the Cloud,* veteran video production consultant Jack James provides a practical guide to cloud processes, concepts, and workflows as they relate to the most widely used cloud applications in the industry. Topics discussed include the benefits of cloud storage, cloud-based production and postproduction pipelines, project and asset management, distribution and archiving, budget and security considerations, and crowdsourcing.

This book will allow readers to:

- ▶ Harness cloud-based tools and processes to enhance your film and video production pipeline and help your creative team collaborate effectively across separate desktop, web, and mobile devices;

- ▶ Discover the benefits of cloud-based film and video production, as well as key approaches to budgeting and planning, project and asset management, distribution and archiving, security considerations, and crowdsourcing in the cloud;

- ▶ Learn how to apply fundamental cloud methodologies and best practices to the most widely used cloud services and applications in the industry, including Adobe Creative Cloud, Autodesk A360, Avid Media Composer Cloud, Asana, Basecamp, and Shotgun.

Jack James currently works for Autodesk, helping UK film productions work with the cloud-based production tracking software Shotgun, and has worked widely in cloud production for film and video. He has previously published two books with Focal Press, *Digital Intermediates for Film & Video* (2005) and *Fix it in Post* (2009).

Film and Video Production in the Cloud

Concepts, Workflows, and Best Practices

Jack James

Routledge
Taylor & Francis Group

NEW YORK AND LONDON

First published 2017
by Routledge
711 Third Avenue, New York, NY 10017

and by Routledge
2 Park Square, Milton Park, Abingdon, Oxon OX14 4RN

Routledge is an imprint of the Taylor & Francis Group, an informa business

Library of Congress Cataloging in Publication Data
Names: James, Jack, 1977– author.
Title: Film and video production in the cloud : concepts, workflows, and best
 practices / Jack James.
Description: London; New York : Routledge, Taylor & Francis Group, 2017. |
 Includes bibliographical references and index.
Identifiers: LCCN 2016027244 | ISBN 9781138694101 (hardback) |
 ISBN 9781138925045 (pbk.) | ISBN 9781315683980 (e-book)
Subjects: LCSH: Motion pictures—Production and direction—Technological
 innovations. | Video recording—Technological innovations. | Cloud computing.
Classification: LCC PN1995.9.P7 J25 2017 | DDC 791.4302/32—dc23
LC record available at https://lccn.loc.gov/2016027244

ISBN: 978-1-138-69410-1 (hbk)
ISBN: 978-1-138-92504-5 (pbk)
ISBN: 978-1-315-68398-0 (ebk)

Typeset in Warnock Pro
by Apex CoVantage, LLC

For Kinga, my motivation, and Claudia, my inspiration.

Contents

Preface

In February of 2011, I found myself in London's Waterloo station, surrounded on all sides by a Microsoft marketing campaign. "The Cloud Is Coming" (or words to that effect) it proclaimed, "Are You Ready?"

I was struck by this for two reasons. Even in 2011, the Cloud had been around for several years in one form or another, although perhaps few people not connected to the computer industry in some way would be aware of this. But more importantly, I wondered why anyone would care. Microsoft didn't seem to be trying to sell a product, just a nebulous concept that didn't really belong to anyone in the first place.

Four years later and the "Cloud" has started to mean something to a much wider audience. For many it signals greater convenience, and for still others it's an extension of freedom to work in different conditions and locations. In some respects, the Cloud is as synonymous with mobile computing as it is the Internet, and as such represents the ability to be connected to everything and everyone at all times (the flip side of this being that it can become ever more difficult to get away from those same things when it's time to take a break).

The entertainment industry can represent one of the best testing grounds for new technologies and methodologies, even as the industry itself is extremely resistant to change. Tight deadlines and large budgets mean that at any particular moment, predicting the exact result of doing something, coupled with the ability to do it quickly, is paramount. This means that any improvements to either are both needed and welcomed, but it also means no-one wants to try anything that is too different from how they're accustomed to doing things, and few people are willing to try anything that has even a slight chance of failure. New ways of doing things have to be battle-hardened and simple to grasp.

It's for that reason that the Cloud, as was the case with digital photography, has taken such a long time to work its way into modern filmmaking

processes. In 2014, I found myself in the very fortunate position where this was starting to change: working with the members of the Warner Bros. studio who were insightful enough to see the benefits that modern technology could bring and bold enough to try and make it succeed despite the teething problems and almost overwhelming opposition to the changes it required.

And succeed it did. I've personally experienced the change of attitude amongst the people working round the clock to get a production finished on time, from being rightly skeptical and weary of technology and workflows that will supposedly make their jobs easier, right through to the realisation of what can indeed be accomplished, and how things they just considered to be aspects of their day-to-day jobs could be streamlined or even fully automated—not to make them redundant, but to free them to be able to make all the decisions that machines can't; in short, to allow them to do the parts of their jobs that they enjoy the most.

As I was writing and researching the material for this book, I was delighted to discover that there's a much greater breadth of services available than I'd assumed to tackle the various challenges faced by many productions. It's easy to imagine Google Docs and Spreadsheets being used across productions, but things like collaborative video editing (powered by the Cloud), things I'd assumed to be in the distant future, were in fact already making inroads in more agile broadcast environments.

Change can be difficult, and certainly it's hard to switch to the Cloud when it means giving up on tried-and-true approaches, but as challenging as it can be, there are gains to be made, and these will only get better over time. The future is ahead of us; hopefully one that allows better communication, with less time doing busywork and more time spent on creativity.

Acknowledgments

First and foremost I would like to thanks Simon Jacobs, Peter Linsley, and John Makowski and the team at Routledge for both nudging and encouraging me through to getting this to print. I also owe a great many thanks to Ryan Mayeda and the rest of the Autodesk Shotgun team, specifically Stephen Chiu, Sarah Haynes, Don Parker, Rob Blau, Alan Dann, Stephane Daigle, Stéphane Deverly, Robért Belanger, and Rob Di Figlia for their wonderful tidbits of advice and knowledge. Similarly, not only would this book not be possible, but I suspect the ideas within would have to wait a few more years, were it not for the likes of Anne Kolbe, Brian Monk, and Adam Sloane at Warner Bros., as well as Christine Felman and Derek Burgess for some guidance. Finally, I also owe Claire McGrane, Mitch Mitchell, Jon Thompson, and Andrew Francis my thanks for their constant supply of knowledge and support over the years.

This book was written entirely in the Cloud using Google Docs.

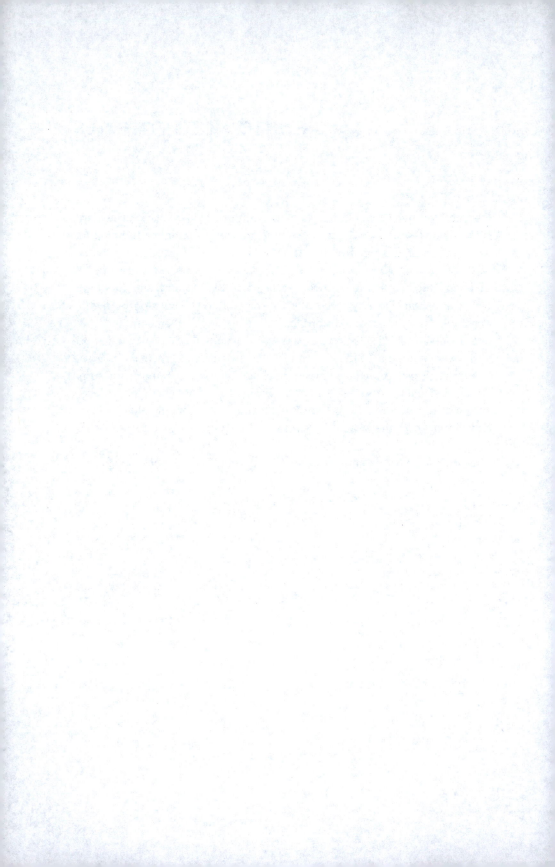

1

Silver Screens and Silver Linings

"You've got to embrace the future. You can whine about it, but you've got to embrace it."

—Matt Groening

THE PROMISE OF THE CLOUD

It's not much of a secret that the motion picture industry has difficulty keeping up with the pace of developments in Information Technology (IT). It took approximately 10 years to fully embrace digital cameras as a viable alternative to 35mm film, and to date, much of the process of actually making a film is dependent on hand-written notes, as opposed to the electronic documents that are used in almost every other industry imaginable.

The latest significant development has fared much better in this regard. The promise of being able to work and communicate easily from any location with a minimal amount of setup and initial cost is something that appeals to pretty much everyone in every role on a production, whether an assistant or an executive. This is the promise of the "Cloud", a catch-all term for a group of technologies dependent on the Internet that provide a number of different IT services that are immediately available to use.

The services on offer span the gamut from file storage and organisation, through aggregation and analysis of data, all the way to distribution and playback of digital media. It's possible to pick and choose which services (if any) to use, but the Cloud is at its best when you use as much of it as possible, with services that tie into each other and provide out-of-the-box automation, saving time and energy and making processes more efficient.

With the Cloud, everything can be archived for posterity, analysed for a variety of purposes, and scaled on demand. Everyone can be connected at all times, providing clearer, more direct lines of communication between people, no matter where they are geographically. Systems and workflows can be consolidated and templated, and processes and knowledge can be shared so there's less reliance on people with specific knowledge of bespoke processes.

From a business perspective, the Cloud is here to stay and is getting bigger. The entire market for the Cloud is estimated to be worth $250 billion by 2017, with organisations big and small investing heavily in both using and creating Cloud-based services.

THE CHALLENGES OF THE CLOUD

It's not all clear skies and sunshine, of course. Though the Cloud promises greater ease and efficiency, there are still challenges ahead. The most immediate problem is the concerns people who are resistant to change have. Having to learn new systems and new ways of working is a difficult sell for people who have built a career out of selling their expertise, experience, and carefully designed systems and practices of their own. The old adage "if it's not broke, don't fix it" can certainly apply to everything the Cloud can provide, and as a result many services can seem limiting or unnecessary, particularly those with limited scope of the larger production process.

What's more, everything new has to be learned on whilst in production. The nature of the business means there's little possibility of a production providing on-the-job training for most crews and freelancers who work only for the duration of the project. Until particular Cloud services reach a critical point of adoption, where it becomes expected that they'll be used on a film, there's also very little chance that crew members and freelancers would independently seek out or pay for training in such

systems in their downtime. This means that Cloud services have to find a balance between ease of use and functionality that's rather difficult to attain—being flexible enough that people can continue to use processes and workflows they're already familiar with, whilst be accessible enough for people to figure out how to apply those processes and workflows without feeling frustrated.

In an environment where everything is connected, it's equally important to realise that many of the processes of making a film or video are isolated from each other. Delivering a script has repercussions all the way to marketing and distribution, but similarly it's unlikely anyone will care about the résumé of a particular actor who didn't make the cut during casting (even though at the time it may have been the most important issue). As a result, there's a tendency towards "information overload" when using Cloud services, with redundant or outdated information remaining in place, and available to people who might not find it as relevant, creating clutter where there should be clarity.

For these reasons, for the Cloud to succeed within production environments, there will likely need to be a new role created. In much the same way as Digital Imaging Technicians (DITs) were needed to help transition from film and video-based shoots to fully digital ones, providing essential functions and support to traditional camera crews, so too we might see the rise of a person (or group of people) whose jobs will be simply to manage the flow of data throughout a production, ensuring that people can see what they need to (and likely, ensuring that they can't see information that's of a secretive nature), pruning data that become irrelevant as time goes by, but also providing a degree of support to help transition people into using new workflows and processes.

HOW TO USE THIS BOOK

This book is intended to provide an introduction to the Cloud, as well as the services available, specifically as they apply to film and video productions. Though this book contains information useful to anyone who is creating audio-visual content and is looking for ways to streamline aspects of it using the Cloud (specifically in terms of working collaboratively or whilst on the move), it is structured to present information in a way that makes the most sense to people working on narrative script-based productions.

There are mentions of various services and sites throughout this book. These are presented as examples for comparative purposes and should not be taken as endorsements of their respective quality. Thorough, independent research is highly recommended before committing to a particular service, and it should be noted that while information is accurate at the time of writing, prices and functionality of many services will be likely to change over time, and as such might be different by the time you read about them. Many of the services mentioned here have free or trial accounts, however, which will allow you to get first-hand impressions of what's on offer.

Though the organisation of the chapters follows the chronological process of a typical production, the chapters themselves can be read out of order, depending on which topics are of interest. As with the Cloud itself, it's possible to make use of the entire book or just specific parts as needs dictate. At the end of each chapter are links to articles that go into some of the topics discussed throughout the book in greater detail, as well as those that provide interesting opinions and points of views.

Chapter 2, "What Is the 'Cloud'?" provides a general overview of the Cloud and the technologies it encompasses, as well as the benefits and disadvantages it provides.

Chapter 3, "Film and Video Production in the Cloud" discusses the role of the Cloud strictly with the requirements and limitations of a production context, covering what the practical and theoretical benefits can be, as well as potential pitfalls to watch out for.

Chapter 4, "Cloud Storage" covers data storage in the Cloud along with comparisons of related services that offer it, as well as the advantages and disadvantages of using the Cloud as opposed to relying on more traditional digital storage approaches.

Chapter 5, "Cloud Computing" looks at services geared towards processing data in the Cloud in a number of ways, whether performing calculations or actually providing a software interface to organising and storing data.

Chapter 6, "Collaboration and Communication" examines the possibilities of using Cloud services to communicate with others through text, voice, or live video, and looks at some of the approaches that are enabled by the Cloud to make collaboration clearer and more efficient.

Chapter 7, "Production" takes a number of processes that are typically required during the course of a production and shows Cloud-based services that aim to build upon or replace them entirely, highlighting where gains can be made by moving to the Cloud.

Chapter 8, "Planning" covers a range of processes that begin before a production even starts, as well as methods for using the Cloud to help with knowledge-sharing and project management.

Chapter 9, "Finance" looks at options for leveraging the Cloud for budgeting and funding productions, as well as options for financial accounting and payroll.

Chapter 10, "Tracking" provides a comprehensive look at managing information with Cloud-based services, whether in the form of digital files or all the information that goes with them.

Chapter 11, "Asset Management" describes some strategies for managing assets with the benefit of the features provided by the Cloud, as well as potential issues to be aware of.

Chapter 12, "Review and Approval" discusses the process of looking at completed work and providing feedback and compares different approaches and Cloud-based services for making the process more streamlined and robust.

Chapter 13, "Distribution and Archive" looks at methods for using the Cloud to share media and information with an audience and other external parties, as well as solutions for long-term storage.

Chapter 14, "Security Considerations" covers different options the Cloud provides to keep information safe, as well as the real and imagined risks to security using the Cloud entails.

Chapter 15, "Automation" illustrates a number of ways the Cloud encourages efficiency and productivity through automation and sharing of data between separate services.

Chapter 16, "Crowdsourcing" provides an overview of some of the ways that the Cloud enables utilisation of a greater number of people than would be possible without it, for a variety of purposes from funding to feedback.

Chapter 17, "Potential" looks to the future, discussing where the Cloud might be headed and the options that might be available in a few years' time.

BIBLIOGRAPHY

Here's Where Amazon and Google Could Make Their Next $100B http://www.wired.com/2015/10/amazon-google-make-next-100-billion/

My Tablet Has Stickers https://medium.com/learning-by-shipping/my-tablet-has-stickers-8f7ab9022ebd#.yy15dt5r6

2

What Is the "Cloud"?

"Behind every cloud is another cloud."

—Judy Garland

THE CLOUD

The "Cloud" is a term—more of a metaphor really—that has come to mean so many things to so many different people, that it defies simple classification. When people talk about the Cloud, they could be referring specifically to "Cloud Storage", "Cloud Computing", or "Software as a Service" (each of which deserves its own explanation), but mostly they just mean "in the Internet". What the Cloud ultimately represents, though, is an abstraction of Information Technology (IT).

If you look at practically any company, there's almost always some requirement for computer hardware and software. Whether it's for scheduling appointments, tracking orders, or sending emails, some form of IT infrastructure is required. Setting up company-wide email involves establishing one or more mail servers and all of the related network setup to get it running. IT staff are then needed to keep it running and also to set it up for individual access. That's just email. Businesses that use computer

technology for anything more sophisticated than sending messages will likely need other, specialised servers installed, software configured, and people to maintain it.

So the first thing the Cloud does is eliminate much of that complexity. Rather than deciding on a system to provide email for a company, then buy, install, configure, and maintain the requisite hardware and software, you instead choose and lease a Cloud-based email system. As long as everyone has Internet access, everything else is taken care of by the service provider. In much the same way you can forgo the expense and time of buying, installing, and cleaning an espresso maker by instead just buying an espresso from a café when you want one, the Cloud lets you buy computer services as and when you need them.

What's actually happening is that there are several companies (most notably, Amazon) each with huge data centers that then lease both computing power (Cloud Computing) and storage (Cloud Storage) to others. The data center owners take care of all the hardware and operating system needs, ensuring everything stays running and expanding or upgrading it as needed. If you wanted to, you could directly lease some of these computing resources directly from many of these vendors, but perhaps what's most fascinating and useful about the Cloud is where other businesses build new services on top of these resources (Software as a Service), and then provide subscriptions to those services.

So in principle you could lease some Azure Cloud Storage from Microsoft and pay a specific amount for all the bytes of data you need to transfer and store. Alternatively, you could pay for a subscription to Microsoft's OneDrive Cloud Storage service, which is built on top of Azure, with a simplified pricing structure and software to enable syncing and sharing files easily. Or you could go even further than that, and take out a subscription to Microsoft's Office 365 platform, getting access to a variety of different office applications, all of which can run wherever there's Internet access, with your documents stored in its OneDrive Cloud Storage. You can even mix and match Cloud services to some extent, so if you preferred to use Google's suite of office applications to edit documents and Dropbox's Cloud Storage for sharing files, you can.

Even if you've got access to a huge IT department, there are still plenty of reasons to look to the Cloud. Certain services might be considerably more cost-effective when offloaded to the Cloud (a great many services are

completely free of charge), and most Cloud-based services can be set up and rolled out much quicker than doing it locally. There are plenty of other benefits to be had too.

BOX 2.1 The Nuts & Bolts of the Cloud

Part 1—The Internet Protocol Suite

The way that data may be transmitted over the Internet (as well as many local computer networks) is defined by the "Internet protocol suite" (more colloquially referred to as "TCP/IP"), a model that separates specifications for different "abstraction layers": the Link layer, which defines how devices communicate with each other; the Internet layer, which allows different networks to communicate with each other (and indeed forms the basis of the Internet in general); the Transport layer, which allows communication of data between two computers, regardless of where they are in relation to each other; and the Application layer, which allows end-users to take advantage of all of this and use services on the Internet that transmit data to each other—the most common of these being Hypertext Transfer Protocol (HTTP), which is used to send information between websites and browsers, but it also encompasses file sharing on local networks (for example, Apple Filing Protocol on Mac-based networks, and Server Message Block on Windows-based networks).

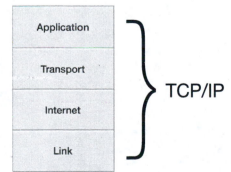

FIGURE 2.1 DIAGRAM OF TCP/IP

BENEFITS OF THE CLOUD

The Cloud is more than just a buzzword or a technology that just happens to be in vogue right now. There are real benefits to using the Cloud such as reduced costs and ease of deployment, as well as its three killer features: sharing, sync, and mobile.

Sharing

Given the assumption that everyone has Internet access, the Cloud makes it very easy to share information with others, whether that information is a note, image, or video, or even something more holistic like a schedule. Exactly how easy and convenient will depend upon the particular service, but because by using the Cloud you're storing data in some data center somewhere, it's technically feasible to allow someone else to have access to that information too (putting aside the scenarios where you're storing data that you positively don't want anyone else to have access to).

A great many things that take place during a production can benefit from this feature. The ability to send files, be they documents or moving images,

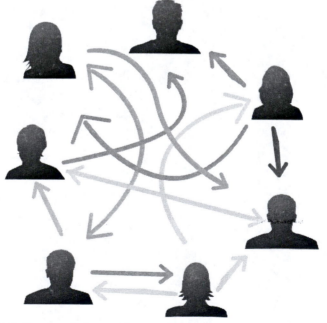

FIGURE 2.2 Sharing Information

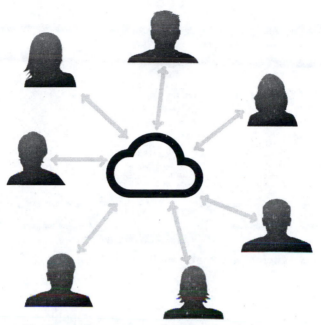

FIGURE 2.3 Sharing Information with the Cloud

to others for review, is something that happens regularly. Letting people know about schedules, providing information, and distributing feedback are all things that the nature of the Cloud can make easier.

Sync

In the 2000s, around the time that the Cloud started to gain traction in the public eye, another trend in computing was that people were frequently using multiple computing devices. They'd likely have a desktop-bound computer in the office, but might then take a laptop to go to meetings elsewhere. The problem was they'd have to constantly remember to copy files between the systems, and as a result it was very easy to lose changes to documents made on a different computer that were not subsequently copied back.

With the Cloud, that's now a thing of the past. Data stored in the Cloud are always up-to-date, and those applications that allow changes to be made whilst offline typically have built-in methods for synchronising changes back. What's more, data in the Cloud can be thought of as being

FIGURE 2.4 Syncing Information

FIGURE 2.5 Syncing Information with the Cloud

"backed up" in the sense that if you lose your computer, or it stops working, the data are still in the Cloud (it's worth noting that many Cloud services perform their own, separate backups of all the data in the event of disaster).

Mobile

Changes in computer technology and hardware over the last decade might mean that individuals are less likely to use both a desktop computer and a separate laptop. Instead, there's a good chance that they'll have a desktop computer or a laptop and one or more smartphones and tablets. Though this doesn't make the need to synchronise data any less relevant, it does mean that people can be connected to the Internet more often, and from more places, thanks to public WiFi and cellular Internet connections.

To the Cloud, it largely doesn't matter whether people are accessing services through mobile devices or desktop computers, the only requirement is an Internet connection. This is in stark contrast to traditional IT services, which at best might require some complicated workflows to allow someone away from the office to be able to access information on a file server, and more often would just be flat-out impossible to facilitate.

FIGURE 2.6 Going Mobile with the Cloud

BOX 2.2 The Nuts & Bolts of the Cloud

Part 2—WiFi

Technically, local area wireless networking (colloquially known as "WiFi" for no particular reason) doesn't really have anything to do with the Cloud, which can function perfectly well without it. However, what WiFi does do is enable Internet access without the need for cables, which is particularly useful for people who are not desk bound. Indirectly, the proliferation of WiFi "hotspots" (places where you can connect to a wireless network and get Internet access) has made the Cloud more appealing and practical, as it allows people to make use of the Cloud from a variety of locations, from hotel lobbies to coffee shops.

Furthermore, the convenience of WiFi compared to running cables means that there are many devices now, from laptops to tablets and games consoles, that can connect to the Internet with relative ease. Indeed, there's a trend in even more types of devices and appliances from televisions to thermostats that connect to the Internet in this way. Many of them are enabling interesting and useful services in the Cloud as a result.

Persistence

On traditional productions, once that production wraps, almost everyone involved leaves to go and do something else. In the best case, materials will be archived somewhere for future use, but even when this is done it can be extremely difficult to refer to or make use of any of these materials on future productions.

In this way, a lot of effort is expended on each production as various people "reinvent the wheel"—repeating the same research and drawing up the same documentation as they may have had to do on previous productions. Even if they have access to materials from past productions, the mere act of finding and obtaining it can be difficult enough to make redoing it simply seem more convenient.

Data on the Cloud on the other hand are typically stored indefinitely, meaning someone can view a document or a photo, or access other information that was saved to the Cloud, months or even years prior, even where it might have been created by someone else.

There's something else to consider too. Documents saved on hard disks, or thumb drives, have a tendency to go missing. On the Cloud, everything is just "there". There's no need to go rooting in a stack of portable drives to find the thing you're looking for; typically with the Cloud you either browse a folder-based structure to find something or even have it bookmarked if it's important enough. What's more, almost all Cloud-based services have embraced the power of search, meaning that even if you can't remember exactly where to find something, you can just type into the search box and let the Cloud figure it out for you.

FIGURE 2.7 Information Lives Forever in the Cloud

FIGURE 2.8 Notifications via the Cloud

Notifications

With the Cloud, people can be informed about new or changed information instantly, through "push" notifications to a mobile device, automated emails, or even through integrations with other applications, like instant messaging.

In practice, this means that people can be notified about changes to a script as soon as it happens, without having to be actively watching the script's development, or be informed when a task is completed, or if there's something awaiting their feedback. This undoubtedly results in clearer communication and greater all-around efficiency for all involved.

BOX 2.3 The Nuts & Bolts of the Cloud

Part 3—Cellular Networks

As with WiFi, cellular networks aren't essential to the infrastructure of the Cloud, but they make it more relevant. Traditionally, cellular networks enabled voice calls to and from cellphones, but could also be used to transmit a limited amount of data. Over time, however, they've evolved to be able to send and receive a greater amount of data, to the point that the current "4G LTE" standard is approaching the same speed as the average WiFi hotspot, making for a good browsing experience whether your phone is connected to a WiFi network or not.

(Continued)

(Continued)

This further extends the reach and utility of the Cloud, as it means you can be mobile, but you don't need to be connected to a known network, and instead can just ensure you've got reasonable reception. Things get even better with "Internet tethering" (or "personal hotspots"), which allows your cellphone to broadcast an Internet connection as a WiFi network, effectively allowing devices without cellular connectivity, such as a laptop, to be used as if on a WiFi network. With this, the ability to connect to Cloud-based services from anywhere is increased significantly.

Scalability

Almost all Cloud-based services are designed to be scalable, so essentially you pay just for what you need at any time. This means you can start off small, for example, opting for a low amount of Cloud Storage, or subscribing to a service with a low number of monthly users, then scaling up as you need more resources, or back down again when you don't.

FIGURE 2.9 In a Traditional IT Environment, Scaling Involves Large Up-front Costs

FIGURE 2.10 With the Cloud, Scaling Is Easier, as You Pay Only for What You Need

This level of flexibility minimises risk and encourages experimentation to a high degree, especially when compared to investing in local IT resources, where you would need to both predict the resources you'll need in the long-term, and then fund them with a high up-front cost.

Convenience

The Cloud provides a level of convenience not possible with traditional IT infrastructure. The services already exist, and most can be used on a moment's notice. If on a whim you decide you need a terabyte of Cloud Storage, you can sign up with a provider and have access to it within a matter of minutes. The same is true of most Cloud-based services; there's no waiting for equipment to be ordered and delivered, then configured and tested—it's just ready to go.

With the exception of some specialised services, there's usually less of a learning curve to using Cloud-based services than their traditional counterparts, because they're designed to be accessible to a wide number of people. Regardless, almost all Cloud-based services have their own support staff who can deal with issues or queries.

FIGURE 2.11 In a Traditional IT Environment, Setting Up a New System Is a Lengthy Process

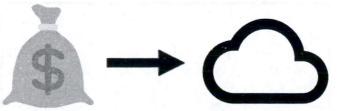

FIGURE 2.12 With the Cloud, New Systems Can Be Set Up Immediately

BOX 2.4 The Nuts & Bolts of the Cloud

Part 4—Browsers

Over time, the humble Internet browser, be it Apple's Safari, Google's Chrome, Microsoft's Internet Explorer, or Mozilla's Firefox, has grown from a way to view websites, to a window to accessing Cloud-based services. Browsers are the operating system on which web-based applications can run, and as such it largely doesn't matter which computer hardware you're using—as long as the browser works, the applications running within them should work.

There are some pitfalls with this system, though. First of all, not all browsers are the same, and as such certain things work (or at least work better) depending on the specific browser used. Older versions of Internet Explorer are notorious for not being able to work with certain services. Modern browsers suffer to a lesser degree—most of the differences in how web applications work between browsers are purely cosmetic—but there are still other potential issues.

Most browsers allow third-party plugins and extensions to be installed to extend their functionality in some way. While many of these can be extremely beneficial, such as a password manager or a way to save screenshots of pages easily, there's also the possibility that so-called "malware" can get installed, causing adverts to be shown at regular intervals, or otherwise interfering with the functionality of unrelated web pages. This is something that the developers of the browsers are currently trying to address in a number of ways, but to the average user, they'll just experience seemingly random issues and not know why.

Automatic Updates

With the Cloud, everything is kept up-to-date automatically. There's no need to download or install updates as would be the case with desktop software; when a Cloud-based service adds new features, they typically just roll them out to everyone at the same time and then the next time someone signs in (or reloads the page in the case of browser-based services), the updates are immediately available.

In general, this is a good thing. Typically updates improve security or performance, fix bugs, or add new features that can improve your workflow or make things easier (or less repetitive) to do. That's not always the case, though, and there have been occasions where a particular service has revamped its interface in some way, which has led to some annoyance amongst users who preferred the previous way of doing things but were then stuck with having to use the new interface. Fortunately, situations like this are rare, and given that customers can effectively stop using a particular service at a moment's notice, services usually listen to feedback.

Consistency

People involved in a production typically have their own processes and methodologies in place for doing certain things in specific ways. Whilst there are many benefits to such an approach, on any collaborative endeavour, this lack of consistency can prove difficult for others who have to pick up a new system or way of doing things on each production.

By enforcing certain conventions for things, be they specific form layouts, step-by-step processes, or even validation of key data, the Cloud can help here too. Cloud services can be "opinionated" to some degree, meaning that the designers enforce particular ideals or methodologies through the interface. For example, a particular review and approval system might insist that a reviewer selects from one of a set number of responses (such as "approved" or "rejected") on viewed items, whereas previously they might have just composed free-form responses in an email, which might have been found to be vague or unclear to the recipient.

DISADVANTAGES OF THE CLOUD

For all the benefits the Cloud provides, there are some limitations too, most notably a reliance on a stable, fast Internet connection. Different Cloud-based services may have ways to mitigate some of these, and they may not all be relevant all of the time.

Running Costs

Although in many cases the Cloud is cost-effective when compared to alternatives, over longer periods of time this may not be the case. Cloud Storage

can be a great example of this—for the first few months of using it, you're likely paying for exactly what you need, but over time it will fill up with files that perhaps are no longer relevant. Before long there will likely be lots of files you don't particularly need to have in the Cloud anymore but that you can't just delete to free up space—but you're paying as much to store them as you are files that are actually benefitting from being in the Cloud. There are solutions to this problem, such as moving them out of Cloud Storage and archiving them on local media (or moving them into cheaper long-term Cloud Storage systems), but these are time-consuming and can be fraught with other issues.

Even though most Cloud-based services have the option to scale down as needed, in practice this can be problematic. If you reduce the number of users in a service, what happens to the data for the users being removed? In some cases these data will remain untouched, in others they might become "frozen", available only if the account is later reactivated, but in some they might just be permanently erased. Because of this, it can mean that it becomes cheaper to keep paying for unused accounts than to lose the associated data.

BOX 2.5 Service Level Agreements

One thing that's of crucial importance when choosing whether or not to use a particular Cloud-based service is to check its Service Level Agreement (SLA). This will tell you exactly what the service provider will guarantee, in particular its uptime (so you know if you can rely on the service being available whenever you need it), but also as to how it guarantees your data won't be lost, and the security measures it has in place.

These factors can vary greatly between different service providers and should factor into your decision-making process, depending on how important you rate them for a particular production.

Internet Connection

The single biggest drawback of the Cloud is the connection to it. If your Internet connection stalls or goes down, so do all your Cloud-powered services. This is particularly true when using mobile devices that rely on a

cellular connection (or when you're *just* out of range of a WiFi network) as the connection can fluctuate wildly, leading to a frustrating experience. A more traditional IT infrastructure on the other hand, where everything is typically connected via cables, is much less likely to face this kind of situation, whereby there's an entire outage of services stemming from one point of failure (a good example of this happening on the same scale in a more traditional environment might be a company-wide power outage).

Some services offer a way around this by having an "offline" mode, but the problem with these is you typically have to know you're going to be offline to make use of them, so if you're faced with a sudden outage, there's not much you can do. Gradually people who are using Cloud services more are becoming more accepting of problems caused by Internet outages but, at the same time, people are increasingly entrusting the Cloud to run critical services. Still, advances are being made in this area, both in terms of making Internet connections more reliable, but also by the service providers to ensure outages cause less of an issue.

BOX 2.6 The Nuts & Bolts of the Cloud

Part 5—Asynchronous Javascript and XML

Asynchronous JavaScript and XML (AJAX) is a technology that revolutionised the World Wide Web around 2005. Previously, for a browser to send information back to a website, such as saving a document or filling in a form, the data would have to be submitted to the site in one go, with the server sending back a new page to the browser. This would result in the entire page reloading, so from the user's perspective, they'd click a button to submit the data, then there'd be a pause for the server to receive the data, process it, and generate a new page, and then the new page would load in the browser, in a similar manner to the user having just forcibly reloading the page.

AJAX changes all that by loading some code when the original page loads. That code then waits for some data to need to be sent to the server, and sends it in the background and waits for a response, before directly modifying the current page with some update. From the user's

(Continued)

(Continued)

perspective, they could be typing some text into a search box, and in the background AJAX is being used to constantly send the current text to the server and continuously updating the page with results (or in the case of something like Google's search bar, updating the page with results). This results in a much better user experience, as they appear to be getting immediate responses as they do things.

It's not *quite* immediate, though, and that's one of the problems with AJAX—any noticeable delays between sending the data and getting a response, such as a slow or unreliable Internet connection, can mean that the interface lags behind whatever the user is trying to do, creating a confusing or frustrating experience. That said, another benefit of AJAX is using it to "poll" a server for updates. Essentially there's no data to send from the user, but code runs in a loop in the background, periodically requesting updated information from the server and updating the contents of the page as needed. This might be used to show changes in stock prices or changes being made to a document by another user, for example.

Speed

Another common concern with web services is that they don't run as fast as desktop applications or services across a local network. Though this concern is valid to some extent, particularly when dealing with large amounts of data that need to be shuttled across the Internet, it's also partially a perceptual issue which is slowly being addressed to some extent by advancements in user interface design.

The development of "Asynchronous JavaScript and XML" (AJAX), for example, allowed for browser-based software to send and receive data to a server on the Internet in the background, without having to first submit a form or reload the page, which had been common practice until then. Likewise, "optimistic updates", whereby the interface makes the assumption that changes made to data will be received without any issue, mean that the experience for the end-user is that everything happens instantaneously, even if behind the scenes the system is playing catch-up with the data.

BOX 2.7 The Nuts & Bolts of the Cloud

Part 6—WebSockets

The main limitation of AJAX is that connections between a browser and a web server aren't persistent, so there's no "true" live, two-way communication. WebSockets is a more recent technology (and accepted web standard) that aims to address this. With WebSockets, there's an established connection that allows a browser (or other application) to send and receive data to a Cloud-based service in much the same way that computers on a local network can communicate with each other.

WebSockets make it easier for developers to build web applications that communicate more directly with their users, and for the users, it results in a better experience. However, the technology has seen very slow adoption, mostly over concerns with compatibility with older browsers and networking infrastructure.

Flexibility

One of the strengths of the Cloud, namely the move towards approachable, consistent design and usability, can also be a weakness. With servers located in remote locations, and software created by a third-party, there's usually little room to be able to tweak things to your own specific requirements. For example, you might have carefully constructed spreadsheets in Excel packed full of macros that do weird and wonderful things that just refuse to work properly within a Cloud environment. Or some reports that have been designed for use over a number of productions, but there's no way to replicate the design within a particular Cloud-based service, which instead offers only its own stock reports.

This lack of flexibility also means it can be hard to switch to a Cloud-based service that integrates well with existing workflows and technologies. Cloud Storage has many benefits, but how useful is it if it can't search certain types of documents or sync files to a specific location? Perhaps that Cloud-based video playback system does everything you need it to, *except* support custom monitor profiles, making it unusable in your existing environment?

BOX 2.8 The Nuts & Bolts of the Cloud

Part 7—Open-Source Software

Open-Source software is software that is published with complete access to its "source code" (the original code used to create it) along with granting the rights to allow it to be reused or modified in any way. This allows developers to build new software using Open-Source software as a foundation and is a big part of why websites and web applications evolve at such a rapid pace—rather than having to build, test, and maintain every aspect of the underlying functionality, developers can just use existing Open-Source software that already achieves a particular function and then just add other features as needed. Often this results in a "virtuous circle", with developers who have used open software to create something new then publishing their improvements as Open-Source.

This also extends to software that users don't even see. Much of the software used to keep servers secure and efficient is Open-Source, as are Mozilla's Firefox browser and Google's Android mobile operating system. There are several foundations and initiatives in place to promote and directly support the development of Open-Source software, so even though many businesses build applications using proprietary software code, there are plenty of businesses that are actually in favour of making their source code available for others to use.

Dependence

The more crucial or embedded a particular service is to what you're doing, the more you become dependent on it. With the Cloud, the decisions about a service's future are entirely out of your hands. If your primary concern is with finance, and you invest in a Cloud-based accounting system, and then the developers of that system decide, for whatever reason, that they're no longer going to support international currency, your only option at that point will be to switch to another service that does.

Although in principle the Cloud means you can switch between services as and when you need to, the reality is that switching from services that

are critical or widespread is not an easy task. The more a particular service is used, the more of a critical role it fulfils, the harder it is to just drop everything and go somewhere else. Often this involves exporting out lots of data beforehand and then manipulating it to work with the new service. Sometimes there's just no way to move data between services. Worst of all, you may not be aware of this until you've been using the service for a considerable amount of time.

Sadly, with the Cloud, you're increasingly at the mercy of the providers to not break your workflow the more you use it. This even goes as far as the "scheduled downtime" that some services will have from time to time. Even if the time the providers have chosen to take the system temporarily offline for maintenance is going to be extremely inconvenient for you, there's nothing you can do about it—it's not your personal IT department, and as such they will make decisions based on their own business needs.

BOX 2.9 A Note on Security

A common misconception about the Cloud is that it is inherently less secure compared to traditional IT infrastructure. Ultimately this depends on the specific policies and expertise behind each of the services used, but there's nothing to differentiate a Cloud-based system from any other networked system as far as security is concerned. Indeed, in many cases the Cloud might even be considered more secure than local systems, as providers can generally afford to hire security experts to rigorously and continuously test the systems for potential issues, something smaller IT departments are unlikely to be able to do.

For more information about security as it relates to the Cloud, see chapter 14.

BIBLIOGRAPHY

Ajax: A New Approach to Web Applications http://adaptivepath.org/ideas/ajax-new-approach-web-applications/

Internet Protocol Suite https://en.wikipedia.org/wiki/Internet_protocol_suite

3

Film and Video Production in the Cloud

"Clouds do not really look like camels or sailing ships or castles in the sky. They are simply a natural process at work. So too, perhaps, are our lives."

—Roger Ebert

THE CLOUD IN PRODUCTION

Film and television productions are highly regimented, with specific processes and familiar tools. There is good reason for this; any changes that are made to a way of doing things, or to how a piece of equipment works, even when well-intentioned, at best causes delays to the production, and at worst can bring it to a complete stop. Nowhere does the adage "if it's not broke, don't fix it" apply better than during a shoot. Consequently, the benefits of making such changes have to be incredibly worthwhile for people to be swayed into trying them. Arguably the biggest such change happened during the 2000s, with the transition of photographic film and videotape capture formats to wholly digital ones. Perhaps the primary drivers for the change were financial, with studios applying pressure to productions to switch in order to cut costs; but the transition was a reluctant one for the many who had to learn new ways of doing things, as well as the tribulations and idiosyncrasies of working with digital formats.

A few years later, and similar transitions are underway. Some have flocked from traditional "2D" cinematography to the brave new world of virtual reality (VR), a technology now almost mature enough to be made available to consumers in much the same way as happened with stereoscopic 3D a decade earlier. Another, quieter revolution is also taking place, however. So-called "Cloud Services" are replacing almost every area of Information Technology; where any service that existed in the form of some software application would now instead leverage the power of the Cloud to perform its functions, from the more general-purpose applications such as for creating spreadsheets or editing images, through to more specialised ones for medical procedures or controlling the temperature of a room. Gradually, almost everything that could be Cloud-based in some way became Cloud-based.

Naturally, the film and video production industries have been slow to adapt to the changes compared to other industries, but that's starting to change, as the benefits for doing so are beginning to become apparent, and those benefits are proving to be incredibly worthwhile. These benefits are easy to see when looking at tasks typically attributed to the Information Technology sector. Sending and receiving data, scaling systems based on usage, and using mobile devices—these all seem like things that are important to people who work closely with computers but less so for people who work with microphones and cameras.

The reality is that while the technology behind the Cloud may not be important to people in a production environment, the impact of that technology, and the changes to methodologies and practices that can come as a result of it, most certainly are. Film and video productions are as much about communication and development of ideas as any other business, key aspects which the Cloud can both enrich and simplify. With that in mind, there are several ways in which Cloud-based technology can improve any size production.

Faster Setup

With the Cloud, everything can start working right away. With most Cloud-based services, there's no time required for setting anything up; sign up with the service and get started right away. At the end of the day there's nothing to tear down, and there's nothing to set up again the next day.

With the benefits of sync and persistence of data in the Cloud, consider the process of replacing a smartphone. Prior to the Cloud, if you wanted

to replace a phone with a new one, but keep emails, photos, and so on, the only way would have been to first back up the old phone and then restore that backup to the new one. Assuming the process worked (and assuming you still had working access to the old phone), you could be up and running again after going through an involved, often lengthy process. In a Cloud-enabled era, however, all you need to do is switch on your new phone, activate your account, and have all the settings and data transferred to your phone automatically.

That's the case for phones, but there's no reason why it couldn't apply to many aspects of working on a production. Camera settings could be wirelessly synchronised between cameras, footage could be backed up automatically as soon as it's recorded, contact information for everyone on the production could be automatically added to your address book for the duration of the project, and so on.

Access to Information

In a typical production, if you need information about something, you need to go get it, which means getting in touch with people who may or may not have that information and hoping they actually remember to get back to you if they don't. With the Cloud, information can come to you. Notifications can let you know about things that are happening that are relevant to you, as soon as they happen. Documentation can be published to a shared space, so there's only one place to check when you need to know something.

If there's something you need to know, but don't know where to find it, the inherently searchable nature of the Cloud makes the process easier. Files that are uploaded to the Cloud can be quickly searched if you know what you're looking, faster than it would be possible to rifle through folders in a filing cabinet. With many systems, it's possible to instantly search the contents of all documents stored in the Cloud, which would be the equivalent of taking each sheet of paper out of the filing cabinet and scanning through them for what you're looking for.

The ease of sharing means that giving others access to information is easier than ever. There's no need to make photocopies or printouts, and even some of the limitations of emailing files are removed, like not being able to send an entire folder of files, or files over a certain size.

A side-effect of all of this also means the production process becomes more transparent. Whereas previously information may have been locked away in a database on someone's laptop, now it's more centralised and accessible. There doesn't need to be any ambiguity about what has and hasn't been done if everyone has access to that information directly. This in particular can be a difficult change for those who are unused to having others effectively looking over their shoulder, but it's a necessary one for better communication and efficiency.

Connectedness

The Cloud is always on. There's no need to worry about what day of the week it is or what hour of the day. Access to the Cloud is available wherever there's an Internet connection. For the majority of Cloud-based services, everything can be done as easily from a mobile device as from a laptop or desktop computer. With more information made accessible through the Cloud, there are fewer constraints based on physical locations. There's no need to drive across town just to watch something for five minutes when you can do it anywhere there's Internet access.

Other people are closer than ever with the Cloud. With notifications signalling people to things needing attention, instant messaging providing a restrained, direct line of communication to other people, as well as more open, persistent communication between groups of people in shared chat spaces, people don't need to be in the same physical location as each other in order to stay in the loop.

As well as allowing people to get access to the information more immediately, this also allows for automated systems to collect and analyze data sooner and more accurately. Processes can be monitored in real-time, with things like spiralling costs flagged sooner, or people notified sooner about changes that affect them. This in turn can even give rise to more room for experimentation in certain areas, as the economic impact of making changes can be more accurately predicted. If a production wants to add an extra hour of shooting to the day, the cost of doing so can be calculated faster and more accurately than ever before with the help of the Cloud.

Efficiency

The Cloud allows you to spend less time travelling between physical locations. You spend less time relaying information and less time hunting down information. Messages carried by the Cloud are recorded for posterity, so

there's no danger of forgetting what was said. Information can be more easily collated and summarised. Processes can be more transparent, and progress more accurately and immediately tracked. All of this leads to greater productivity and more effective use of time.

With consistent, predictable costs, no need to worry about building systems up or tearing them back down again, and no restrictions on location, productions can be leaner and more cost-effective. All in all, the Cloud leads to greater efficiency.

BOX 3.1 Transitioning to the Cloud

The Cloud isn't an "all or nothing" proposition. Individual processes and tools can be singled out and trialled as needed. Best of all, most of them can co-exist with established processes. For example, you can invest in a small amount of Cloud storage to allow for easy sharing of certain files with others but can continue to use networked file servers for everything else. Similarly, you can continue to go to formal screenings of work-in-progress productions as well as viewing material via Cloud-based review and approval systems.

In this way, there's often very little risk to trialling Cloud-based services alongside current processes in order to determine if they can yield some benefit. In some cases, it might be that using a Cloud-based service is useful only to supplement traditional approaches, but in others it can lead to new ways of doing things that make the previous ones obsolete.

That said, there are still some points to consider when transitioning to the Cloud:

1. Does it have a future? Is the Cloud service likely to be around in the long-term, is it well-established, and does the service have a clear vision? For some types of services, particularly those intended to be used only on an ad-hoc basis, it may not matter if they'll exist in a few months' time. For others, it may be crucial that the services offered are likely to stick around (and in the same form) for a longer period of time. Related to this is being assured that the service is secure and reliable.

(Continued)

(Continued)

2. Is it compatible? Does the service work with existing applications and procedures, and can it fit comfortably into established pipelines? The less friction there is in switching to a new system, the better. If a new process is able to adapt to working with particular files or processes that you're currently using, there is less risk involved in making the switch, and there's a greater possibility for being able to back out if things don't work out as expected.

3. How open is it? What kind of access does the service give you to your data, as well as its own processes? A service being more open doesn't mean it's less secure than a more closed one, just that you can get access to your data whenever you need it, in whichever form you need it. For one thing, this prevents "vendor lock-in", wherein you completely lose access to all your files and information if you terminate the contract, but for another this means having things like Application Programming Interfaces (APIs) and integration with other systems.

ROLES THE CLOUD CAN PLAY

The Cloud is versatile when it comes to finding roles for it to fill on a production. Seemingly every department and phase of the production can benefit by being Cloud-powered in some way. Some of the key departments on a typical production are covered in the following sections, along with aspects of the Cloud that might benefit them the most.

Directing

Directors can take advantage of the Cloud for many aspects of review and approval (see chapter 12), as well as to get a "big picture" view of the production schedule and progress (see chapter 8).

Producing

Producers can utilise the Cloud for review purposes (see chapter 12), for budgeting and other financial needs (see chapter 9), for planning and getting an overview of the schedule (see chapter 8), and for distribution concerns (see chapter 13).

Production Management

Production managers, location managers, and assistant directors will likely benefit the most from the collaborative nature of the Cloud (see chapter 6), as well as services that help with managing the crew (see chapter 7), scheduling (see chapter 8), and budgeting (see chapter 9).

Continuity

Script supervisors should explore the options provided for the Cloud for recording information (see chapter 10).

Casting

The topics of auditioning and casting will be of most interest to casting directors (see chapter 7).

Camera & Lighting

The camera and lighting crew will find collaborative uses of the Cloud most relevant (see chapter 6), as well as the topics of on-boarding and time tracking (see chapter 7). The director of photography should also investigate the use of Cloud services for review and approval (see chapter 12). Digital Imaging Technicians should also consider managing media (chapter 11) and digital dailies (chapter 12).

Production Sound

Production sound mixers can leverage the Cloud for recording information (see chapter 10), managing audio files (see chapter 11), and time tracking (see chapter 7).

Art

The Cloud has a big role to play when it comes to allowing artists (concept artists, set decorators, costume designers, and visual effects artists) to collaborate well (see chapter 6), gathering feedback and approval of artwork (see chapter 12), and organising digital art assets from pre-production through to post (see chapter 11).

Editorial

Editors, assistant editors, and colorists can all take advantage of Cloud services for post-production (see chapter 7), managing metadata (see chapter 10), and assets (see chapter 11), as well as review and approval (see chapter 12).

Sound

Sound editors, Foley artists, composers, and mixers should investigate using the Cloud for tracking progress (see chapter 10), managing digital assets (see chapter 11), and for review and approval purposes (see chapter 12).

Visual Effects

Visual effects teams can utilise many different Cloud services, in terms of using post-production tools (see chapter 7), planning schedules (see chapter 8), tracking progress (see chapter 10), managing assets (see chapter 11), and structuring review and approval (see chapter 12)

THE PERILS OF THE CLOUD IN PRODUCTION

Although the Cloud can bring many benefits to video and film productions, there are some aspects of it that are in opposition to the needs of many types of productions. Though the technology behind the Cloud is constantly improving, and many companies are working to mitigate these limitations, productions would do well to be cautious when considering moving to the Cloud, in light of some of these.

Internet Access

Many Cloud services work best when there's a steady, consistent Internet connection. They require the ability to constantly send and receive updates, something that is only possible via the Internet. When the connection goes down, the service may fluctuate or even stop working completely, which depending on the nature of the service provided, can be devastating.

Unfortunately, the nature of productions, especially whilst shooting, means that a stable, consistent Internet connection cannot always be guaranteed.

Some productions are able to set up WiFi access for everyone, even when on-set, but these are often unreliable in practice. Often crew members must rely on their own cellular data plans to get Internet access under such circumstances, which themselves may be unreliable or unsupported by a particular Cloud service.

Other factors come into play too. More security-conscious productions outright ban the presence of any Internet-enabled devices during a shoot, preventing any use of Cloud services for the duration of the shooting day. The specific impact of this depends on the Cloud service itself. Many Cloud services provide a way to view information "offline", without an Internet connection, showing a snapshot of the information as it was the last time the service was connected. It's also common for many Cloud services to have a built-in synchronisation system, so that it's still possible to add or change information even when offline, with the changes then sent to the service later when a connection is available.

However, there are still services that do not allow for a lack of an Internet connection, and in these cases, it might mean that people would have to record information some other way (for example, by making notes on a notepad, or saving files to a portable drive), and then updating the information in the Cloud service manually later. Clearly this is not an ideal situation, as it is both error-prone and time-consuming.

Education

Many people on production have a preferred way of doing many parts of their job. As such, any time changes to that process are made, there can be some resistance. Requiring people to learn new processes, technology, and applications can be difficult in itself, but the nature of many productions can mean this is compounded by there not being any formal training for new systems, which can lead to people struggling to adapt to the new systems with the same degree of efficiency as they had before. With the Cloud still in its infancy (at least, as far as its role within production is concerned), further complications can arise where a particular service is simply unable to provide the same speed or functionality as its more traditional counterpart.

Much of this can be helped in the long-term through standardisation and development of the services. As more Cloud-based applications and services are trialled on different productions, they'll adapt to become more efficient

for the people using them. Similarly, if a particular system is used by the same person across multiple productions, they'll gain increased familiarity with it, learning shortcuts and what to avoid.

Accountability

Many Cloud services serve a number of different industries and cater to different situations. As such, they may be unwilling to be held accountable to issues specific to the needs of a particular production. A Cloud-based video playback system, for example, might have a limit on the length or number of videos that can be accessed in a given period, which a production might run into. When limitations like this are found, the service may become effectively worthless to the production, but at the same time, the service provider may not see the value in addressing the concerns of the production, and instead the production might have to find and switch to a different service.

This can be different from how productions are used to working—that everyone works together with the single purpose of bringing the production to completion, with almost all other considerations secondary. Many Cloud services won't (or can't) put a single client's needs first, and instead will provide a "service level agreement" (SLA) outlining where those boundaries lie. The SLA can even include provisions for a certain amount of maintenance or unexpected downtime, and it's absolutely critical that productions are aware of exactly how any such stipulations will affect them prior to relying on Cloud service providers for anything important.

4

Cloud Storage

"It's not the having, it's the getting."

—Elizabeth Taylor

At its most basic, Cloud Storage is just a copy of a file on the Internet *somewhere*, but that can be accessed from *anywhere*. The most familiar form of this is a photograph, a single copy of which may be uploaded to a social networking site, instantly available for others to see without the fuss of having to send emails or thumb drives, but the same concept extends to any type of digital file.

Cloud Storage is probably the most familiar part of the Cloud for most people. The concept of a file is easy for most people to grasp—whether this means a song from an album, a digital photograph, or a document of some type. Traditionally such files were stored on "local storage"—a person's own computer (or a disk attached to that computer), but since the early days of Cloud Computing there has been some form of Cloud Storage, whether in the form of attachments in webmail, documents in Google Docs, or images in Flickr.

Before long, two things became clear: first that there were unexpected side-effects of saving these kinds of documents in the Cloud (both positive and negative), and second that people wanted to be able to do more of the things that would typically be relegated to a computer desktop such as organising, copying, and deleting.

FIGURE 4.1 Cloud Storage

Recipe for Cloud Storage

What You Need

▶ Several megabytes (or more!) of electronic documents, saved on a computer or mobile device;

▶ A Cloud Storage service account. For speedy preparation, this service should come with an app specifically for your computer or mobile device;

▶ An Internet connection.

What to Do—from a Desktop Computer

1. If you haven't already, connect to the Internet;

2. Open the File Browser;

3. Transfer (copy or move) the documents, files, and folders that you want stored in the Cloud to your Cloud Storage folder;

4. Let the files upload for a little while, and then they're ready to serve.

What to Do—from a Mobile Device

1. Make sure you're on WiFi (or on a data network if your cellular plan allows);

2. Open the app with the document ready to share;

3. Tap the share button lightly, and be sure to pick your Cloud Storage app;

4. Watch the document completely upload, and it's ready to serve.

BOX 4.1 The Nuts & Bolts of Cloud Storage

Part 1—Transfer

In some ways the easiest part of running a Cloud Storage service is transferring files to (and from) the service in the first place. Much of the Internet itself is founded on the systems of file transfer, and as such, many technologies such as Hypertext Transfer Protocol (HTTP), File Transfer Protocol (FTP), and the like already exist and can be leveraged by service providers without much effort if needed. That said, many service providers actually build their own transfer protocols to get around existing limitations or provide some other benefit, such as synchronisation or enhanced security.

As a result, different Cloud Storage services will have different features and limitations when it comes to the process of merely getting the files onto the Cloud in the first place, before you even consider what's possible once they're there.

Part 2—Storage

What's interesting (or perhaps confusing, depending on your perspective) about Cloud Storage is that the files and folders saved on the Cloud actually exist on physical disks somewhere, in much the same way as they would if you kept them locally. Technically they're just bits and bytes of data saved to digital storage devices and subject to the exact same risks and problems as if you'd saved them onto your laptop's hard drive, including accidental deletion, data corruption, and even theft.

In reality, though, Cloud Storage providers are able to make use of greater redundancy and superior hardware to maintain the data stored,

(Continued)

(Continued)

especially when you consider it's in their best interest to make sure their clients' data remain intact.

Part 3—Sync

The original, and perhaps still most useful, feature of Cloud Storage is the ability to synchronise files between devices. Though this has been possible on desktop computers in a number of ways prior to the advent of Cloud Storage, doing so often required a needlessly complicated system of networking and backup software that made simply using thumb drives a preferable situation for most people.

Then Dropbox came along and gave users a single folder on their computer. Whatever anyone put in that folder would automatically get copied to any other computer that had Dropbox installed. If they then changed the file on another computer, the original file would be updated too.

Many of Dropbox's first users had no idea what the Cloud even was, just that they now had a simple, understandable way to get the same files on each of their computers. Naturally this service evolved in a number of ways, but this core functionality remains a strong selling point (and still remains the only relevant feature for many users) and is included as standard in most Cloud Storage services.

Part 4—Management

So you've stored some documents in the Cloud. Now what? Depending upon the particular Cloud Storage provider, there are many options for managing those documents, from downloading them later, to organising them into folder structures, synchronising them to multiple devices, searching them, sharing them with others (and setting various permissions for doing so), or even inviting collaborators to edit them directly.

Almost all of these options have analogues to a traditional desktop computer file browser, but the nature of using a web page to do these things allows for a number of affordances that makes each of these processes easier for users to understand. There are even features that work much better than a desktop counterpart could, such as the real-time collaborative editing of a Google Spreadsheet.

That said, there are still plenty of areas where you can't beat working with a file on a computer. It's unlikely a consumer Cloud Storage service would ever have the ability to play back a DPX image sequence, or be able to directly edit a Final Draft screenplay, but it's trivial to do such things on a desktop computer, given the right software.

BENEFITS OF CLOUD STORAGE

Ease

Cloud Storage can actually be easier to use than, say, a removable drive. You don't have to worry about which types of computers it will work with, there's a constant reminder of how much space is available and, strictly speaking, you don't even need to organise files—you can just use Cloud Storage as a dumping ground and rely on search functions to find files when you need them.

Access

One of the most obvious benefits to Cloud Storage is the ability to access files from anywhere (anywhere with an Internet connection, at least). Put your location stills in Cloud Storage somewhere, and you've got access to them at hotels; make sure a copy of your release forms are saved to the Cloud somewhere, and you need never worry that you don't have them next time you need them.

In addition to the desktop and mobile software that can be used to organise and access files in Cloud Storage, most providers also offer the means to organise and access files through a web portal as well. Not only does this provide a convenient way for users to access their files when the mobile or desktop software is unavailable (such as when using someone else's computer, for example), but it also allows for additional management and configuration for files. For example, the web interface for Box has comprehensive file and folder sharing options, as well as the ability to add notes, features that are not directly available when browsing the same files on the desktop.

Synchronisation

Many Cloud Storage services include synchronisation of files between devices in some way. Not only does this ensure a particular file exists on each of your devices, but it also means that updating one of them automatically updates the others. Add some records to a FileMaker database on your desktop computer that's synchronised to a Cloud Storage provider, and the next time you open it on your laptop those records will be there, without needing to use a dedicated server.

Collaboration

As with much of the Cloud, if Cloud Storage is about anything it's about connecting with others. Most Cloud Storage providers provide a way to share your files with others (most of them offer a way to do so securely as well as conveniently), but some even go as far as allowing you to work collaboratively, letting others make changes to your files, or providing the means to make remarks on them. Some providers also have an Application Programming Interface (API), allowing users to build their own software to interact with their data in some way.

Cost-Effectiveness

When you can buy a terabyte of external storage for less than a hundred dollars, it raises the question of why you'd want to spend (typically) significantly more for a Cloud Storage solution for a prolonged period of time. However, it's important to remember that in many cases you're actually paying for all the other benefits Cloud Storage gives you, beyond the simple case of *just having somewhere to store some files*. Storing files is cheap but maintaining them is expensive.

Security & Reliability

One of the benefits of using a Cloud Storage provider as opposed to relying on just keeping the same files in a folder on your desktop computer is that you get the benefits of the providers' (hopefully) greater IT expertise and resources. Cloud Storage providers typically have an extremely high level of data redundancy that mitigates the likelihood of any particular file becoming lost (or corrupted), even if they were to simultaneously lose multiple data drives. Many also couple this with data encryption (at the point of transfer and when the files themselves are stored) and other digital and physical measures to prevent your data being accessible by the wrong people.

It might seem counter-intuitive to protect the confidentiality of your data by giving it to someone else, but in doing so, you potentially get an army of IT technicians working round the clock to protect your files, in a way that would be difficult for even a blockbuster-budget production to be able to replicate.

Versioning

Many providers have begun to include versioning features as part of their service. Any changes made to a file (including if the file itself is deleted) are stored as a version of that file, and older versions can be accessed later as needed (although some providers only store such versions for a limited period of time).

BOX 4.2 Data Storage and Redundancy

A myriad of things can go wrong with files stored on traditional disk drives, and any of these issues can lead to some corruption of a single file in the least severe instance to the entire contents being lost for good. This has been a problem for anyone using digital storage since before Cloud Storage even existed, and as such there were several ways to minimise the potential damage a disk failure could incur. These came in many different forms, such as having a solid backup system, or spreading data across multiple linked drives, but they all boil down to one thing: redundancy, or having multiple copies of your data.

The concept of redundancy is easy enough to understand when it applies to a backup system—if you lose a disk full of camera reports that you've previously copied to a second disk then your data are still safe (assuming, of course, that second disk is fine). The same principle applies to Redundant Array of Independent Disks (RAID), except that instead of two or more complete copies being stored on separate disks, each file is split across multiple disks, along with some extra data that allows the files to be re-created in case of a problem.

If a single disk in a RAID is lost, for example, it's not a big deal (other than replacing the faulty disk), because there's enough data stored on all the other disks to re-create the data on the disk that was lost. There are different configurations of RAID that allow for files to be safe even if two (or more) disks are lost simultaneously, each with trade-offs of requiring more storage space, more physical disks, or just more time to recover from failure.

Most Cloud Storage providers are in a position to offer data redundancy across not just multiple disks but multiple *facilities*. In theory, one of Amazon S3's data centers could be hit by an atom bomb and its clients' data would still be intact.

DRAWBACKS OF CLOUD STORAGE

Online Requirement

One of the biggest strengths of Cloud Storage is also one of its biggest drawbacks: its dependence on the Internet. Find yourself without an Internet connection, and you'll find yourself without access to your files. This is less of an issue for those providers that also offer some sort of syn-chronisation option, because then at least you still have the local copy of your files when you can't get to the Internet, but there's a point where this becomes self-defeating—you don't necessarily want to have all your video dailies saved to local storage all the time because it's a waste of disk space most of the time.

Speed

For most real-world uses of Cloud Storage on any production, speed is going to be one of the primary legitimate concerns for most people. You can transfer files only as fast as your Internet connection allows, and if you're planning to regularly transfer lots of large files (like camera footage) back and forth, you're going to experience limitations and frustrating delays no matter how fast that connection is.

The concept of making a "copy" in terms of Cloud Storage actually involves what could be considered two time-consuming processes: first the files must be uploaded to the Cloud and then downloaded elsewhere (although at least such uploads normally only ever have to be made once).

Capacity

Cloud Storage, like local storage, tends to be cost-effective in terms of how much data you store up until a specific point. For local storage, it's pretty common to buy disks to a total of around 10 terabytes (TB) or so before things start getting expensive and you have to think about getting special-ised hardware or keeping a stack of disks on a shelf somewhere; for Cloud Storage there tends to be a limit of around a terabyte or so until the cost goes up steeply (many providers simply offer a maximum storage plan with no option get more), although conversely many will also offer a plan that gives you around 5 gigabytes (GB) or so for free.

Although it's likely Cloud Storage limits will continue to increase over time, this will likely coincide with a corresponding increase in capacity per disk of local storage, which will remain more affordable for higher volumes of data.

In terms of the amount of data a typical production might generate from pre-production to post-production, 5 GB might well be enough to store pertinent spreadsheets and text documents, but once you start including reference images and photos you could find yourself running into that terabyte limit before the film is done. If you were to start thinking about storing camera footage as well, you'd need something in the order of hundreds of terabytes of storage for a typical feature film (and a very fast Internet connection to get it there).

Trust

In handing data to a third-party, you are placing a degree of trust in them, not only in terms of security and reliability, but also in terms of the privacy and confidentiality of your data. The terms of service of most of the popular Cloud Storage providers, from Google to Dropbox, can be so vague as to defy any guarantee that anyone working within those companies will not implicitly have access to your files as they please. Whilst there's never any question that "your content remains your content", there are also significant concessions to allow the companies to look inside your files, with possible reasons for doing so ranging from serving targeted advertisements to preventing piracy.

One possible (if not necessarily practical) way around this is to encrypt the data yourself before sending it to the Cloud. Doing so will ensure no-one else will be able to access any data you send, but in doing so you forfeit some of the benefits of using Cloud Storage in the first place, such as the ability to view or collaborate on documents online.

BOX 4.3 Doing More with Files in the Cloud

It's no coincidence that Cloud Storage services are starting to look more like social media services than the file browsers they originally emulated. For some, such as the photography-oriented Flickr, this is unsurprising,

(Continued)

(Continued)

as sharing and giving feedback on each other's submissions is a key part of the service; but even more traditional file management services like Microsoft OneDrive feature the ability to create photo albums that are abstracted from the file/folder hierarchy and can be shared with others.

Roll Your Own Cloud Storage

Somewhat ironically, there are several options to turn local storage into Cloud Storage. Western Digital's "My Cloud", for example, gives you the ability to access the contents of a local drive across the Internet, but without the subscription cost associated with Cloud Storage providers (and without the associated security and reliability benefits). Similarly, free software such as OwnCloud Server can be installed to your own web server to provide Cloud Storage that you control directly.

Cloud Storage Business Models

One of the unexpected side-effects of Cloud Storage was that people were willing to pay for it. In an era where even Internet behemoths like Facebook were struggling to create web-based services that people would pay real money to use, companies like Microsoft and Apple found that they could successfully create tiered plans for different levels of storage at different price points, and then create the services to help people fill them up, rather than the other way round.

Perhaps most notably, in 2013, Microsoft launched its Office 365 desktop software as part of a package that included 1 TB of Cloud Storage space, at a price point that directly competed with the ubiquitous Dropbox. Essentially, they matched Dropbox's storage plan, and threw in their entire software suite with it. Similarly, in 2014, Apple launched its iCloud Photo Library service, a way to automatically store a user's entire photo collection in the Cloud, with a similarly tiered price plan to Dropbox. Dropbox itself launched Carousel in 2014, a mobile app that would help you fill your Cloud Storage quota by automatically uploading your photos and videos, whilst providing the added benefit of freeing up space on your mobile device.

(Continued)

(Continued)

Password Protection

In 2014, there were reports of Cloud Storage service Dropbox having been hacked, with unauthorised people having been able to get access to several million accounts. A similar, albeit smaller-scale incident was reported later the same year with Apple's iCloud service. The sad truth was that in both cases, access to the accounts in question was obtained indirectly, in one case by attempting to match a list of previously known email and password combinations from other sites, and in the other by exploiting known facts about the users in question to successfully reset their passwords. In both cases, these breaches could have been avoided entirely had the users signed up for two-factor authentication, which registers the account to a specific cellphone number in addition to the standard username and password.

POPULAR CLOUD STORAGE SERVICES

Dropbox (dropbox.com)

Cost: free (feature-limited), $100/year (Pro), $180/user/year (Business)

Availability: desktop, mobile, web

Capacity: 2 GB (Free), 1 TB (Pro), Unlimited (Business)

Security/Privacy: username/password, two-factor authentication, encrypted storage, remote wipe (Pro, Business)

Access: desktop sync folder, web portal, mobile apps, API

Management: files can be organised into folders and subfolders; individual files or entire folders can be shared with others, selectively synced to devices, deleted, copied, moved, renamed, and downloaded; versions of each file are tracked; photos and videos can be organised into "albums"; certain file types can be viewed directly

Undoubtedly one of the most popular Cloud Storage services, Dropbox has been around since 2007 and boasts 300 million users. Not only is it very simple to use, but it's also extremely reliable for syncing files across a

number of different platforms, and has a number of powerful features hidden away, such as fine-grained sharing settings, and integration with a large number of third-party applications.

Box (box.com)

Cost: free (Personal), $5/month (Starter), $15/user/year (Business)

Availability: desktop, mobile, web

Capacity: 10 GB, 250 MB/file (Free); 100 GB, 2 GB/file (Starter); Unlimited, 5 GB/file (Business)

Security/Privacy: username/password, two-factor authentication, encrypted storage

Access: desktop sync folder, web portal, mobile apps, API

Management: files can be organised into folders and subfolders; individual files or entire folders can be shared with others, selectively synced to desktop devices, deleted, copied, moved, renamed, and downloaded; versions of each file are tracked; certain file types can be viewed directly; collaborators can edit folder contents

Box is more targeted to businesses than individual users. As such there's an emphasis on permission control and the ability to collaborate with others within folders. It features a robust search function and generally solid feature set.

Apple iCloud (icloud.com)

Cost: free–$20/month

Availability: desktop, mobile, web

Capacity: 5 GB (Free), 20 GB ($1/month), 200 GB ($4/month), 500 GB ($10/month), 1 TB ($20/month)

Security/Privacy: username/password, two-factor authentication, encrypted storage

Access: desktop sync folder, web portal, mobile apps

Management: files can be organised into folders and subfolders; individual files can be emailed to others, deleted, and downloaded; photos and videos can be organised into "albums" and shared with others; some file types can be viewed directly; some file types can be edited directly; built-in applications for storing notes, passwords, contacts, email, reminders, and calendars

Apple's contribution to Cloud Storage gets better the more Apple products you connect to it. Though both Mac and Windows desktop computers are supported, on the mobile front, only Apple devices are supported. Although the service as a whole handles a number of different types of data elegantly, from notes to video, these work best with Apple's own desktop software, and in fact its actual file storage system is rather lacklustre.

Google Drive (drive.google.com)

Cost: free–$300/month

Availability: desktop, mobile, web

Capacity: 15 GB (Free), 100 GB ($2/month), 1 TB ($10/month), 10 TB ($100/month), 20 TB ($200/month), 30 TB ($300/month)

Security/Privacy: username/password, two-factor authentication, encrypted storage

Access: desktop sync folder, web portal, mobile apps, API

Management: files can be organised into folders and subfolders; individual files or entire folders can be shared with others, selectively synced to devices, trashed, deleted, copied, moved, renamed, and downloaded; versions of each file are tracked; photos and videos can be organised into "albums"; some file types can be viewed directly; some file types can be edited directly; built-in applications for storing contacts, email, and calendars

Google's offering provides much of the same functionality as iCloud, although it features access from a greater variety of devices and platforms, as well as a vastly superior interface for manipulating and sharing files. It also uses a trashcan metaphor, in that files that are deleted are not immediately removed from the storage, but instead go into a special folder from which they can be recovered later or permanently removed.

Amazon Cloud Drive (amazon.com/clouddrive)

Cost: $12/year (Unlimited Photos), $60/year (Unlimited Everything)

Availability: desktop, mobile, web

Capacity: photos + 5 GB (Unlimited Photos), unlimited (Unlimited Everything)

Security/Privacy: username/password, encrypted storage

Access: desktop upload, web portal

Management: files can be organised into folders and subfolders; individual files or entire folders can be trashed, deleted, copied, moved, renamed, and downloaded; photos and videos can be organised into "albums"; some file types can be viewed directly

Although Amazon's Cloud Drive service offers excellent value for money in terms of its storage plans, its limited desktop integration means you have to specifically send individual files and folders to the service as opposed to the sync folder option that other services use. In terms of security it's a bit of a slouch too, protected only via a login and password with no possibility to enable two-factor authentication. There's also no possibility to share files with others.

Microsoft OneDrive (onedrive.live.com)

Cost: free–$4/month, $5/month–$20/month (Office 365)

Availability: desktop, mobile, web

Capacity: 15 GB (Free), 100 GB ($2/month), 200 GB ($4/month), 1 TB (Office 365)

Security/Privacy: username/password, two-factor authentication, encrypted storage

Access: desktop sync folder, web portal, mobile apps, API

Management: files can be organised into folders and subfolders; individual files or entire folders can be shared with others, selectively synced to devices, trashed, deleted, moved, renamed, and downloaded; versions of each file are tracked; photos and videos can be

organised into "albums"; some file types can be viewed directly; some file types can be edited directly; built-in applications for storing notes, email, and calendars

Microsoft's Cloud Storage service has a similar feature set as most of the other services, but specific features depend on which one of the 10 available plans you opt for. Compared to the other services which offer encrypted storage as standard, only the business or enterprise plans offer this feature on OneDrive. Perhaps the biggest selling point for the service is that the Office 365 plans bundle Microsoft's Office suite of desktop, web, and mobile applications.

Amazon S3 (aws.amazon.com/s3)

Cost: based on usage

Availability: web

Capacity: unlimited

Security/Privacy: encryption key, encrypted storage

Access: web, API

Management: files can be organised into folders and subfolders; individual files or entire folders can be shared with others, deleted, moved, copied, renamed, and downloaded

Amazon S3 is designed to be used in conjunction with other software. It has a rudimentary web-based interface, but unless you plan on using it for a very small number of files (and very large files at that), you'll find other options that have a much lower barrier to entry. If you intend to make use of its comprehensive API (or make use of some application that uses it), there's a lot to like, and it can be cost-effective for a high volume of data. The service is priced for both storage and transfer of data, and the rates depend on the volume of data stored and transferred, meaning it can be difficult to determine exactly how much the service would cost to use. There are three tiers of storage pricing: "standard", "reduced redundancy" (whereby the integrity of data is not assured in the long-term, but the cost is lower), and "glacier" (the cheapest option, but more suited to long-term archive, as retrieval can be comparatively slow).

Google Cloud Storage (cloud.google.com/storage)

> **Cost:** based on usage

> **Availability:** web

> **Capacity:** unlimited

> **Security/Privacy:** encryption key, encrypted storage

> **Access:** web portal, API

> **Management:** files can be organised into folders and subfolders; individual files can be shared with others, deleted, and downloaded

Similar in almost every respect to Amazon S3, but with a more comprehensible pricing structure, Google's Cloud Storage is more for developers than end-users and features a similar three-tier pricing scheme (and charged separately for transfer and storage of data): "standard", "durable reduced availability" (the integrity of data is assured, but the retrieval time is reduced), and "nearline" (for data that does not need to be retrieved quickly or often).

Flickr (flickr.com)

> **Cost:** free (ad-supported), $50/year (ad-free)

> **Availability:** mobile, web

> **Capacity:** 1 TB, 200 MB per photo, video and photo files only

> **Security/Privacy:** username/password, two-factor authentication, per-file privacy settings

> **Access:** web portal, mobile apps, API

> **Management:** individual images and videos can be edited, tagged with keywords, annotated, shared, downloaded, and organised into "albums"; individual albums can be organised into "collections"

Flickr is a bit of a standout compared to other Cloud Services, as it's for videos and photos only. There's a huge amount of metadata associated with

each file, both from the camera (in the form of location and EXIF data) and from the site itself (in the form of annotation, comments, and usage rights). There's an abundance of sharing options (including comprehensive permissions and the ability to send files to groups) and a full-featured web-based photo editor. Everything is automatically included in a "photostream" and located on a map where possible.

BIBLIOGRAPHY

2014 Celebrity Photo Hack http://en.wikipedia.org/wiki/2014_celebrity_photo_hack

Amazon S3 FAQs http://aws.amazon.com/s3/faqs/

Cloud Storage Providers: Comparison of Features and Prices http://www.toms hardware.co.uk/cloud-storage-provider-comparison,review-33060.html

Dropbox Wasn't Hacked https://blogs.dropbox.com/dropbox/2014/10/dropbox-wasnt-hacked/

iCloud Security and Privacy Overview https://support.apple.com/en-gb/HT202303

Is Google Drive Worse for Privacy Than iCloud, Skydrive, and Dropbox? http://www.theverge.com/2012/4/25/2973849/google-drive-terms-privacy-data-skydrive-dropbox-icloud

OwnCloud Server https://owncloud.org/

Some Home Truths about Storage, or Why Is Enterprise Storage So F-Ing Expensive? http://serverfault.com/a/2493/160124

Western Digital My Cloud http://www.wdc.com/en/products/products.aspx?id= 1140

5

Cloud Computing

"You know, while the other guy's sleeping? I'm working."

—Will Smith

Cloud Computing might be the next great frontier of technological progress. The idea of using a computer to send work for another computer somewhere else to do might seem pointless, but the reality is there can be a great many benefits to doing so. Just as a director of photography might delegate responsibilities to a lighting crew on a shoot, so might a laptop or tablet be used to call in the computing power of a room of supercomputers on the other side of the globe.

That's all well and good, but you might be wondering what practical uses it has. The short answer is it can be used for any traditional computing process that would take a long time on your personal computer, which means things like video compression or data mining and analysis of large amounts of data. From the perspective of a large production, the most obvious opportunity for use is post-production, or more specifically, visual effects. Most visual effects production requires a tremendous amount of computing power, for processes like analysing camera motion, generating simulations, performing image manipulation, and rendering—generating the high-resolution footage at the end of the process. Many of these processes are hampered by the fact that they're time-critical, there's always likely to be a point at the

FIGURE 5.1 Cloud Computing

end of the production where the visual effects artists must suddenly have to generate high-resolution versions of all of their finished work in one go, to satisfy an impending deadline. Having racks of computers available on demand to help with the load is clearly a tantalising prospect for many.

The long answer, though, is that it's invariably more complex than that. First you have to balance the time it takes to send the data across to the computers in the Cloud against the time saved by not doing it yourself, and then you have to factor in building the infrastructure to enable all this to happen. Even after all that, you need to consider the financial implications and probably some security measures too.

Right now, there are few out-of-the-box Cloud Computing Services that can be easily adapted to fit the specific requirements of a production, but undoubtedly we'll start to see more in the future. For the time being, if you want to take advantage of this powerful technology, your only viable choice is to build it on top one of the many services available that offer some sort of interface to run programs.

Recipe for Cloud Computing

What You Need

- ▶ A Cloud Computing service account;

- ▶ A program or set of instructions you want to run;

- ▶ An Internet connection.

What to Do

1. If you haven't already, connect to the Internet;

2. Open your Cloud Computing service's interface;

3. Prepare the program you want to run;

4. Mix in any required supporting files;

5. Allow time for the results to bake;

6. Serve the result.

BOX 5.1 Uses for Cloud Rendering

Part 1—Analysis

With the vast majority of productions relying on digital cameras as their primary capture method, much of the audio and video created is immediately ready to take advantage of a wide array of digital tools. These range from things like video stabilisation (to remove unwanted camera movement) and rolling shutter (to remove distortion present in movement when certain digital cameras are used) to audio correction (to remove unwanted noise). More esoteric types of analysis such as shot type detection (whether a given shot is a close-up or wide shot) and face detection are also possible.

All of these are potential candidates for Cloud Computing, with footage uploaded to the Cloud service, analysed, and either corrected footage or the analysis data sent back. For productions already planning to store their rushes in the Cloud, setting up a system to perform some of this type of analysis whilst it's there could be an added bonus.

BOX 5.2 Uses for Cloud Rendering

Part 2—Transcoding

One of the greatest benefits of digital technology is that everything can be easily copied and be made available everywhere. If you upload a digital movie to the Cloud, it can be made immediately available for an executive to watch on her mobile. That's the promise, at least.

(Continued)

(Continued)

The reality is that different devices have different capabilities and requirements. Raw 4k-resolution footage doesn't lend itself particularly well to being viewed on a mobile device, and that's where transcoding comes in. Transcoding is the process of transforming digital media from one format to another. If you've ever uploaded anything to YouTube, you've seen transcoding (indeed, Cloud transcoding) in action—that delay where your movie must be "processed" before it is available for viewing. Once that's completed, YouTube is able to send your movie to different devices, in a format specifically tailored to the needs of that device. This same process can apply to a more customised or restricted context for your own footage—having it be viewable at a specific level of quality on a specific device, for instance, or even forcing it to have it watermarked to the specific person watching it.

More specific to modern productions, though, is the problem of translating raw (and possibility proprietary) footage formats into something accessible to the production itself, as well as any of the facilities that will be using the footage for further work. This "scanning" process (so called for its roots in the digitisation of celluloid) is typically carried out by a third-party, but this need not be the case, and indeed it is something that could potentially be fulfilled by Cloud Computing, particularly if all the footage will be stored in the Cloud.

BOX 5.3 Uses for Cloud Rendering

Part 3—Rendering

It probably comes as no surprise that post-production, and visual effects in particular, comprises the most computing resources used on a production, whether it be for beautification of select drama shots or intense CGI-laden spectacles. Of this, the rendering process, by which the overall effect is baked into the original footage, is probably the most computationally demanding process required. Not only that, but it's also something that needs to be done a lot, both for previewing purposes whilst the work is carried out by the artists, but also because there will typically be multiple versions of multiple shots that a given facility will need to produce. Even worse, there's typically a "crunch"

Planning to render in the Cloud?

Now	29%
1 Year	59%
5 Years	90%

Source: shotgunsoftware.com

FIGURE 5.2 Visual Effects Studios Planning to Render in the Cloud

point towards the final delivery of the production, where a great many render jobs will be required in a short space of time.

Traditionally, these are handled by "render farms", banks of computers that exist in the facility simply to process render jobs. There are a lot of costs associated with running render farms, in both the hardware and maintenance costs, but also the real estate they require, and even the (sometimes) team of people to manage and coordinate their availability. With costs in other areas spiralling downwards (and the market becoming more competitive as a result), it's an area that seems ready to take advantage of the more "on-demand" costs of Cloud Computing, paying simply for the computer resources as and when they're needed.

Indeed, in a survey conducted in 2015 of 125 different visual effects studios (j.mp/cloudrenderpoll), just under one third were already tapping into the power of Cloud Computing for rendering, with 90% planning to do so within five years. Clearly, rendering on the Cloud will be a crucial part of most visual effects production pipelines before long.

BOX 5.4 Uses for Cloud Rendering

Part 4—Stereo Conversion

The process of converting something shot with a single camera for projection in stereoscopic 3D (also known as dimensionalisation) bears a lot in common with rendering—it can require a lot of computing resources and must typically be done within a short timeframe. It requires taking a footage from a finished production (in two-dimensions) and then

(Continued)

(Continued)

adapting that to end up with footage that gets shown to the left eye, and corresponding footage for the right eye, as if a stereoscopic camera had been used to record everything in the first place, and providing the illusion of 3D to the audience.

Broadly speaking, there are two approaches to stereo conversion: you can have an artist hand-paint every single frame of a finished production to get a set of frames for the left eye and a set of frames for the right eye, or you can use software to automate this process. Having an artist do the work invariably produces superior results, but takes an awful lot longer (and can be considerably more expensive). In practice, there's typically a mixture of both approaches, and there's usually more than enough computer processing needed to make a case for using the Cloud to do it, although this would typically require a large turnover of data.

BOX 5.5 Uses for Cloud Rendering

Part 5—Simulation

One last process that deserves a mention is running simulations. Commonly simulations are run as part of more complex visual effects generation such as for simulating how things like hair, foliage, and fluids move in computer-generated animations, but similar tools can be used for pre-visualisation of shots before the camera even rolls, such as when planning out more involved stunts or crowd scenes.

Typically these simulations are run locally on the artist's own computer, but this can take time, and the limited amount of source data required to run the simulation means it could potentially be faster to upload everything to a Cloud Computer and have it run the simulation much faster and send back the results instead.

BENEFITS OF CLOUD COMPUTING

Speed

Although there's typically a longer lead time involved with Cloud Computing, in terms of the time it takes to get all the required resources to the

service provider before the actual process can run, once processing starts it is potentially much quicker than doing it locally. This isn't always the case, as some processes might need to run sequentially (each part of the process must complete in a specific order before the next can begin), but for those that can run in parallel, there can be a huge time saving compared to running the same process on a local computer.

Cost-Effectiveness

Done right, Cloud Computing can save both time and money for various tasks. Prices will continue to drop as more providers enter the arena with different methodologies and offerings. The pricing models are based around usage, so you don't need to factor in what happens if there's a hardware failure or any of the myriad of issues that can prevent a particular computer from being available for use; if the service provider encounters such an issue, they simply rotate a working system into use for you.

The Cloud Storage Synergy

If you're already reaping benefits from storing files in the Cloud, there's a natural next step to harnessing the power of Cloud Computing. Part of the problem of Cloud Computing, namely getting all the files you need *into* the Cloud to be available to use, is solved if you're storing them on the Cloud for other reasons. In principle (access between different Cloud Service providers notwithstanding), if you store everything you shoot in the Cloud, it should be fairly trivial to use Cloud Computing to process that footage, whether it be for analytical purposes, transcoding it to make it available for viewing across different devices, or making it available for rendering or stereo conversion purposes.

Limitless Resources

With most Cloud Computing providers, there's plenty more resources available than you'd need to use. You can scale up when you need or release resources when you don't. You typically pay for computation as you need it, so there's no upkeep or maintenance costs to worry about the rest of the time. What's more, these resources can be made available almost immediately, so there's no appreciable delay when extra power is needed.

DRAWBACKS OF CLOUD COMPUTING

Difficulty of Setup

Without the availability of pre-packaged processes that can be run to accomplish specific tasks at the current time, someone has to actually write the programs to be run in the first place. This can be a monumental amount of work in itself, especially when you consider that each Cloud Computing service provider has its own interface and language for running processes. Until more productised solutions become available to fulfil specific needs that productions are likely to face, harnessing the power of Cloud Computing will likely depend on the availability of software engineers the production has access to.

Compatibility

Even where out-of-the-box Cloud Computing solutions do exist to perform specific tasks, the chances are that there will be compatibility issues. Different Cloud Computing providers each have their own idiosyncrasies and requirements in terms of security and access, and as such, processes tend to be created to work with a given provider as much as to solve a specific problem.

You might have a transcoding program that can be used with Amazon's Cloud Computing service, for instance, but that assumes you're also using their Cloud Storage service. If you're instead using Box to store your files, then you're faced with the dilemma of trying to adapt the program to work with Box or instead copy all of the relevant files to Amazon. Either approach will take time and result in additional expense that might make it inconvenient to use at all.

Software Licenses

Even if you have the engineering resources to adapt some software you already use to make it work in the Cloud, you might find that it depends on some component that expressly (or even vaguely) forbids its use on a Cloud Computing service. Navigating these legal issues can be costly and time-consuming and again make the entire effort of utilising the Cloud wasted.

Availability of Assets

Ensuring access to all required assets for a specific process to work can be difficult, especially if they come from different places. It's one thing for an artist to render a visual effect shot on his workstation, it's quite another to

be able to collect all the footage, textures, models, and metadata together and make them available to a computer you don't own or have direct access to, located somewhere on the Internet.

Monitoring Work in Progress

With work being done somewhere else, it can be difficult to monitor exactly what's happening with it at any given moment. Much of the time, for smaller processes, that doesn't necessarily matter; if you send a movie file to be transcoded and nothing valid comes back, you know something has gone wrong, but for longer-running (and thus more expensive) processes it becomes more important to have ways to monitor progress so that you aren't wasting money on computing resources that aren't actually doing anything useful.

Related to this can be the inability to interrupt long-running processes. If you discover that camera reel you've just submitted for image processing is actually not required for the production, there's little point having all the processing done and incurring a cost for the work.

Similarly, the nature of Cloud Computing means that processes that would normally take a prolonged period of time can be done much faster, which then has the adverse effect of not having time to monitor or interrupt them effectively. It's important, then, to think about protocols for Cloud Computing jobs in a different way than with traditional computing.

Speed

Given that the main purpose of leveraging Cloud Computing is to reduce the time taken to perform some computation than when doing it on a local system, there's a point where you can invest so much time in preparation that any gains made by having greater computing resources available are ultimately lost in terms of the overall length of time to execute the process. For example, it might take a technician 30 minutes to transcode an hour of high-resolution footage, but only 10 minutes for a web service to perform the same process. However, if it takes 20 minutes or more to upload the footage to the web service before it can begin processing, then you don't gain any benefit over having the technician doing it.

That said, careful planning with these limitations in mind can sometimes make the process efficient, especially when there are numerous, easily repeatable chunks of processing needed. With the previous example, if the

FIGURE 5.3 Without the Cloud, Processing Tasks Happen Serially

FIGURE 5.4 With the Cloud, Processing Tasks Can Happen in Parallel

technician actually had 10 separate batches of hour-long footage transcodes to perform, they might be able to "queue up" the uploads of each batch and have the transcoding of each happen as soon as they're ready. In this more parallelised situation, it could take around 3.5 hours from the start of the first upload to the completion of the final transcoding process, which is a significant improvement over the 5 hours it would take the technician, having to process each batch sequentially.

Whilst data transfer is an obvious time consideration, there are others too. There's preparation of the computation process itself, which if custom-made, might have to be adapted to fit different situations, and even for more generic ones, there might be a lengthy configuration or setup process to contend with before the work can begin. Finally, there's also the possibility that a given Cloud Computing service might not guarantee immediate availability of resources at the time you request them; there might be a significant period of time before you can be allocated the computing power you need.

The submission of source data to the Cloud for processing (and the subsequent retrieval of resulting files) may take a significant amount of time as well as other resources to facilitate the transfers. However, these issues may already exist, particularly within facilities that comprise departments in different geographical locations.

Cost

Although Cloud Computing can be very cost-effective compared to using local resources, there are so many factors to the overall cost of a given

process that it can be extremely difficult to know what the actual cost of a given process is. Even in the simplest case, where the service provider charges a flat rate for the amount of computation you need (regardless of whether you spread the processing work over a large number of machines for a relatively short period, or opt to tie up a single machine for a longer period), there are still various overhead costs to consider, whether from setting up the process to run in the first place, to ancillary costs such as bandwidth and storage of temporary and final assets required by the process. Even if not strictly accurate, the alternative to Cloud Computing is to "do it yourself for free".

There are other challenges here too. If mistakes are made in setting up the process, you still get charged. Consider this: if you take advantage of Cloud Computing to run a process that might otherwise take a week, in a couple of minutes (but at significant cost), there's probably no good way to monitor (or even interrupt) the process to make sure it's doing exactly what you need it to. You set it off and pay for the work, and if all that work goes to waste, well you're still going to be billed for it.

Finally, there's the reality of Cloud Computing services as they exist today. Almost all of them, barring those built for specific purposes, have ludicrously complicated pricing structures. If you're going to be relying on a Cloud Computing service to do one specific thing repeatedly, then you can probably estimate the cost of that process over time, by looking at historical costs for running it in the past. For everything else, though, it can be rather tough to try and predict just how much something is going to cost before you've done it.

Security

As with most Cloud services, there are security issues to consider. Can sensitive data (pictorial or otherwise) be intercepted to or from the Cloud Computing provider? Can the service provider themselves be trusted with any data you send them?

In many cases, these are the same questions you'll be asking of Cloud Storage service providers. Generally speaking, it seems unlikely that any individual calculation that is run on a Cloud Computing service would expose any sensitive data, but the source data that might need to be sent to the service to run the processes on might. Depending exactly what you're doing, you might need to send reams of financial data or footage or still images that relate directly to the production (and often months before the production's general release), in

short high-value material that if leaked could wreck the production before it is even completed. Many generic Cloud Computing service providers would assume that you won't be using their services with any sensitive data of this nature, and you'll likely find lots of language in their terms and conditions that anyone working at their company has unrestricted access to said data (it's probably also worth mentioning that other clients are potentially running software on the same physical machine as you. Whilst the service providers go to great pains to ensure that clients are sandboxed [completely isolated] from each other, it would be advisable to bear this in mind in the long-term).

These issues are probably less of a concern for smaller productions than big studio productions, of course, and as the various services mature and become more specialised, it seems likely that those that are designed to process financial data or footage specifically will be able to address these concerns in a more comforting way.

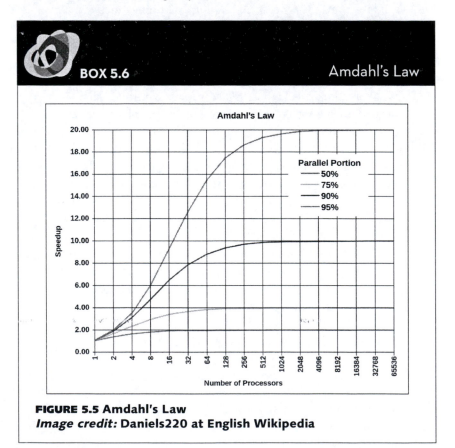

BOX 5.6 Amdahl's Law

FIGURE 5.5 Amdahl's Law
Image credit: **Daniels220 at English Wikipedia**

(Continued)

(Continued)

Amdahl's Law states that "the speed-up of a program from parallel-isation is limited by how much of the program can be parallelised". According to this law, there's a point where the effectiveness of "throwing more computers at the problem" falls off and doesn't actually save you significantly more time.

Indeed, by accurately plugging in the proportion of the process that can be made parallel (versus the proportion that must be completed sequentially) into the equation that forms this law, it's possible to identify the sweet spot of completing the process in the best time, whilst essentially maximising your return on investment in the number of processors you need.

Smart Cloud Computing

In spite of all the moving parts involved in Cloud Computing and the resulting futility in trying to estimate how long processes will take (and cost), there are still some best practices you can adopt to try and use Cloud Computing services in an effective way.

1. When in doubt, send it. If you're not sure if some source data are needed by a given process, make them available to the process anyway. In many cases, it's easier to swallow the cost of transmitting additional data to the service than it is to have the process run and fail and have to be run again later.

2. Generate proofs of everything where possible. For example, if you have a lot of footage queued up for analysis, try to test with a small sample size first to make sure the results are as you expected. In the case of transcoding footage, it's preferable to either transcode low-resolution examples first to allow for quick eyeballing of the results, and/or high-resolution single frames to check details.

3. Prepare for Cloud Computing. Perhaps the smartest way to make use of Cloud Computing right now is to have it available to use in situations where local processing is inadequate in some way, such as when a rapid turnaround is needed. Set up and test a Cloud Computing pipeline for intensive tasks but depend on more traditional, local resources whenever possible.

(Continued)

(Continued)

> 4. Don't think bigger, think smaller and more numerous. Cloud
> Computing is at its best when you use it to work with lots of tiny
> pieces, rather than trying to push through one big huge calculation.
> Bigger calculations can result in bigger failures, and more individual
> pieces are easier to spread over multiple processors.

POPULAR CLOUD COMPUTING SERVICES

Amazon Elastic Compute Cloud (aws.amazon.com/ec2/)

Pricing: free, on-demand, reserved, spot

Storage: via Amazon S3

Amazon Elastic Compute Cloud (EC2) offers access to some of the larger
Cloud Computing data centers available, but they do so through a pricing
system that is extraordinarily complicated, with a great many different pric-
ing plans and tables of options within each of those. One of the interesting
things Amazon does in terms of pricing is their "Spot Instancing" model,
where you can bid for processing power that would otherwise be going
unused and potentially get a really good deal as a result.

The on-demand pricing model is charged per hour, depending on which
specific configuration of hardware and operating system you require, and
from there you essentially get a blank canvas to upload the software you
want to run, which will probably rule it out for use for all but the most
technically-inclined (it's worth noting that immediate availability of the
service is only guaranteed with Amazon's "reserved option"). Finally, a
number of specialist Cloud Computing services are also available, includ-
ing graphics processing hardware (GPU), as well as various ancillary ser-
vices to provide metrics or set alarms.

Amazon Elastic Transcoder (aws.amazon.com/elastictranscoder/)

Pricing: free, on-demand, reserved, spot

Storage: via Amazon S3

Amazon Elastic Transcoder offers a relatively straightforward way (compared to just using its EC2 service, for example) to transcode videos to different formats. There are options to encode some basic metadata into the transcoded media, as well as digital rights management via PlayReady. Media can optionally be encrypted throughout the process of upload, transcode, and download.

However, documented support for different video formats and codecs seems rather limited; there's no mention of common production formats such as Apple ProRes or Avid DNXHD, for example (though reportedly the latter is indeed available through the service). Furthermore, there doesn't appear to be a way to scale up resources if you need a lot of transcoding done quickly.

Microsoft Azure (azure.microsoft.com)

> **Pricing:** by usage, rate dependent on service required

> **Storage:** Azure Storage, Azure Cache, Azure StorSimple

Microsoft's answer to Amazon EC2 offers a similar service with similar features but with a less complicated pricing structure. They promise that you pay for just what you use, but in doing so sacrifice some of the affordability of Amazon's specialist pricing models. Microsoft is clearly making moves in this area to lower the barrier to entry, but in its current state it still requires a great deal of technical expertise in order to get up and running.

Microsoft Azure also offers a robust, dedicated service for transcoding media (or encoding with PlayReady Digital Rights Management [DRM] or clear key Advanced Encryption Standard [AES] encryption), even including support for multichannel Dolby Digital Plus audio (and offers a "premium" flavour of its service, which supports the Avid DNXHD format).

Brightcove Zencoder (brightcove.com/en/zencoder)

> **Pricing:** per minute of output media

> **Storage:** N/A

Zencoder offers a very solid Cloud Transcoding service, one that's very flexible, feature-rich, and with a simple pricing model. With Zencoder, there are no

charges for transfer or storage of media, you just pay per minute of transcoded video. There are multiple methods to submitting media for transcode, including SFTP and Aspera. The service claims to be 14 times faster than Amazon Elastic Transcoder, whilst also offering email and chat-based support, closed captioning, and thumbnail generation as part of the package.

The service doesn't retain media for very long on its own servers, but it can be connected to send and receive media from other Cloud Storage services. There's comprehensive support for most codecs, including DNXHD and ProRes, and there's even support for transcoding live video streams.

CloudConvert (cloudconvert.com)

Pricing: from $0.01/minute of conversion time

Storage: N/A

CloudConvert is different in that it doesn't just offer to convert audio and video. The service also offers to convert a variety of different file types, such as spreadsheets, e-books, and fonts. It's also possible to set up watch folders in Dropbox or Google Drive to have contents processed automatically.

BIBLIOGRAPHY

90-Second Beer Poll: Cloud Rendering http://blog.shotgunsoftware.com/2015/04/90-second-beer-poll-cloud-rendering.html
Amazon EC2 FAQs https://aws.amazon.com/ec2/faqs/
Amazon Elastic Transcoder https://aws.amazon.com/elastictranscoder/
Amdahl's Law http://en.wikipedia.org/wiki/Amdahl%27s_law
Art of Stereo Conversion: 2D to 3D—2012 http://www.fxguide.com/featured/art-of-stereo-conversion-2d-to-3d-2012/
Does Amazon's Cloud Transcoding Service Make Sense for You? http://www.studiodaily.com/2013/02/does-amazons-cloud-transcoding-service-make-sense-for-you/
Encoding On-Demand Content with Azure Media Services http://azure.microsoft.com/en-us/documentation/articles/media-services-encode-asset/
Fast Renderings in the Cloud http://evstudio.com/fast-renderings-in-the-cloud/
Gustafson's Law http://en.wikipedia.org/wiki/Gustafson%27s_law
Rendering on the Cloud—Autodesk Labs Project Neon http://autodesk.blogs.com/between_the_lines/2010/07/rendering-on-the-cloud-autodesk-labs-project-neon.html
What Is Cloud Computing? http://aws.amazon.com/what-is-cloud-computing/

6

Collaboration and Communication

"No matter what people tell you, words and ideas can change the world."

—Robin Williams

COMMUNICATION IN THE CLOUD

Communication can take many forms: face-to-face, audio or written communication, recorded or live, conference or announcement. All of these may take place on a typical production, and all of these are available to some extent via the Cloud.

On a typical production, there are many reasons why communication is needed, but different forms of communication may be generally attributed to different aspects of the production process. For example, pre-production generally requires debate and discussion about what might happen, the sharing of ideas, and the evolution of those ideas into plans. This usually requires a lot of face-to-face conversations between smaller groups of people, much of which may not be relevant later on.

Production generally revolves around the coordination and execution of plans, with people given instructions as they're issued. Thus, live communication

of some sort is required, typically with a small group broadcasting to a larger group (the most obvious example of which is the assistant director calling for action at the start of a take), as opposed to a two-way discussion. In addition, records are made in some form (such as continuity notes) as to everything that happened.

Once post-production starts, the focus shifts to being more about trying to understand what has already happened. The editor is piecing together disparate footage to make a coherent narrative, whilst visual effects artists re-create the shooting conditions of various shots based on reference notes and other materials. As such the communication required becomes more about reaching back into the past to get information, from whatever documentation or communication archived in some form might be available.

Each of these phases also has a great deal of review and approval, whereby some work is made available (either as a finished piece or a work-in-progress) and then people involved can provide feedback on it. Traditionally this usually involves scheduling meetings and providing feedback in person, but as we'll see in chapter 12, this need not be the case in a Cloud-powered environment.

Instant Messaging

Instant messaging, be it in the form of SMS, email, or something like WhatsApp (whatsapp.com) is probably one of the most common forms of electronic communication in use today. Type a message to someone and have them receive it almost immediately. Simple and effective. But even with something as innocuous as instant messaging there are potential benefits brought by the Cloud.

Synchronisation is the primary area where improvement can be made: with a Cloud-enabled instant messaging system, message history can be made available no matter which device you happen to have to hand. Even better, when you receive an instant message, you can receive it on multiple devices, so if you don't happen to have your phone in hand, you can still receive it on a laptop or tablet, for example.

But perhaps a less obvious benefit is security. The popular instant messaging application Telegram (telegram.org), for example, emphasises the privacy of all communication through its service, offering robust encryption

of messages and even the ability for them to "self-destruct" after a period of time, something not really possible with other messaging applications (whilst also boasting faster transmission than any other messaging application).

Voice Over IP

For all the benefits that instant messaging provides, sometimes you just can't beat the sound of someone's voice for quickly conveying information. Though a telephone is an obvious choice, there are some downsides. First and foremost is cost. Telephone calls are billed by usage, with longer-distance calls typically costing more than local calls. Second, the person you're trying to call likely has more than one contact number, which means you might need to try each of them in succession until you reach them. And as a minor point, you don't know if the person you need to speak to is actually available until you try to call them. This is mitigated by some degree by voicemail, but voicemail has plenty of its own issues, such as being somewhat hard to access (typically you can do it only from your own phone, which doesn't help if your phone happens to be dead at the time).

Enter Voice over IP (VoIP), the Internet-based telephone system. Rather than relying on a traditional phone line, VoIP digitises your voice and then uses the Internet to send it to someone else (and does the same for the recipient). In practice, this means you get the exact same experience as a traditional phone, but using an Internet connection that is already paid for (and doesn't care about the distance between callers). It does depend on having the right hardware and software, but the hardware is typically built-in to your computer anyway (the requisite microphone and speakers are part of most laptops or mobile devices as standard), and adequate headsets are not hard to come by if it isn't. As for the software, there's plenty to choose from that are available for free, and in many cases bundled with your computer's operating system (such as FaceTime or Skype). That said, this does lead to one of the main problems with VoIP, which is that most of the software is designed around proprietary infrastructure, which in turn means that if you want to call someone using specific software, they'll likely need to have the same software. In practice you can assume most people who use VoIP at least occasionally will probably have Skype (skype.com) as it's the most popular service and available on most platforms, whereas Apple aficionados will likely have FaceTime (apple.com), as it's readily available to anyone with a Mac, iPhone, or iPad.

Naturally, the Cloud can help make even VoIP work better. Using Google Voice, for example, will cause all your devices to ring when you get a call, and is able to both make calls to traditional telephones (for a fee for international calls), as well as receive them, and it even lets you switch between devices during a call. And then it adds in some other features you didn't even know you wanted, such as the ability to automatically block certain callers, or only allow calls through from certain people or at certain times of the day, conference calling, permanent retention of all text messages and voicemails, and even transcription.

BOX 6.1 VoIP and Emergency Calls

Sadly many VoIP services (including those provided by Apple, Google, and Skype outside of a select few locations) do not allow for the ability to make emergency calls (to 911), so the traditional telephone hasn't lost its usefulness in at least that area yet. Part of the reason for this is that trying to identify a VoIP caller's geographical location is somewhat unreliable, and there are likely other logistical reasons that make it difficult to implement successfully, but ultimately there's a significant cost implication that VoIP service providers aren't willing to absorb for a supposedly "free" service. As such, you'll see disclaimers with many of these services that they are "not intended as a replacement for your telephone".

Transcription

One of the most powerful features of the Cloud, the ability to quickly search thousands of pages of text across different documents, is so easily taken for granted that it can be frustrating to work with forms of communication that are not easily indexed, namely audio. Audio notes can be incredibly convenient to create but impossible to get the important content from without listening to them in their entirety. The solution to this lies in the process of transcription—turning the words in the audio to text—but as anyone who has used any dictation software will tell you, most transcription is somewhat unreliable (more so when there's a lot of industry-specific terminology being used).

(Continued)

(Continued)

> Being as it's such a tough problem to solve, most Cloud-based communication systems don't offer any sort of transcription features (so there's no way to automatically transcribe those FaceTime calls for example), so even if you've recorded an audio conversation, there's no way to make that recording searchable for future reference, at least not unless you use a third-party service. That said, there are several Cloud-based transcription services available that feature the ability to transcode a given audio file. Speechmatics (speechmatics.com) is one such example (and it also has an API, so it could be used in conjunction with a specifically engineered pipeline given enough resources), so it might be that this technology becomes more widely adopted in the future.

Video Conferencing

It used to be the case that video conferencing was relegated to high-end business communication. The cost and infrastructure required was such that it had to be specifically installed in a fixed location and participants all had to be equipped with the same technology, technology which had a tendency to be complicated to use. In practice, this meant that it was rarely viable to have access to video conferencing technology outside of a board room with staff readily available to provide support.

But just as VoIP democratised voice calls, faster Internet access and an abundance of video-capable devices meant that it was trivial to add live video to VoIP services. Skype, for example, has had this feature since 2005 (merely two years after its original launch), and most of its competition followed suit shortly after. Whereas Skype was primarily aimed at providing ad-hoc calls between a small number of people, other services, such as Citrix's GoToMeeting (gotomeeting.com) can support hundreds of participants, each of whom can connect via a computer, mobile device, or even a browser. As each participant likely has their own video camera, this also means there's the opportunity to see everyone in close-up, rather than from a zoomed-out conference room perspective. Then there's the ability to share screens—meaning someone can demonstrate software on their laptop or show a presentation, shown full-screen to other participants easily and seamlessly.

Moreover, the Cloud can remove some of limitations of traditional video conferencing without replacing them entirely. For example, the Cloud-based

BlueJeans (bluejeans.com) service allows users of a high-end service such as Polycom RealPresence to confer seamlessly with someone using a web browser or mobile device.

BOX 6.2 Remote Technical Support

It should be noted that the next step from someone sharing their screen is giving someone else the ability to control their computer. This can be useful for a variety of purposes, such as coaching someone to use software or follow a particular procedure, but it can also serve as a convenient way for someone to provide IT support remotely.

Say, for example, you're at a remote location on a shoot, and you run into problems with your email client. As long as you have Internet access and the right software, someone from the technical support department could be given access to your laptop from wherever they are based and go in and fix the problem, thus saving time bouncing instructions back and forth over the phone.

Hybrid Communication

Where this gets even more interesting is with products and services that provide several of these communication methods packaged together, so you can start with, say, a messaging system or chat room, and then reply with a voice or video call depending on how the conversation goes.

Perhaps an artist needs some direction with an idea. This could start off with a short verbal brief sent via instant message, to which they then reply with a digitised sketch, and the director can then start a conference call with the artist and other key decision makers to discuss the finer points, with perhaps the artist even sharing her screen and making annotations or changes on the fly.

This is, of course, possible by switching between different applications, but each time people have to switch to another application, there's the possibility that time will be lost, with anything from having to log in to each service,

to having to resolve technical issues, and even the problem of task-switching to be considered. None of these are conducive to the creative process, and effort should be made to be able to transition between different forms of communication as smoothly as possible.

Google Hangouts (hangouts.google.com) is one such example of this. Available from within Google's Cloud-based email Gmail (gmail.com), their social media site Google+ (plus.google.com), or as a standalone mobile or browser-based app, it looks like a traditional instant message client, but it has readily available buttons to initiate group messaging, and voice or video chat, as well as little touches like easy linking of locations and sync across devices.

Taking this even further are services like Slack (slack.com), which allows messages to be saved to different "channels", which can represent different teams or topics (or both) that people can subscribe to (and which are fully searchable and persistent), as well as allowing for file attachments, private groups, integrations with other services, and a fully-featured API for custom integrations.

Social Networking

A social network service allows each user to have an online persona (typically represented by a single "page" for each person), and to have them establish links with other users. Facebook (facebook.com), for example, allows users to connect to each other as friends, whilst LinkedIn (linkedin.com) lets users connect to each other via their business relationships. Thus each user forms part of a number of social networks between many people.

In some ways, social networking is merely a logical consequence of the Cloud rather than a separate paradigm. The Cloud provides ways for people to be connected, to share ideas and media, and to do so asynchronously, and all of these things are considered the foundation of any social media platform. As well as allowing users to provide information about themselves to each other (whether for self-promotion or other reasons), social networks also encourage feedback on this information from others.

Different social networking services encourage different behaviour. For example, Twitter is primarily text-based, with an imposed limit on the length of each message, and a model that lends itself better to users broadcasting information rather than engaging in discussion; whereas Facebook tends to

be more about sharing media and encouraging discussion. Most other social networking services exist to serve niches, such as Snapchat, which is primarily concerned with communication via images or videos (which are *not* saved once they're viewed); Whisper, which allows users to anonymously post messages superimposed over an image; and Bubbly, which allows users to post voice recordings.

Although it can be tempting to think of social networking sites as a good way to form a hub for a production, there are several disadvantages to doing so that make the other options more viable. In general, social media sites exist to serve individuals as opposed to organisations, and as such do not provide any liability that confidential material could be exposed (and indeed, there are several legal reasons why conducting any sort of business on sites like Facebook is a bad idea), nor is there typically a way to administer users (beyond adding or removing them from private groups), which means that the emphasis would be on the production to create, for example, a private group, but on the individuals to set up accounts and join the group. Moreover, any information entered into social media sites is typically very difficult to extract and use elsewhere.

That said, there are plenty of situations where social media sites can be a cost-effective, efficient way to provide communication within a production (or when used as an aid to employing potential cast and crew), and can also serve as an excellent platform for marketing purposes, such as giving the public a curated glimpse of the ongoing production in order to build hype.

POPULAR COLLABORATION & COMMUNICATION SERVICES

Apple iMessage (apple.com)

> **Pricing:** free (requires Apple device)
>
> **Features:** secure instant messaging, group messaging, file attachments (up to 100 MB), share current location, screen sharing

iMessage is one of the most popular messaging applications used by productions, most likely by virtue of the fact that it is bundled with every Apple device. However, this is also its greatest failing, as you can't communicate

with anyone using a non-Apple device (there's not even a browser-based version available).

WhatsApp (whatsapp.com)

> **Pricing:** free for 1 year, $0.99 per year for subsequent years

> **Features:** instant messaging, group messaging, photo or video attachments (up to 16 MB), share current location, browser-based

WhatsApp is the most popular mobile instant messaging app in existence, with close to a billion active users as of 2015. Its main benefit is that your account is tied to your mobile phone number, meaning you don't need to register or look up contacts you already have in your phone's contacts list. However, it's currently lacking in its ability to send large attachments, and its general lack of encryption of messages will likely rule it out from security-conscious productions.

Telegram (telegram.org)

> **Pricing:** free

> **Features:** secure instant messaging, group messaging, file attachments (unlimited size), share current location, browser-based, API

Telegram is probably the best candidate for instant messaging for any size production. Not only is it free, but it has security features that put everything else to shame (including the ability to have messages self-destruct), whilst still having all the features and ease of access of every other instant messaging client, and then adds the ability to attach files of unlimited size and a set of comprehensive APIs.

Voxer (voxer.com)

> **Pricing:** free (feature-limited), $4/month

> **Features:** audio messaging, group messaging, file attachments, share current location, browser-based

At its most simple, Voxer allows you to use your mobile device (or Windows client or browser) as a "push-to-talk" communicator, in the same way as a

walkie-talkie. It has a number of benefits over a regular walkie-talkie, such as asynchronous messaging—meaning you can listen to a message later as well as live, and then have all the benefits that you'd expect from a text-based messaging application, such as message archiving and forwarding. It's possible to send audio messages to up to 500 people at once, making it a tempting low-cost replacement for the traditional walkie-talkies in frequent use during shoots, aside from the fact that it requires an Internet connection to function.

FaceTime (apple.com)

Pricing: free (requires Apple device)

Features: VoIP, audio calling, video calling

As with iMessage, FaceTime is a reasonably popular video conferencing application due to being available across most Apple devices. However, its limited feature set (and its hardware requirements) mean that it is quickly outgrown.

Skype (skype.com)

Pricing: free (ad-supported)

Features: instant messaging, group messaging, file attachments, location sharing, VoIP, audio calling, video calling, calls to telephones, video conference calling, screen sharing, browser-based

Probably the most common video calling system around, Skype has a cross-platform, comprehensive feature set but is hampered by poor security features and advertisements (unless you maintain a line of credit for making calls to telephones, making it less suitable as a long-term option).

Skype for Business (products.office.com/skype-for-business)

Pricing: $5.50 per user per month (or as part of Office 365 Business subscription)

Features: instant messaging, group messaging, file attachments, location sharing, VoIP, audio calling, video calling, calls to telephones, video conference calling, screen sharing, remote control, browser-based, API

Although it shares superficial functionality with the free version of Skype, Skype for Business is actually based on Microsoft's former Lync communication system. It has many of the same features as regular Skype (including the ability to connect to people both with Skype and Lync clients) and also adds some extra things like collaborative annotation of presentations and allowing up to 250 participants on a single call, all of whom can act as presenters as needed.

Google Voice (voice.google.com)

> **Pricing:** free

> **Features:** phone management, conference calling, text messaging, voicemail, transcription

Although it doesn't offer any VoIP options, Google Voice offers a number of features that work in conjunction with a regular telephone. Register for a free Google Voice number, and it will route incoming calls, causing all your phones to ring when you receive a call, as well as emailing you with text messages and transcribed voicemails. Most features are available only to those in the US.

Cisco WebEx (webex.com)

> **Pricing:** free (up to 3 participants, limited functionality), $24/month (up to 8 participants), $49/month (up to 25 participants), $89/month (up to 100 participants)

> **Features:** video conference calling, screen sharing, VoIP, audio calling, group messaging, session recording, remote control, browser-based

The main selling point of WebEx is its security features. All communication is fully encrypted and meetings themselves can be password-protected, so only attendees with the password may join. The service also offers a shared "meeting space" for each meeting, where attendees can post comments and attach files. The system also allows for control of a participant's computer to be shared, so someone else can remote control their system. It has clients for Mac, Windows, Linux, and mobile devices. There's a browser-based client available, but it lacks in functionality compared to the other clients.

GoToMeeting (gotomeeting.com)

> **Pricing:** free (up to 3 participants, limited functionality), $29/month (up to 5 participants), $49/month (up to 25 participants), $59/month (up to 100 participants)

> **Features:** video conference calling, screen sharing, VoIP, audio calling, group messaging, session recording, remote control, browser-based

GoToMeeting shares a similar feature set with WebEx, although it is lacking in the ability to easily share files during a meeting. There are clients for Mac, Windows, and mobile devices, although the Mac client is noticeably inferior to the Windows one. As with WebEx, there's a free edition of the client software available, but interestingly you don't need to actually register an account to use it, and can start a meeting immediately.

BlueJeans Network (bluejeans.com)

> **Pricing:** undisclosed

> **Features:** conference bridging, session recording, video sharing, browser-based

BlueJeans offers a slightly different solution to the problem of Cloud-based conference calling. It's first and foremost a browser-based "bridging" service. The idea is that participants have any of a number of different conference call systems, and the BlueJeans Network allows these to be unified into a single conference call. So one participant might be using a hardware-based conference room, another might be using Skype for Business, and still another just using a browser, but the service allows all of them to communicate seamlessly.

One of the main drawbacks of the system is that it's reliant to a degree on being able to access the third-party services. Formerly Skype was available as a bridgeable service, but then an update to Skype removed this functionality, which meant any BlueJeans users who relied on Skype had to switch to using the browser version of BlueJeans instead, thus somewhat defeating the purpose of having it. The company also does not publish its pricing plans, so it can be difficult to estimate whether the service actually represents good value for money.

Twitter (twitter.com)

Pricing: free (ad-supported)

Features: public and private instant messaging, API

One of the hallmarks of Twitter is its 140-character limit on every message posted. There's not much to say to its usefulness as a communication system, other than it can be a very effective way to quickly get messages to a large group of people. However, the privacy (or not) of a particular message is determined by a single setting—either all your messages ("tweets") are made publically available or none of them are. For accounts which enable privacy, the account owner must grant access to other Twitter accounts individually (publically viewable tweets are visible to anyone, whether they have a Twitter account or not).

Google Hangouts (hangouts.google.com)

Pricing: free (requires Google+ account)

Features: instant messaging, group messaging, file attachments, location sharing, VoIP, audio calling, calls to telephones, video conference calling, screen sharing, browser-based, API

Google Hangouts provides many of the same features as Skype but works it into a slightly different context. Users create a "Hangout" or virtual room in which to send messages and share files and initiate video or audio conference calls, providing a sense of structure to discussions and topics as opposed to the more ad-hoc nature of Skype communication.

Hangouts also provides a means to schedule live broadcasts (each of which can be made public or announced only to specific groups of people), which are then archived on YouTube afterwards. However, it is not possible to actually prevent anyone else from viewing the broadcast, as anyone with the link can view it, even if it was sent to them by a third-party.

Slack (slack.com)

Pricing: free (feature-limited)–$15/user/month

Features: instant messaging, group messaging, file attachments, VoIP, audio calling, video conference calling, screen sharing, remote control, browser-based, API

Slack takes a similar approach to Google Hangouts by letting users create contexts with which to discuss and communicate with each other. Within a given organisation, any number of "channels" can be created that are visible to everyone in the organisation. Private groups can be formed that are hidden from everyone else, and private one-to-one communication is also possible. Within any of these contexts, there's a robust set of features for sharing information, whether in the form of text, file attachments, or any of a wide number of integrations with third-party services.

The integrations allow other applications and services (such as Box and Twitter) to automatically post notifications to specific channels or groups as needed. What's particularly interesting about Slack is that the free version, whilst lacking in some of the enterprise-level features (such as greater retention of message history), is actually a solid offering in its own right. Historically Slack's feature set has been aimed at people within software and information technology sectors, but much of the core functionality is just as applicable to people in other industries, and as of right now the feature set is rich enough to be of value to people collaborating on small productions and feature films.

Sqwiggle (sqwiggle.com)

> **Pricing:** free (feature-limited)–$25/user/month

> **Features:** instant messaging, group messaging, file attachments, VoIP, audio calling, video conference calling, screen sharing, browser-based, API

Sqwiggle takes a different approach, based around the idea of forming a single team of people who are then accessible to each other at all times. Of note is its "presence" feature, a snapshot of each team member that is updated regularly in order to make everyone on the team feel more connected to each other.

BIBLIOGRAPHY

Better Videoconferencing in the Cloud http://www.informationweek.com/government/cloud-computing/better-videoconferencing-in-the-cloud/d/d-id/1113504

Evaluation of the Blue Jeans Network (BJN) Video Collaboration Service https://
 www.internet2.edu/media/medialibrary/2015/03/06/Wainhouse_Evaluation_-_
 Blue_Jeans_Network_Service_-_2015_Feb.pdf
Secure Messaging Scorecard https://www.eff.org/secure-messaging-scorecard
Skype for Business Online Limits https://technet.microsoft.com/en-us/library/skype-
 for-business-online-limits.aspx
Web Conferencing: Unleash the Power of Secure, Real-Time Collaboration http://
 www.webex.com/includes/documents/security_webex.pdf

7

Production

"I now truly believe it is impossible for me to make a bad movie."
—Jean-Claude Van Damme

SOFTWARE AS A SERVICE

With the advent of the Cloud, the software industry started changing. Traditional business models, whereby a particular version of a computer application would be bought by customers, who would then use that software for as long as they needed (or until a new version was released that they'd pay again to upgrade to), seem to make less sense in an era where software can be updated more regularly, with automatic updates made available via the Internet. Sticking to this business model meant holding big, new features back until some arbitrary time where they could be packaged up and sold as a new version. The timing of such releases could be problematic too—wait too long and risk customers switching to more feature-rich products, but publishing new paid upgrades too regularly risks losing customers who feel they are being nickel-and-dimed. Coupled with this, the natural evolution of a great many software products was to integrate them with Cloud Services to some extent, and a general desire to make applications "platform-independent" (de-emphasising a need to run the application on Windows XP,

for example, and instead making it available for users with smartphones, or operating systems such as Mac OS X or Linux) meant that making the software run on a hosted server instead, with users accessing it via a browser became a very attractive prospect.

For this reason, many software publishers switched to a subscription-based service, where customers instead pay a subscription to access the software (and these are often tiered in such a way that a customer pays more for access to more features). Arguably this model is more to the publisher's benefit than to their customers': the publisher is under less pressure to release big features (but on the other hand, solid infrastructure, good technical support, and customer service become much more critical), there's no concern that the software will be pirated (instead, there's the concern that the server will get infiltrated or attacked by malicious people or groups), as well as financial benefits; meanwhile the customers only really benefit from a lower up-front cost (potentially the cost may be lower in the long-run, but that's not always the case), and even worse, give up the ownership of their data to some extent.

Take the review and approval process, for example. Traditionally, notes made during reviews would need to be emailed (or even passed around on paper) to relevant parties. Now, web-based software like Adobe's Creative Cloud allow these notes to be added via a browser directly to Adobe's server and logged there, where the relevant parties can access them. Simple and convenient, yet what about when there's network disruption? Or worse still, if you decide it's not financially viable to maintain the description and, as such, lose access to all that information—your information—because it's all stored on a third-party server? Sure, there are ways to back up or export this metadata as you go with many of these services, but it's added busywork of the sort that's supposed to be eliminated by moving to the Cloud.

Coupled with that are the general disadvantages of all Cloud services—namely a dependence on a stable Internet connection—but there's also the fact that application performance tends to be sorely lacking when compared to a "native" desktop application—we're not likely to see a full-blown audio or video editing system as a web app that's a viable alternative to a desktop editing system any time soon, due to the raw, immediate processing power required to manipulate video footage (particularly high-resolution footage) in real-time.

Still, there's no disputing that the model is here to stay—an increasing number of traditional software development companies are migrating their desktop-based products to something at least partially web-based (and almost certainly subscription-based), with the end result that many of them are solving the same problems independently from each other, in terms of document management, search, and file sharing.

As of 2015, almost every type of desktop software has a Cloud-based counterpart, from traditional office-based software like word processing and scheduling, to those more specific to film and video production, like production management, editing, and visual effects.

PRODUCTION MANAGEMENT IN THE CLOUD

The fact that "production management" is almost synonymous with "busywork" probably isn't much of a surprise, but it needn't be. Much of production management involves checking things are where they need to be, happening when they're supposed to be, and then producing reports about everything that happened. As productions become ever more complex, with fewer people tasked with more responsibilities, it's increasingly harder to keep on top of all of those things, at least until you factor in ways to streamline them.

Time Tracking

When it comes to tracking what crew members are working on, where they've been doing it, and how long for, it's a lot easier to have them "check in" with their location and status to the Cloud, rather than have to spend a lot of time and energy in calling around and leaving messages for each other. The requisite technology to enable this for each crew member—a GPS and Internet connection—is available in pretty much any smartphone, and solutions such as TSheets (tsheets.com) provide the software and database for capturing all the information from them in. Moreover, this can all be done in an automatic manner, meaning that aside from having all of that data logged for later on, it's possible for production managers to get an idea of exactly where everyone is and what they're working on whilst they're on the clock. This can be useful to productions with lots of crew (as in a film shoot) as well as for smaller teams that are very mobile (as in a group of news crews).

Even if keeping tabs on the whereabouts of all crew members at all times seems a little bit creepy, systems like this allow for more accurate tracking of overtime, and the amount of time spent is gathered and available in real-time. It's possible, for example, for alerts to be configured if overtime is about to happen, with easy access to the estimated financial impact of any overtime before it happens—information that can be invaluable to a producer trying to weigh up whether an extra hour of shooting is really worth it.

A final bonus to the real-time time-tracking systems offered by the Cloud is that crew members don't need to then go and fill in timesheets (or be chased up to do it) after the fact. The data have already been collected and are accessible, so all that's left to do is have it approved and submitted for payment.

Status Reporting

For departments that don't need the level of granularity afforded by time tracking but still need to communicate their status to each other (particularly

FIGURE 7.1 Time Tracking with the Cloud

FIGURE 7.2 Status Reporting with the Cloud

when they're in different locations from each other), services like Working-On (workingon.co) might be suitable. Instead of everyone being gathered into a meeting to announce to each other what they'll be doing that day, they can simply send this information to the Cloud, and it's collated with everyone else's status, available to view online as needed, or redistributed in a daily email, for example. This can save a lot of time for larger teams and can be especially useful for anyone who is away from the office.

Document Management

Several key documents are central to the production management process on a television or film shoot (most notably the scripts), and these can change and evolve over time. Managing these documents effectively requires knowing things like which is the latest version of each, as well as controlling who has access to what. In the case of the script itself, this can be extremely complicated, because there are typically many versions of a script, and different people may be allowed to access only certain portions of particular versions.

For example, during casting, only specific, isolated sections from the script may need to be available to performers to read from. When shooting a scene, however, some people will need access to the entire script to see context, others will be concerned about the script only as it relates to the current scene, and still others (for example, "day players", who are typically required for a limited part of a scene only) might need to see only a small section.

Still other types of documents may need to be distributed in mass, such as health and safety reports. Traditionally this is handled via fax or email, but keeping track of who was sent which documents in this way can be tricky. Factor in each document potentially having different versions, and it might be time to start looking into ways to make these processes better.

TABLE 7.1 Key Documents

Scripts
Contracts
Staff, crew, actor agreements
Permits
Location agreements and information sheets
Budget reports
Health and safety reports
Insurance documents

FIGURE 7.3 Document Management with the Cloud

Cloud-based solutions such as Entertainment Partners' Scenechronize (www.ep.com/home/managing-production/scenechronize/) provide a number of dedicated features to simplify many of these processes. Instead of managing and distributing documents manually, you instead upload them to Scenechronize and have them distributed from there, with the ability to control which person sees which document (or part of the document), with the ability to then do things like collate documents together per person. With security being a key factor, documents can also be watermarked with each person's name, and the system can be set up to easily issue hard copies as opposed to sharing digital files.

BOX 7.1 Scanning Documents

For all the strengths of Cloud-based document management, they all have one major weakness: the documents must exist in some digital format. On a typical production, however, many documents will not have a digital counterpart, particularly for contracts and other legal paperwork.

In order to make these documents available, they must, therefore, be scanned, which can be a tedious extra step for anyone who is used to simply sticking their documents in a filing cupboard. However, desktop document scanners are reasonably common in most office environments, and there's even the possibility to use apps on mobile devices that have cameras to quick scan in document pages for uploading to the Cloud.

CASTING & CREWING

Casting Calls

Traditionally, the casting process comprises two logistical problems for casting directors: obtaining casting materials from potential talent and then distributing a selection of those to others. One of the reasons this is fraught with difficulty is the number of different ways materials can be submitted. DVDs and paperwork may be sent by post in one instance, whilst online reels and links to personal websites may be emailed in another.

It shouldn't come as much of a surprise then that services such as Cast It Talent (castittalent.com) exist to make the process smoother by providing a single entry point for actors and agents to submit materials, and then provide a uniform interface for casting directors to view those materials, without having to sift through paperwork and disks, and with the pertinent information presented in the same way for each submission. The talent (or their agent) logs into the site, and uploads their showreel and related documentation to the Cloud. The service then handles any conversion or formatting, collates all the submissions together, and presents them to a casting director with a single, consistent interface.

However, this can also be taken further, so that the casting directors can continue to add to this database, for example, adding notes, photographs, and videos they capture in subsequent meetings with actors, and then be able to share relevant items with other members of the production, such as directors and producers, as well as the hair, make-up, and wardrobe departments. Thanks to the Cloud, anyone who needs access to all of this material has it without the casting team having to worry about making and disseminating copies out to different people.

FIGURE 7.4 Casting Submissions in the Cloud

Crew Selection

Though the crew selection process for a given production is perhaps not as rigorous as it is for the cast, it's still a crucial and somewhat laborious one. The majority of productions rely on department leaders to source their own team, and whilst this is preferable in a number of ways (having people who work well together is perhaps just as important as the skills they each have on an individual level), there will be occasions where some positions can't be filled this way, such as when potential candidates have conflicting schedules.

Often then, department leaders need to fall back to a more traditional approach to fill positions for crew members, such as calling around, placing job postings, and conducting interviews. Given the time-sensitive nature of production, many of them consider this searching process to be too much of a time sink considering the other things they need to do in preparation for the production starting up.

Though there are Cloud-based services such as LinkedIn (linkedin.com) that can be used to improve this process, there's nothing readily available that's tailored to film and television productions that can be considered as definitive for crew selection as, for example, Cast It is for casting. The Internet Movie Database (imdb.com) can serve as a useful resource for seeing who worked on which productions, but there's no indication there as to what the quality of their work was like and what they actually did in a given role.

Larger studios may have an internal database concerning crew members used on previous productions, but these aren't always made easily available to the people who might need access to them, and similarly there's little incentive for department heads to update them even if they do have access. Clearly this is an area that's primed for the Cloud to fill, with a single service that acts both as a résumé library as well as a recommendations system, and that persists between separate productions.

Crew On-Boarding

An often-overlooked challenge, particularly with large productions, is ensuring that each of the (potentially) hundreds of crew members know what they need to know in advance of the production starting. Broadly speaking, such information might include who the key members of the production team are; locations and dates for shoots, production offices, and other

notable places; as well as more general information like what the details and spirit of the storyline is. Though this can be done via traditional means, such as through face-to-face meetings, emails, and so on, the process may be complicated somewhat by security protocols—whereby only some people are given access to certain information, and some communication channels may be considered too insecure for certain types of information.

Furthermore, these problems become more pronounced the later a given crew member joins the production. When a production is further along, it can require a lot more effort in getting someone up-to-speed, along with tracking down the necessary and up-to-date documentation that has been produced at that point.

As with the problem of crew selection, though the on-boarding process seems an appropriate one to be handled by the Cloud, there's currently no single service that tackles this problem directly. Productions, therefore, on-board their crew with whatever resources and tools they have available, which tends to result in holding multiple meetings with separate groups, as well as producing documentation that is tailored to specific people. As with the crew selection process, this can be a somewhat thankless task for every-one involved, and one that seems needlessly laborious.

That said, the collaboration and communication tools outlined in chapter 6 can certainly help, particularly those that offer hybrid communications, such as Google Hangouts or Slack. These can allow for different "rooms" (or "channels") and keep a history of everything posted, allowing those who join later to get up-to-speed on previous discussion points more eas-ily. There's also Trello (trello.com), a Cloud-based service that allows the creation of "boards" that can be used to organise "cards" (individual pieces

FIGURE 7.5 Crew On-boarding in the Cloud

of documentation) in a metaphor that's simple to understand and that can be kept up-to-date, which could serve this purpose well, particularly when making use of its integrations with third-party services.

CREATIVE DEVELOPMENT

There's a lot of busywork and administration that happens on every production. So much so that it can become easy to forget that every production is ultimately a creative endeavour. As such it relies on software and services that are creatively-focused. This might be in the form of illustration software for concept artists, writing software for screenwriters, editing systems, or compositing software for visual effects artists.

Any of these can benefit from the increased mobility and collaboration that the Cloud allows for, particularly when it comes to the review and approval process (which will be explored in more depth in chapter 12), but also during the creative process itself. Even the process of screenwriting, traditionally a solitary and isolated endeavour, has begun to move to the Cloud, both for secure document storage and versioning, but also for easier integration with script breakdown and scheduling applications.

For example, Adobe Story (story.adobe.com) has all the features you would expect from a word processor targeted to screenwriting, but being Cloud-based, it means that every draft and revision of a script is immediately and automatically available to producers to begin doing breakdowns and schedules. This can save time for all involved but also reduce the complexity of having to notify people when changes to the script are made.

Indeed, Adobe has taken a similar approach with all of its creative-focused software. Its Illustrator and Photoshop applications, both of which are employed by certain roles throughout a production, such as within the art and marketing departments, are now strongly tied into the Cloud. As you might expect, this allows for access to the suite of creative applications as well as any project documents from any device, meaning artists can sketch out ideas on a phone, then seamlessly switch to a desktop system and continue working, before finally opening their work on a tablet to take and show to someone, continuing to make adjustments directly as needed. Likewise, everyone is able to work more collaboratively, as in the case of someone drawing a background whilst someone else works on the foreground of a single piece of art.

FIGURE 7.6 Using the Cloud to Share Components of Files

But it doesn't end there; after all, it is relatively simple to make use of pretty much any Cloud storage service to work in this way. With the Adobe Cloud ecosystem, however, it's possible to think of work in terms of not only finished work, but also the components that make them up. For example, a Photoshop document might have multiple layers of images, whereas an Illustrator document could have text with specific styling, or shapes using a specific colour scheme. Instead of simply sharing different documents between artists to allow them to conform to a specific style, the underlying presets can be shared. For example, a colour palette could be defined for a particular scene by the director or director of photography using an application such as Adobe Capture CC and then shared with a concept artist working in Adobe Illustrator. Or the marketing department could design a specific combination of font styling, colour, and text effect and make that available to any artists working with text. Or a location scout might grab a single layer of a Photoshop document to use as a reference when looking for a particular location.

With everything connected at such a granular level, there's less time and effort spent on redoing the same work, and less need for individuals to need to start their creative process from a blank page.

BOX 7.2 Adobe Capture CC

Some applications which might have otherwise been considered novelties in an era where there are hundreds of thousands of mobile apps readily available to play with are given new meaning when placed in the context of the

(Continued)

(Continued)

Cloud, and specifically when used within an application "ecosystem" such as Adobe's Creative Cloud. Case in point is Adobe Capture CC. Available for iOS and Android, it may at first appear to be a gimmick—having the ability to generate a colour palette via your device's camera or turn a photograph into a vector image might at first seem mildly entertaining rather than useful.

However, once you consider that these can become components for others to work with, it becomes a ludicrously simple and powerful tool. The app itself directly allows the creation of colour palettes, vector shapes, brush patterns, and colour looks without any degree of technical expertise or training and generates everything from previously captured photos or directly from the camera.

A director of photography might use it on set (or whilst scouting) to define colour themes to apply in later scenes or in post-production, whilst someone in marketing might capture details from set decoration that can instantly be made available to illustrators to work with in a format that's ready to use (assuming, of course, that everyone else is already invested in the Adobe ecosystem).

FIGURE 7.7 Adobe Capture CC

POST-PRODUCTION

The demands of much of post-production, particularly when it comes to speed and storage capacity (a typical digital shoot will consist of many terabytes of footage, much of it needing to be accessed immediately at any time, which is both impractical and expensive for most Cloud-based services), means the Cloud is not as suitable for other stages of production. However, different types of productions have different needs, and there are many situations where the Cloud can play an important part in post-production.

Editing

Although the tight deadlines, high volume of source footage, and the need to view everything at high resolution means that feature films and high-end television production can't have the luxury of using the Cloud as part of the editing process for the most part, there are other situations where the Cloud can provide huge benefits to a production.

News crews, for example, can leverage the Cloud to prepare and send footage from remote locations, or even perform full editing in the field. At a minimum, remote crews can upload select footage to Cloud storage, which can then be downloaded by an editor elsewhere to work with, and then in turn upload finished sequences for transmission. But more sophisticated options exist.

For example, Avid's Media Composer Cloud (avid.com) offers several benefits over more traditional editing, in the form of streaming media, the time-saving ability to upload edits even as they're in progress, and being able to selectively download media for use offline. Features such as these can help to make even remote teams seem more connected to the base of operations and can maximise the benefits of the Cloud whilst reducing (even if not eliminating) the drawbacks.

In situations where the editor is remote but with the camera crew, she can edit the footage received directly from the camera whilst it is simultaneously being uploaded for access to the base, then begin uploading the sequence prior to completion, before sending the final changes to the sequence at the end (which should be faster than uploading the final sequence in one go). And where all parties are remote, the camera team uploads footage to the Cloud, which is then downloaded and worked on by the editor as needed, and who then uploads the final sequence.

FIGURE 7.8 Editing Environment with Local Network

FIGURE 7.9 Editing Environment with Remote Crew

FIGURE 7.10 Cloud-based Editing Environment

Other approaches are also available. Forbidden's Forscene (forscene.com), for example, leans towards a more approachable, ad-hoc system. Forscene provides a web-based interface that provides for the primary aspects of editing, from ingest and logging, through editing and review, to syndication and digital mastering. This can provide smaller teams with the basic

infrastructure to do editing, without needing to rent lots of equipment or set up a facility. All that's needed is Internet access, a web browser, the source digital media to upload to the system, and a subscription for as long as needed.

POPULAR CLOUD PRODUCTION SERVICES

TSheets (tsheets.com)

> **Pricing:** $16 + $4/user/month (annual billing), $20 + $5/user/month (monthly billing), $80 + $4/user/month (over 100 users, annual billing)

> **Features:** mobile-based time tracking, browser-based time tracking, location tracking, overtime alerts, approval settings, live reporting, historical reporting, integration with accounting systems, API

Tsheets represents one of the most comprehensive Cloud-based solutions for time tracking, able to track time via mobile apps with GPS data if needed, and all data are consolidated in real-time so managers can get live reports and anticipate (and estimate the impact of) overtime before it happens, and then produce a number of financial reports and export data directly into applications such as Intuit QuickBooks if needed.

Labor Sync (laborsync.com)

> **Pricing:** $10/user/month

> **Features:** mobile-based time tracking, browser-based time tracking, location tracking, live reporting, historical reporting, integration with QuickBooks

Labor Sync has a similar approach to Tsheets, although it offers fewer features and is more expensive. Of note is the ability to send messages to individuals directly from within the application.

Toggl (toggl.com)

> **Pricing:** free (up to 5 users, feature-limited), $5/user/month ("Pro" features), $49/user/month ("Business" features)

Features: mobile-based time tracking, browser-based time tracking, historical reporting, integration with project management systems, API

Toggl takes a slightly different approach from Tsheets, with a focus on project management as opposed to finance. It has support for grabbing project data from Basecamp or Asana, and can sync data with FreshBooks, but may not be suitable for larger productions that are concerned with tracking ongoing costs. One notable feature is that it provides integration with other browser-based services. Create an appointment in Google Calendar, for example, and you'll see an option to automatically log the time to Toggl.

WorkingOn (workingon.co)

Pricing: free (ad-supported, feature-limited), from $4/user/month

Features: browser-based status reporting, daily email report, integration with project management systems

WorkingOn provides a simple way for people in teams to post updates about what they're doing, which can then be forwarded on to other chat applications such as Slack, and collated in a daily email summary. There's no mobile application offered, and its limited functionality makes the paid versions seem expensive unless you have a very specific workflow.

Trello (trello.com)

Pricing: free (feature-limited), $8.33/user/month ("Business" features), $20.83/user/month ("Enterprise" features)

Features: organise information and attachments visually, browser-based, mobile apps, integrations with Cloud storage and project management systems, API

Trello uses a "card" metaphor, where individual documents or pieces of information are visualised as cards on a "board" that can be organised into lists. Individual boards can be shared with others, allowing for collaborative brainstorming processes or the ability to collect and publish lots of information in a simple way.

Scenechronize (ep.com/home/managing-production/scenechronize/)

Pricing: undisclosed

Features: document storage, contact database, scheduling, automated script breakdown, watermarking, browser-based, mobile apps

Scenechronize provides Cloud-based document management with some features geared towards film and video productions. Notably it includes automated script breakdown and tight controls over who can see what, with user-specific watermarking on documents as required. It also has some scheduling features, and contact information and dashboards tailored to individual crew members.

Cast It (castitsystems.com)

Pricing: based on production budget

Features: document storage, contact database, scheduling, watermarking, browser-based

Cast It provides a way for casting departments to organise media related to the casting process, as well as allow talent and agents to submit materials in a secure, uniform way. Casting directors can then select and forward on videos and other media to other departments for review.

Adobe Story (story.adobe.com)

Pricing: free (feature-limited), $10/user/month or included with a Creative Cloud subscription

Features: create, edit, and break down screenplays; integration with Adobe Premiere; browser-based

Adobe's word processor for screenwriting allows for easy collaboration, breakdown, and scheduling, though these aspects of it are perhaps not as fully-featured as those offered by Scenechronize. However, a mobile version that was previously available has since been withdrawn with no alternative offered, and development on the application itself seems to have stagnated.

Adobe Creative Cloud (creative.adobe.com)

Pricing: $20/month (individual, single application, 20 GB storage), $30/user/month (multiple users, single application, 100 GB storage), $50/month (individual, all applications, 20 GB storage), $70/user/month (multiple users, all applications, 100 GB storage)

Features: over 20 desktop and mobile applications related to digital imaging, synchronisation of presets and other assets

Adobe made a somewhat controversial switch from a traditional software license business model to a subscription-based one (completely discontinuing the traditional software line in 2013), meaning users would always get the latest versions of its software rather than having to periodically "upgrade". The applications included run the gamut from digital image creation and capture through organisation, video editing, visual effects, audio editing, web design, and colour correction, all of which have some Cloud-enhanced functionality, in the form of easy sharing and sync.

Avid Media Composer Cloud (avid.com)

Pricing: undisclosed

Features: editing of local and remote media, make remote media available offline, submit in-progress sequences

Avid's Media Composer Cloud doesn't fundamentally change the way editors create sequences, but what it does do is streamline the process of working remotely. Rather than have to set up a file-sharing system and then coordinate requests for media to use remotely, the editor can remotely connect to a workgroup server and browse, upload, and download media as needed. As a bonus, sequences being worked on can begin to be uploaded prior to completion, instead of waiting to transfer just the finished sequence at the end (and saving time as a result).

Forscene (forscene.com)

Pricing: $200/user/month + $1,000/year ("small" facility), $200/user/month + $4,000/year ("large" facility)

Features: 100 hours proxy media storage, browser-based video editing, mobile video editing apps

Billed as a fully-featured Cloud-based video editor, Forscene works in any Java-capable browser or via a mobile app. It requires a dedicated server for ingesting media, but otherwise users just need an Internet connection to be able to log, rough cut, review, and publish sequences.

BIBLIOGRAPHY

Introducing Adobe Capture CC https://blogs.adobe.com/movingcolors/2015/10/05/introducing-adobe-capture-cc/

No Film School http://nofilmschool.com/

8

Planning

"Anyone who does anything creative is always gonna want to change."
—Will Ferrell

COORDINATION IN THE CLOUD

Even the smallest production requires a great deal of communication, coordination, and effort; as a production gets bigger, so each of these requirements increases and becomes ever more challenging. Coordinating a shoot day on a student production of 10 crew members takes a good measure of planning, but any given day on a production with a reasonable budget might involve orchestrating the whereabouts of a thousand people at a time.

This is a situation that's not necessarily specific to video and film productions; there are many kinds of live events that face these same challenges, and a great many more types of businesses that have to ensure large numbers of people are working in a synchronised manner to achieve a particular aim within budget or logistical constraints. However, it's safe to say that video and film productions have their own established, novel solutions to these issues.

Call Sheets

The humble "call sheet" is one such solution. Issued the evening before each shoot day (typically printed and handed out or emailed to everyone), it provides a high-level glimpse of who's needed where and at what time, and other pertinent information, such as contact information for key people and a risk assessment evaluation.

Though useful, this traditional approach is by no means ideal—for one thing, it doesn't update according to changing circumstances (instead, a new sheet must be issued and redistributed whenever there are significant changes), for another, there's no way to verify if the recipients receive (or even read) it. Furthermore, because call sheets are intended for mass distribution to many people across different departments, the amount of information it contains that is actually relevant to each recipient is very small, and the recipients have to scan through a lot of information to find the important parts.

In the connected, mobile domain of the Cloud, this needn't be the case. Individuals can instead receive the same information directly to their phones, with changes pushed out as soon as they happen. This micromanagement can be done through software rather than requiring coordinators to tailor individual call sheets for each person. Instead they might simply allocate people to specific groups and then document what's needed for each group. When the time comes to send out the call sheet, the software sends out the information to each person in the group, with the most relevant parts for each person highlighted in some way.

Indeed, the information provided by call sheets can be enriched by the power of the Cloud, with maps and directions relayed as well as simple destination addresses, up-to-date weather forecasts, and links to other pertinent information.

Services like Studio Binder (studiobinder.com) also provide a way for recipients to acknowledge receipt of the call sheet, relaying this back to coordinators, so they can tell if anyone may not have received theirs, and then follow-up with them separately.

SCHEDULING IN THE CLOUD

Fortunately, scheduling is not a problem that is specific to film and video production. As such, there are a great number of tools and services to help

with scheduling, and an increasing number of them are Cloud-based. Two features of the Cloud in particular are useful to the problem of scheduling—first, that it is usually a collaborative process, and second, that it is often possible to pipe data to or from other Cloud-powered services.

Calendars in the Cloud

The simplest form of scheduling is to simply block out time in a calendar—something that can be done easily just on paper. But several Cloud-enabled calendar applications exist, many of which are free (both Google and Apple provide free Cloud-based calendars). Using a Cloud-based calendar allows it to be shared with others. Whilst trying to come up with a schedule, this can allow multiple people to collaborate to work out which dates and times are most suitable and will work for all concerned. Once a schedule is agreed upon, the sharing feature becomes useful in a different way, as it can be made available to an entire crew, for example (this is also referred to as creating a calendar "subscription").

Moreover, it's possible to have multiple calendars, each shared with a different set of people. So there might be a "main unit" calendar and a "second unit" calendar, or perhaps "pre-production", "shoot", and "post-production" calendars, of which certain people might subscribe to just one, and others subscribed to all of them. Any changes that are made to any of these calendars are syndicated automatically to all subscribers, so there's no need to worry that anyone might have out-of-date information. Finally, it's usually possible to "invite" individuals to a specific calendar event, regardless of whether the entire calendar is shared or not. Invitations are normally just sent out as emails (further emails are sent if the event is modified in some way), but some email applications recognise these emails automatically and will just update the user's calendar accordingly.

BOX 8.1 Smarter Calendars

It's one thing to make everyone aware of events once they've been scheduled, but the challenge still remains: how do you pick the correct date and time to best suit everyone involved? Sadly this tends to

(Continued)

(Continued)

involve lots of coordination and communication for everyone involved (or at least their assistants), and this results in lots of time wasted. But with Cloud-enabled calendars, this need not be the case. With access to everyone's calendars, it is much easier to determine the best available date and time for an event. The problem, of course, is that participants may not want the organiser to have access to their entire schedule. However, if this is done without the organiser personally having access to individual calendars, as in the case of a third-party scheduling software, this becomes a much more viable possibility.

Indeed, software such as Meekan (meekan.com) uses sophisticated algorithms to identify free time based on not only participants' calendars (or via a poll where direct access to the calendar is unavailable) but also on the intent of the event. So, for example, if the organiser requests a "lunch meeting", then the software will aim to pick an appropriate time slot.

Project Planning

Project planning is about taking a complex project and working out how best to get it done in a given timeframe with a particular set of resources. How accurate and reflective of reality this ultimately ends up being is based on a few things, with prior experience factoring pretty heavily into it. In essence, planning a project involves splitting it into smaller, more manageable tasks, each of which has an estimated duration and can be assigned to different people (thus maximising efficiency by allowing them to be run in parallel with each other), and where needed, with associated costs. For projects that are individual episodes of a television show, there's the advantage of being able to analyse previous episodes, with the planning of each subsequent episode becoming (one would hope) easier and more accurate. Regardless, each project will likely have its own unique quirks and challenges, and as such must be planned individually to some degree.

Clearly, all of this involves a great deal of collaboration between different people, and possibly across different departments, and that's where the Cloud comes in. While many of the collaboration and communication tools discussed in chapter 6, as well as the scheduling services covered throughout this chapter, can be invaluable as part of the project planning process, there are several systems that are designed to specifically address the needs of planning projects.

Wrike (wrike.com), for example, allows project planners to create a series of tasks for a project and then set assignees, dates, and dependencies for each. Though these are all actions that can be taken in the majority of desktop-based project management software, the fact that it's in the Cloud provides some very powerful features. First of all, it's easy to invite others to collaborate on a plan. This allows multiple planners to work together on a single project, but it also allows assignees to be involved at an earlier stage. If someone is unavailable on a specific date, they can log in to the system and notify the planner early on. Conversely, this also allows assignees to be aware of potential dates they're involved with early on.

Naturally this also gives rise to the possibility of notifications, so if someone completes a task, relevant people can be notified of this. Likewise, when any dates on a task change, the task's assignees can be notified immediately and automatically. For executives and other stakeholders, there's the possibility to share reports as well as a high-level overview of a project's timeline. Finally, as with many Cloud-based services, there's the possibility to attach files to tasks and add comments.

BOX 8.2 Gantt Charts

One of the most popular ways to visualise the schedule of a project is the Gantt chart (named after its inventor, Henry Gantt), which became very popular once they became available on computer systems. In a Gantt chart, each task is represented by a horizontal bar along a time-line, with tasks that can be done in parallel stacked above one another. Typically there will be arrows between bars to indicate dependencies, diamonds to indicate milestones, and the bars themselves might be partially shaded to indicate progress through a task.

One particularly interesting development of having Gantt charts available within computer software was that they could be interactive, that is to say that project managers could drag them around on the timeline and have the respective dates update to match, providing an intuitive approach to planning tasks. Such interactive Gantt charts are a feature of most Cloud-based planning applications, so you can expect to see them a lot if you're involved with project planning in some way.

(Continued)

(Continued)

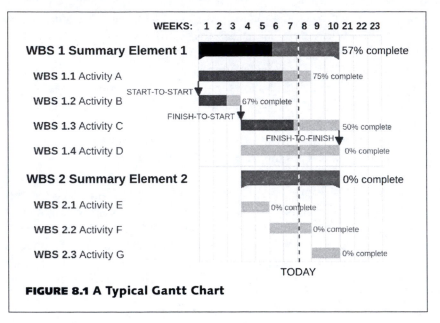

FIGURE 8.1 A Typical Gantt Chart

Resource Planning

A related, but slightly different, approach to project planning is "resource planning". Whereas project planning centers on the tasks that need to be done, resource planning instead focuses on managing a finite set of resources in order to complete tasks. This approach means it's easier to make sure that available resources are being used efficiently across multiple projects, as opposed to making sure individual tasks are scheduled efficiently within a single project (which approach is more suitable will, of course, depend on the specific production—for feature film production it's preferable to ensure everything that needs doing gets done as quickly as possible, even where this means there are resources effectively going unused).

With this approach, anything that can be considered a resource, such as a particular camera or a member of the cast or crew, can be allocated to specific tasks or projects. This makes it easy to see at a glance what everyone is doing (or will need to be doing) on a specific day. Ganttic (ganttic.com), for example, provides a strictly resource planning–oriented approach to project management, allowing planners to schedule individual resources and assign them to tasks without fear of having them overlap.

Project Management

Planning a production is one thing, but actually keeping track of work that needs to be done is a different matter. On a given shoot day, numerous individual tasks contribute to the overall aim of getting certain things filmed, with each department having to independently track their own areas of responsibility. For some, it may not seem appropriate or necessary to use computing technology to do this, let alone the Cloud. For example, the catering department on a shoot is primarily concerned with ensuring that food and drinks are ready as needed, and it seems unlikely they'd need to be connected to the Internet to get that done. But on the other hand, at least part of that process is highly dependent on other departments. If the shoot's timing changes at short notice, this affects their schedule of preparing meals. Similarly, other departments might like to know what the menu is for the day ahead of time, so that they can place orders and guarantee there's enough of everything for everyone. If at least some of this information is available in the Cloud, there's less need for long communication chains to keep everyone in sync on each other's needs.

Other departments, or other phases of a production (post-production for example), might more closely resemble a more traditional office environment, with people desk bound and working with desktop computers. In these environments, people might encounter the same types of issues that people in other industries have, such as needing to know about the progress of work that's being done by others, the whereabouts of particular documents, or to otherwise get information about processes and procedures. Each of these problems has, to some extent, been solved by various services based in the Cloud.

A number of so-called project management systems are available in the Cloud, though many of them have different philosophies in their approach. Basecamp (basecamp.com) emphasises six key areas (discussion threads, real-time chat, scheduled information gathering, to-do lists, document storage, and scheduling) for project management, whilst Asana (asana.com) promotes a more formalised, primarily task-oriented approach, with discussions and document storage all happening within the context of particular tasks.

Regardless of the specific approaches, what the Cloud-enabled systems all seem to agree on is that having the means to communicate in a structured

way (and have conversations available for posterity) is as important as the process of tracking individual elements of work. Tellingly, this plays well to the strengths of using the Cloud, as with more traditional, desktop-based approaches, these conversations might otherwise be locked away in private emails or other, unshared documents.

Knowledge Management

With any significantly involved process, it can become necessary to keep track of different processes or additional information provided by others. There might be strict policies or compliances to adhere to when doing certain things, or complicated workflows with multiple steps that need to be noted somewhere for people to follow. People undoubtedly have their own way of keeping track of such things, but on any collaborative project, much of this knowledge needs to be shared with others.

In the Cloud there are a number of ways for people to track information and share it, with the simplest being to record information in a document that is shared online, such as Google Docs (docs.google.com), all the way through virtual shareable scrapbooks like Evernote (evernote.com) or Microsoft OneNote (onenote.com), up to bespoke "wikis".

First popularised by the community-driven encyclopedia Wikipedia (wikipedia.org), wikis are sites that share information by allowing users to freely edit and create individual pages. Although wikis tend to be associated with sites that have lots of different articles and information, they can be just as suitable as a means to hold even a handful of pages—the key things are that they can evolve over time as more information is added and that multiple people have access to them.

As such, it can be useful for productions, or even individual departments, to make use of a wiki to track pertinent information, for example, having pages for each location on a shoot with relevant information, or step-by-step procedures for different things. Everyone can access the information, and anyone can add or clarify anything they feel is appropriate. It's certainly possible to accomplish these goals with something like Google Docs, but the advantage of a wiki is that it's easier to collect different pages into a single site, with links between pages that don't need to be updated regularly.

For example, Google Sites (sites.google.com) provides a straightforward way to build wiki-like sites, each with a searchable set of pages. Microsoft's Sharepoint Online (sharepoint.microsoft.com) might be seen as the ultimate realisation of a wiki, with the ability to create and share entire sites of pages and with several high-end analysis features also available to those interested in knowing how all the information is being used.

Project Portfolio Management

For people who need to manage a large number of projects, but also be concerned about higher-level business strategy, a "project portfolio management" system might be needed. Typically these will comprise many of the benefits of project planning and resource planning applications, but also the means to analyse risks and zero in on potential issues with projects. Ideally, this means that there's one person or more looking at the big overview of all the projects, with other project planners concerned with the details of specific projects, but that ultimately all the data are in one centralised place. Again, the Cloud provides an ideal foundation for this process.

Microsoft's Project Online (products.office.com/en-us/Project/project-online-portfolio-management) is one example of such a system. Project planners can establish proposed schedules for work to be done, workers can provide updates on their progress, and executives can see an up-to-date overview of all projects at any time, in a way that would be much more complicated with traditional desktop-based software.

Production Planning

There are also systems that specifically cater to planning film and video productions, providing both a framework to capture and store information within them and the potential to streamline various tasks. Celtx (celtx.com) is one such example and includes script editing, storyboarding, breakdown, scheduling, and budgeting capabilities in a single place, along with a carefully designed process to allow the information to flow easily from one process to the next.

The benefits of such a system are that everything fits together in a familiar way and there's less need to "reinvent the wheel" to, for example, work out how to break down a script in a suitable way. Everything is in one place,

so there's less switching between different systems to perform a set of tasks. However, the issue with systems like this that are "opinionated" (that emphasise or enforce a particular way of doing things), is that they can be less flexible than other approaches or combination of systems. If, for example, you don't like Celtx's approach to storyboarding or scheduling, you'd have to use a separate system anyway.

POPULAR CLOUD PLANNING SERVICES

Studio Binder (studiobinder.com)

> **Pricing:** free (feature-limited), from $15/month

> **Features:** document storage, contacts database, personalised call sheets

Studio Binder takes some of the tedium out of generating call sheets by automatically adding pertinent data based on the shoot location, such as weather and map links, and ensures everyone receives call sheets that are personalised, with just the information that's relevant to them. It also allows recipients to confirm they've received the information, so that coordinators don't need to spend time contacting each person individually.

Google Calendar (calendar.google.com)

> **Pricing:** free (or as part of Google Apps for Work)

> **Features:** shared calendars, subscribed calendars, event invitations, browser-based, mobile apps

Google Calendar has all the features you'd expect from a Cloud-based calendar, with the added benefit that lots of third-party systems provide their own integrations with it. The sharing functionality is very fine-grained, allowing specific permissions to be set for each person the calendar is shared with.

Apple iCloud Calendar (icloud.com)

> **Pricing:** free

> **Features:** shared calendars, event invitations, browser-based, mobile apps

Apple's calendar offering is robust, with the caveat that you need Apple hardware to make the most of it (though there is a functional browser-based version). It doesn't have the same level of control over sharing calendars that Google provides, allowing others only to either make changes to the calendar or not.

Doodle (doodle.com)

Pricing: free (feature-limited), from $39/user/year

Features: calendar polling, browser-based, mobile apps, API

Doodle allows the creation of polls for scheduling meetings amongst invitees. Based on the responses to those polls, it calculates the most suitable date and time for the meeting.

Meekan (meekan.com)

Pricing: free

Features: calendar polling, mobile apps, API

Meekan builds upon the feature set of Doodle, using information from participants' calendars directly to schedule meetings where possible, and then falling back to creating polls for those whose calendars are not available. It also supports scheduling via natural language, for example, "Set up a meeting with the production team ASAP". Integration with Slack is also available.

Wrike (wrike.com)

Pricing: free (feature-limited), from $50/month

Features: project planning, Gantt timeline, reporting, mobile apps, API

Wrike offers a full-featured project planning system, with all the features you might expect in a desktop application like Microsoft Project (and supports the "Critical Path Method" model), but also enriched by the Cloud, with features like easy collaboration, notifications, and integrations with other systems.

Ganttic (ganttic.com)

> **Pricing:** from free (based on number of resources required)
>
> **Features:** project planning, Gantt timeline, reporting, mobile apps

Ganttic provides a way to plan projects through resource planning rather than task-based planning. The service allows users to specify individual resources that are available across projects and then allocate them to projects and tasks on a timeline.

Basecamp (basecamp.com)

> **Pricing:** $29/month (internal teams), $79/month (internal teams + clients)
>
> **Features:** project management, schedule tracking, task tracking, document storage, mobile apps, API

Basecamp has been available for over a decade in different forms, but the latest incarnation focuses on a few key areas, in particular the importance of real-time and threaded communication between people on a project. There are some other unique features to the service, such as being able to schedule an automated email to request information from participants, but the idiosyncratic design of the system might not be to everyone's taste.

Asana (asana.com)

> **Pricing:** free (15 users, feature-limited), $8/user/month
>
> **Features:** project management, schedule tracking, task tracking, document storage, mobile apps, API

Asana offers a task-centric workflow for teams working on projects. As with a typical project planning system, projects can be set up with scheduled tasks, although here only the due dates for tasks are tracked. Each task can then have assignees, subtasks, conversation threads, and associated file attachments and are essentially presented in user-defined lists until checked complete.

Evernote (evernote.com)

Pricing: free (feature-limited), from $3/user/month

Features: shareable pages, task tracking, document storage, mobile apps, API

Evernote is one of the most popular Cloud-based note-taking systems available. Individual pages, or "notes", may be created (with file attachments) and individually shared with others. The service is integrated with many other services, so it is possible to automatically create new notes from a number of different sources.

Microsoft OneNote (onenote.com)

Pricing: free

Features: shareable pages, task tracking, document storage, mobile apps, API

OneNote is comparable to Evernote in many ways, but it does have the advantage of being free (Microsoft OneDrive is used for storage). It also leverages Microsoft's word processing technology, so actually formatting individual notes is arguably more powerful than Evernote. However, it does lack some of the more high-end features and integrations that Evernote offers.

Google Sites (sites.google.com)

Pricing: free

Features: wiki site, document storage, API

Google's take on wikis is available for free (though file storage is limited based on the type of Google account used), with everyone able to set up individual sites with their own set of pages and then invite others to view or contribute to them. It's unsophisticated but easily accessible and more than adequate for all but the most demanding requirements.

Wikispaces (wikispaces.com)

Pricing: from $100/year

Features: wiki site, document storage

Wikispaces provides a Cloud-based, full-featured wiki for capturing and sharing information. It's perhaps losing relevancy in an era where similar features can be found in other systems, but it offers a "true" wiki experience and might represent better value for money for larger groups.

Microsoft Sharepoint Online (products.office.com/en-us/ SharePoint/sharepoint-online-collaboration-software)

Pricing: $5/user/month (or as part of Office 365)

Features: shareable pages, document storage, API

With Sharepoint Online, Microsoft brings the feature set of its Sharepoint system to the Cloud. Put simply, Sharepoint allows users to create and manage sites of pages and documents in much the same way that Google Sites does but brings with it a lot of enterprise-level features for controlling access and performing analysis.

Microsoft Project Online (products.office.com/en-us/ Project/project-online-portfolio-management)

Pricing: $33/user/month

Features: project portfolio management, project management, Gantt timeline, reporting, mobile apps

Perhaps the most fully-featured of Cloud-based project management systems, Project Online supports scheduling, resource management, task management, risk management, and a whole host of other options. It might be considered overkill for all but the most complicated and involved productions, but for those wanting to manage a lot of productions running concurrently, it will likely have everything executives and managers need.

Celtx (celtx.com)

Pricing: free (feature-limited) from $10/user/month

Features: script editing, storyboarding, breakdown, scheduling, budgeting, project management, reporting, mobile apps

Celtx offers a production management and planning system specifically designed for film and video productions. As such, it has many features that aren't available through other systems, such as script editing and break-down, and the various sections of the system work together in a coherent way. However, this does mean that users are effectively "locked in" to the system and provides maximum value only if you want to use it in its entirety, which might not be the case across different departments.

BIBLIOGRAPHY

Meekan Raises $870,000 to Connect the World's Calendars http://techcrunch. com/2014/11/06/meekan-raises-870000-to-connect-the-worlds-calendars/

Work Management Report 2015 https://www.wrike.com/work-management-report-2015/

9

Finance

"Never confuse the size of your paycheck with the size of your talent."
—Marlon Brando

FINANCE IN THE CLOUD

As with any type of business endeavour, money plays an important role in the production process. Defining budgets and then tracking actual costs as they happen are two important components of this process, but what's most important (aside perhaps from how much the production ultimately ends up making) is getting money with which to fund the production in the first place.

Often financing works in tandem with budgeting. Preparing a production with an all-star cast will likely require greater funding (though one would hope that it would likewise lead to greater revenue) and a large budget as a result. On the other hand, not being able to secure the desired level of funding would mean cutting back on the budget, possibly dropping some above-the-line items and potentially compromising the overall production value as a result.

FIGURE 9.1 Traditional Financing for Productions

Even in the 2010s, the main possible avenues of financing remain unchanged: having a film or television studio bear most of the financial responsibility is probably the most obvious choice, as well as getting private investment or pursuing advertising opportunities such as product placement. For more modest budgets, various grants or personal finance might suffice.

That said, the Cloud does bring with it some new potential avenues to funding productions. Crowdfunding (which will be discussed in greater detail in chapter 16) allows for a large amount of money to be raised through a high number of people each contributing a small amount. This has been used to great success on several notable productions, such as *Anomalisa* (2015) and *Veronica Mars* (2014).

Borrowing money is cheaper thanks to the Cloud. "Peer-to-peer lending" is a replacement to more traditional financial loans, such as you might get from a bank for example. With a peer-to-peer loan, such as offered by Prosper (prosper.com) or Lending Club (lendingclub.com), individuals loan money to each other (typically on unsecured terms), with the service acting as an agent for the transaction. The lender collects a higher return than they would typically get from a savings account (around 5%–10% depending on the estimated risk), and the borrower has a lower amount to repay than they would with a loan from a bank (around 5%–30% depending on the service used and terms of the loan). Naturally the service itself takes a percentage of each loan.

Clearly this can be extremely beneficial to those seeking to borrow money (if perhaps a little less so for people looking for opportunities to make some money), but there are some caveats that might make it inappropriate for

FIGURE 9.2 Peer-to-Peer Loans

fully funding a production. First of all, the amounts that are loaned are typ-ically quite small, so it seems unlikely you'd be able to borrow seven-figure sums of money, for instance. Additionally, it is expected that repayments are made regularly and across a specific time period. This might not be suitable for many production types, which would not see any revenue until a period of time after the production has actually completed.

That said, this is a relatively new area with lots of possibility for growth, and it may be that in time we will see new low-interest lending models based on peer-to-peer finance that are better suited to the needs of different productions.

Movie Production
Incentives and the Cloud

BOX 9.1

Movie Production Incentives are some form of financial reimbursement or compensation, in the form of a grant or tax rebate, for example, that is given by a local government (or state in the US) to a production meeting certain criteria, to encourage production to take place there. For example, shooting in Canada rather than in the US through the Canada Film Capital scheme (canadafilmcapital.com) can result in tax credits on labour costs, potentially saving the production a significant amount of money compared to shooting elsewhere.

It's interesting to note that although the Cloud doesn't directly have any bearing on such incentives, what it does do is remove many of

(Continued)

(Continued)

> the barriers to taking advantage of such schemes. For example, when deciding where a shoot needs to happen, productions making heavy use of the Cloud will not need to be as concerned with things like IT support and infrastructure and can make use of numerous services to stay in touch with people elsewhere.

The peer-to-peer model also has another financial application. For exchange of currency, such as when needing to transfer money to someone in another country, cutting out banks and exchanging dollars for Euros directly with someone else first is more cost-effective (and in many cases, faster) for both parties. Services such as Midpoint (midpoint.com) act as a broker in this regard, with both parties sending their money to the service, which calculates the exchange rate, takes a commission of around 0.5%, and then forwards the amount in the new currency on.

UK-based WeSwap (weswap.com) extends this idea to the exchange of currency for people going abroad. Through a similar system to that of Midpoint, people wishing to exchange currency are paired up, with the service receiving the money, taking a percentage (starting from 1% of the overall transaction, depending on how quickly you need it) and then providing a prepaid charge card credited with the new currency to both parties for use overseas.

BUDGETING IN THE CLOUD

In simple terms, production budgets represent the overall expected expenditure for a production. These are typically broken down into "above-the-line" (those incurred by high-level expenditures, such as the main talent, directors, producers, and screenwriters) and "below-the-line" (everything else) costs. On larger productions, different departments each draw up its own budget, which then feed into the overall budget.

Creating an accurate budget is an important precursor to securing the right amount of funding in many cases, but the reverse situation is equally important—productions have a fixed amount of money available to spend and must then work out the best way to spend it. Both scenarios require skill and experience in predicting real-world costs and being able to negotiate

deals on different things, and even larger budgets can feel constraining when there's an abundance of potential expenditures to consider as a result.

At the present time, there are no noteworthy Cloud-based services that cater specifically to budgeting productions, though it's certainly possible to make use of something more generic, such as Google Sheets (sheets.google. com) during the budgeting process, which at least lends an aspect of collaboration to the mix (for more on Google Sheets, see chapter 10). However, many of the features of the Cloud mean this will likely change in the future. It's possible to imagine a time where many of the contributing factors of line items in a budget, such as the rental cost of a specific lighting package per day, could be syndicated by rental companies into a specific budgeting system, allowing for the person creating the budget to easily compare costs between competing rental companies, or to see the estimated financial impact of adding an extra day of shooting, at the push of a button.

Moreover, as the prevalence of the Cloud grows and becomes more integral to different productions, tracking tools could feed directly into something of a "living" budget, which is recalculated as changes to the production take place, such as when a shot that was previously considered to require expensive visual effects is removed from the final cut. It would also be possible for production companies and studios to easily aggregate data from past productions, to get a more accurate picture of "real-world" costs for different things, such as shooting with a particular camera that has a low rental cost, but is more expensive in terms of post-production.

ACCOUNTING IN THE CLOUD

Whether the budget on a production is realistic or not, there's the need to actually track how money is being spent, as well as provide the same types of services as any company would, with regards to collecting and making payments. This, however, is an area that is very well-represented within the Cloud.

Intuit's popular accounting package QuickBooks (quickbooks.intuit.com) recently switched from a traditional desktop-based application to a Cloud-based service (and subscription-based pricing model), touting amongst the benefits that it would allow accountants to work from anywhere and on almost any Internet-connected device, and that using the Cloud-based system required less data entry than its previous desktop one, as it would be

able to connect to other services to download and categorise transactions and other data automatically.

When it comes to paying the crew, the Cloud can play an important role here too. Services such as Entertainment Partners' Payroll Services (ep. com/home/paying-crew-and-talent/payroll-service) automate a great deal of paperwork and calculations for things like tax deduction and can make payments directly into people's accounts. Services such as Gusto (gusto. com) aim to inject some personality into the process by generating paystubs that are more personalised and attractive.

The Cloud allows for other possibilities too. Many Cloud-based accounting systems have integrations with Cloud-based time-tracking systems (see chapter 7), making the collection of data about hours worked easier and more accurate. Services such as Activehours (activehours.com) allow employees to "cash out" their accrued earnings prior to their scheduled payday, by linking their bank account to the service and submitting a copy of their timesheets each time they want to cash out.

POPULAR CLOUD FINANCE SERVICES

Prosper (prosper.com)

Pricing: 6.9%–31.2% for borrowers

Features: peer-to-peer lending and investing

Prosper acts as a broker for peer-to-peer loans. People wishing to borrow an amount between $2,000—$35,000 take out a fixed term loan with monthly repayments spread across 3 or 5 years, at an interest rate between 6.9%–31.2% depending on factors such as credit score. Meanwhile, others can "invest" in loans, seeing an estimated return of between 4%–12%, depending on risk (the risk in this case being that a loan may not get repaid).

Lending Club (lendingclub.com)

Pricing: 5.3%–31.0% for borrowers, 1% for investors

Features: peer-to-peer lending and investing

Lending Club functions in much the same way as Prosper, but with loan amounts between $1,000–$40,000 for personal loans or $5,000–$300,000 for business loans. Businesses may also apply for a line of credit. The service is paid for through a 1% fee on payments made back to investors.

Midpoint (midpoint.com)

Pricing: up to 0.5% of transaction value

Features: peer-to-peer international money transfer

Midpoint aims to make international money transfers cheaper and faster by pairing people wishing to exchange money between different currencies, effectively bypassing slower and more expensive traditional currency exchanges made by banks. Where no suitable pairing can be made, traditional exchange is used.

WeSwap (weswap.com)

Pricing: up to 1.4% of transaction value

Features: peer-to-peer currency conversion

Adopting a similar process to Midpoint, WeSwap pairs people wishing to exchange different currencies together and then transfers the converted currency to a prepaid charge card for use abroad. The service is charged based on how quickly the money is needed, with instant transfers charged at 1.4%, and up to a week at 1% of the transaction.

QuickBooks (quickbooks.intuit.com)

Pricing: from $27/month

Features: accounting, invoicing, reporting, mobile apps, API

Quickbooks is one of the most popular accounting systems in use. Having released a Cloud-based platform, the company seems to be focusing its resources there, with development of the desktop versions receiving largely insignificant updates. The Cloud-based edition of its software, however, is fully-featured, with mobile apps and integrations with a large number of different services available.

CloudBooks (cloudbooksapp.com)

Pricing: free (feature-limited), from $10/month

Features: accounting, invoicing, reporting, time tracking

A more basic offering compared to QuickBooks, CloudBooks has an eye on ease of use and simplicity. Aimed more at individuals and freelancers than entire accounting departments, it has features such as time tracking and a number of reports included even with the free version.

FreshBooks (freshbooks.com)

Pricing: from $13/month (based on number of clients required)

Features: accounting, invoicing, reporting, mobile apps, API

Another accounting system focused on simplicity and accessibility, Fresh-Books aims to makes processes like invoicing and expense-tracking easy to manage. Primarily aimed at smaller businesses, the service also allows payments to be taken online, with a particularly nice touch that payments can be made directly from invoices generated by the system.

Entertainment Partners Payroll Services (ep.com/home/paying-crew-and-talent/payroll-services/)

Pricing: undisclosed

Features: accounting, invoicing, reporting, time tracking, payroll

Entertainment Partners' suite of Cloud-based products represents perhaps the only Cloud-based system currently available that is designed specifically for the entertainment industry. This allows it to take into account factors such as union and labour laws for compliance, as well as providing some industry-standard reports for things like hot costs and allowing for tracking of production incentives.

Gusto (gusto.com)

Pricing: from $35/month (based on number of employees)

Features: payroll, API

Gusto manages the payroll process, including managing tax filings and other deductions as applicable, whilst generating personalised paystubs and handling transactions automatically. Primarily designed for smaller businesses (of fewer than 100 employees), it might be better suited to smaller teams, particularly those without dedicated payroll accountants.

Activehours (activehours.com)

 Pricing: free

 Features: payment on demand, mobile apps

Activehours lets users of the service get paid on demand, based on the hours they've worked rather than their designated pay date. When someone wants to get paid in advance, they submit a copy of their timesheet to the system, and based on the hours they've worked, the service will transfer the appropriate funds into their account. Any amounts that are withdrawn in this way will be deducted on the actual pay date. The service is free but funded by optional donations.

10

Tracking

"I pretty much try to stay in a constant state of confusion just because of the expression it leaves on my face."

—Johnny Depp

Even excluding the terabytes of footage that are produced, a typical production generates a huge amount of data. Data in the sense of what was done where and by whom, but also in terms of opinions, notes, and considerations about the many minutiae of the production's process. This information can be stored in hundreds of different places, often unavailable to the people who might need it, and can be the cause of a great deal of delays, mistakes, complications, and confusion.

Ideally, every production would have very strict conventions and standards so as to reduce ambiguity, with everything labelled in a consistent way. In this ideal production, everyone would be able to store information that's relevant to them and have the information that's also relevant to someone else readily available. Managers would be able to get a higher-level view of everything automatically and know, for example, how many costumes are available at a particular time or how many scenes in a script are left to be shot. All of this is possible, of course, with experienced crew members and well-designed practices, but all of it can be made much easier by using the Cloud.

SAVING TO THE CLOUD

As discussed earlier, Cloud storage offers many benefits as a way to save documents when compared to just saving them on a local computer. However, there are many other types of data that can't (or shouldn't) be strictly categorised as "documents", and as such storing them as files within Cloud storage becomes something of a step backwards, as it effectively siloes information that might be relevant to something else.

For example, on a shoot there might be reports made by a camera assistant (or someone else) about every shot recorded, with details such as the lens used, the focus distance, and so on. Though this might be done purely for the camera department's benefit, it is information that might be useful to a number of people. An editor might be interested in just having a record that such a shot exists, and this can be information that visual effects and stereo conversion facilities consider crucial to doing their jobs.

Sadly, all too often, even where this information is recorded somewhere, it is typically on paper that is filed away somewhere, and then may be forgotten about or lost (or just considered too much effort to track down once the shoot wraps and the respective crew moves on to other things). Even for records that are kept in a digital format, whether in a note-taking application or a spreadsheet or database, they might not be made available to the people who could benefit from them, or might be in a format that's not readily accessible (for example, some crew members use databases where the information is structured in a non-standard way).

For productions that are investing in the Cloud as a way to make information more accessible, the temptation is to just make sure all of this is digitised, either originating in a digital format, or else scanned and saved. Although this is a step in the right direction, it inevitably leads to the digital equivalent of "clutter"—lots of files that have to be managed and organised. There might be less browsing through stacks of paper and archive boxes to find something specific, but there's a lot of looking through folders and double-clicking files instead.

Some of these issues might be resolved by using a Cloud storage service that also indexes the contents of files, thus making them all instantly searchable, but this applies only to certain file formats, and even then, searches are limited to specific keywords. You could search for documents containing

"Pinewood Studios", for example, but probably not find something more specific, like "costume reports for main character for shoot days at Pinewood Studios" unless you had organised files in a very specific folder structure.

Moreover, summarising data is just not possible with a collection of files. If you wanted to know how many takes were shot on a given day, or how much of the budget is going to a particular department, that's not information you'd easily get from looking at a bunch of files. Clearly, a better approach is needed. Fortunately, such approaches already exist and are readily available.

STRUCTURED DATA IN THE CLOUD

Spreadsheets

As soon as someone finds that unordered notes or free-form documents aren't able to provide enough structure or clarity to all the information they need to record, they'll likely turn to a spreadsheet. A spreadsheet is a digital document with a grid of "cells" that can each hold some information, such as text or a number (in some cases it's possible to put images or file attachments as well). Spreadsheets are familiar to anyone who's ever worked in any sort of office environment, as they provide ways to create ad-hoc lists and tables, and record information in a neater layout, whilst still remaining free-form enough to not seem restrictive.

There are plenty of advantages to using spreadsheets. They're reasonably intuitive and don't require any formal training to get started with, at least not until you want to start summarising or performing calculations on the information in them. Simply click on a cell and start typing and apply some formatting if needed to make cells visually distinctive.

Spreadsheets are free-form, so there's no need to structure information in a specific way (although you might want to do this regardless if you need to be compliant with some other system or if you adopt a convention that others have been using for consistency). They're also portable, meaning that it's easy to get information in and out of them (indeed, many Cloud services have an option for importing and exporting spreadsheet data).

Even though spreadsheets are easy to get started with, they have a lot of powerful functionality under the surface. Most prominently is that any cell

can contain a "formula" which is simply something calculated from something else. This can be a total of a column of numbers, for example, but it can also be the combination of two cells of text, or other types of calculations with greater complexity.

As spreadsheets lend themselves well to tables of data, it's also fairly easy to use them to generate a variety of charts. For example, if you had a spreadsheet listing a breakdown of costs for a particular shot, you could generate a pie chart to show the distribution of costs across the shot; likewise if you had a list of how many soundbites were recorded each day, you could produce a line graph showing their accumulation over time.

Though spreadsheets have been in use on desktop computers for decades, one of the common problems with them is that they're not inherently collaborative. If two or more people want to make changes to a particular spreadsheet, they either have to coordinate with each other, sending copies of the spreadsheet back and forth, and even if there's shared access to the spreadsheet itself (if it's on a network drive for example), one person may have to close their copy to allow another to open it.

With the Cloud, though, that doesn't matter. With Google Spreadsheets (docs.google.com), for example, all data are stored in the Cloud, so there are no files to manage (although they can be downloaded as files if needed, and individual spreadsheets can be organised alongside uploaded files on Google's Cloud storage service). Using a Cloud-powered spreadsheet like this means that it can be easily shared with multiple people (each of which may be given permission to edit or just view all or certain parts of the spreadsheet) and that multiple people may access the spreadsheet simultaneously. This then allows for several people to add information to a particular spreadsheet, or have one person edit whilst others are viewing it, or allow people to structure the spreadsheet more interactively together. With all the data stored in the Cloud, it also means it's possible to edit it via mobile devices.

Spreadsheets do have several drawbacks, though. First and foremost, trying to use them with any sort of relational information, such as connecting information about a specific television episode with information a particular season can be tricky. Furthermore, it can be difficult to search for things in a straightforward way, or cross-reference different types of information. Then there's the inherent difficulty with trying to audit everything, to keep track of which changes to the information was made when and by whom.

There *are* ways to do these types of things with spreadsheets, but they tend to be complicated and not necessarily intuitive (Cloud-based spreadsheets seem to have an additional disadvantage compared to their desktop counterparts, which is that they can get rather unwieldy once they pass a certain number of cells of data).

As a rule of thumb, once you start spending a long time trying to do something in a spreadsheet that seems like it *should be* much simpler, it's probably time to upgrade to a new approach.

Relational Databases

Because spreadsheets are free-form, you might have one spreadsheet with a list of people and which department they belong to and another with a list of tasks people need to do. But these two lists of information don't "know" anything about each other, so it becomes difficult to, for example, group tasks by department without resorting to constructing formulae and reorganising the data beforehand.

With a relational database, information can be structured more intelligently. You can be specific about what different things are and how they're related to each other. In a database, different types of things are represented as separate "tables", and each table has its own set of "fields", properties that are loosely analogous to columns on a typical spreadsheet (so "due date" might be a field, as might "name"). Each table also has a number of records, which can be thought of as the rows on a typical spreadsheet (so each person recorded in a database might exist as an individual record on a "people" table).

The immediate benefit is that everything is structured in a consistent way. Each record in a table has the same fields as every other record in that table so aggregating or filtering all the information is straightforward. Furthermore, with relationships correctly defined, it's similarly easy to group and find related data.

Lots of systems exist for creating databases, and most of them are designed to be collaborative without any reliance on the Cloud. The main draw to using a so-called Cloud database, such as Google's Cloud SQL (cloud.google. com/sql) is that you don't have to worry about all the setup and maintenance from an IT perspective. However, these provide only a "back-end"

to a typical database application. This means they provide a way to structure and store data but no "front-end", or easy way to allow for editing and displaying the data. This means that significant time and expense must be spent on creating these systems.

To counter this, some Cloud services that provide an accessible approach to creating and storing information in a custom database, whilst also providing an easily customisable interface for displaying and editing the underlying data are gaining popularity. Airtable (airtable.com), for example, provides browser- and mobile-based interfaces to create multiple databases, each of which can have different tables, and each of those can have a number of different types of fields created. Best of all, the interface is easy to get to grips with and allows for customisable form and grid views of all the data. Relationships between the different tables can be created in a very free-form way, simply by adding a special type of "link" field to data on other tables.

The problem that remains, though, is that designing and creating a database from scratch is a daunting task even without having to factor in the creation of the front-end. Depending on the specific database system used, this can be difficult from a technical standpoint, but it can also be difficult conceptually. Often a particular structure (or "data model") that seems to make sense initially needs to be changed later on to accommodate different priorities or unexpected limitations. Furthermore, setting up relationships between different types of data can be difficult to get right. Every time a data model needs to be changed, it's possible that the data within will need to be reconciled in some way, which can be time-consuming and complicated.

BOX 10.1 Back to Spreadsheets

As useful and powerful as databases are, particularly when compared to spreadsheets, an interesting side-effect of using them is that it's often useful to dump out data to spreadsheets in a number of situations.

Sorting through duplicated records is one such problem. When there's duplication of data in a database, it can be difficult to reconcile the duplicates easily within the database itself. In this situation, where possible, it's preferable to first export the data and open the data in a

(Continued)

(Continued)

spreadsheet, then filter the duplicates and move or copy information between different rows, before finally updating the main database with the reconciled data.

In addition, it's not a simple matter to just make a copy of a database to give to someone else in most cases. Even in those database systems that do offer a way to make a direct copy of the data, there will typically be lots of additional information (metadata) or structural information that is not relevant to the data you're trying to send. In this instance, it's often a lot easier for the sender and the recipient to just export a spreadsheet and send that.

Hybrid Approaches

As spreadsheets and databases actually have a lot in common with each other, some approaches have been to try and combine the relative strengths of each into a hybrid approach. Fieldbook (fieldbook.com), for example, presents a streamlined spreadsheet interface to users but leverages much of the power of relational databases by allowing links to be established between different "sheets". So you could create a sheet for tasks that need to be done, another for projects, and then have a "project" field on the tasks sheet that is linked to the projects sheet. When you edit one of the cells in the project column, you choose between different projects that are listed on the projects sheet.

Behind the scenes, these systems are maintaining a relational database, but the end-user doesn't have to understand the mechanics to use it effectively. As far as they're concerned, they're just using something like Google Sheets, but with a few extra features. The system even retains familiar features from other spreadsheet applications, such as creating formulae and filtering and sorting.

Whilst these approaches may be suitable for collating data together quickly and informally, they can be considered too generalised for more overarching scenarios. Spreadsheets, for example, are a great way to build a list of episodes in a television series, along with specific information like the air date or running time, and a database could be constructed quickly as a way to log footage for every episode; however, neither of these approaches are designed to have any "business logic", that is, some understanding of what

each piece of information is from a practical perspective or how they might all fit together to lead you to the successful completion of the production. For that, a more specialised approach is needed.

Industry-Standard Production Tracking Systems

As the Cloud matures, an increasing number of tracking systems are emerging, each of which may be tailored to meet specific business needs. Numerous such systems exist for the software development industry, and other industries such as construction are embracing the Cloud, with tracking solutions catering specifically to their best practices and methodologies. Fortunately, the film and video production industries also have a number of specialised tracking systems available.

Autodesk's Shotgun (shotgunsoftware.com), for example, is aimed squarely at the visual effects and animation industry. Because of this narrow focus, its customisable database comes predefined with fields, tables, and relationships already set up in a way that works well for those industries. This leads to less time spent trying to map out how the data should fit together and allows users to enter and find information right away. Furthermore, emerging industry trends are able to be anticipated and folded back into the system's design, which can result in the system actually nudging users into a more streamlined approach in their day-to-day work.

For pre-production, systems like Production Minds PMP (production minds.com) might be a good fit. Things like scenes and shooting locations are predefined in the system, which also has some understanding of how they relate to each other. This makes it easy to add information that's relevant and provides structure for people who view the information later on. It also means that common processes like script breakdowns (and revisions later on) are factored in to the system, so there are tools that help manage those processes.

There's something of a paradox in using systems that are designed for specific purposes, which is that they can be both less flexible and require more training to use. With well-established systems, this may be less of an issue; if a particular system is considered to be an "industry standard" then it is expected that many people within that industry are well-versed in how to use it, but with many of the emerging Cloud-based systems that won't always be the case. The lack of flexibility can be made up for if the system

offers integrations with other systems (or, ideally, an API, though this will likely require some technical expertise to make use of) or there's at least a way to "round trip" (export, edit, and re-import) data somehow.

TRACKING INFORMATION IN THE CLOUD

Regardless of the system used to actually store information, there are a few steps to consider on every production, in order to capture all the useful information whilst not draining resources in the process and, ultimately, in order to make the process worthwhile. The details will vary depending on the type and specific make-up of each production but, broadly speaking, there's three aspects to tracking information in the Cloud: capture, organisation, and analysis.

Capturing Information

Lots and lots of information is generated at all stages of every production. Some of it is relevant only for a certain amount of time (such as how many sheets of paper the art department needs on a particular day), and each bit of information varies in overall importance (how much of the budget is being used by a particular shot), but for an ideal system that can capture any information, there are two crucial questions: how easy is it to capture this information (what's the cost of capture), and how much is this information worth (what's the value of the capture)?

Figuring out the relative value of any information is inherently problematic. Often there's no way to know whether a particular piece of information will prove useful at some point in the future. Something that might appear to be an unimportant detail at the time (such as the fabric used in a particular costume) might hold great value later on to someone else (such as a visual effects artist trying to animate a digital re-creation of that costume). Experience will help, of course, but it's not always possible to anticipate every single thing that might prove useful, especially when a large number of people are involved and there's the pressure of time.

The ideal tracking system, then, instead ensures that the cost of capture is always low enough that the value doesn't really matter. Going back to the costume example, if the designs and associated notes were created in a digital format, then the process of capturing them merely involves copying

them from one location to another, and possibly doing some format conversion. With a sufficiently streamlined Cloud-based system, even that might not be necessary. If the costume designer is storing his or her designs and notes on the same Cloud-based system as everyone else in the first place, no copying or conversion would be needed.

Indeed, productions that are fully committed to using the Cloud will likely have an easier time capturing absolutely everything. The Cloud loves to store information in its various forms, whether chat messages or digital images, and with the proper automation and integrations in place, even completely separate Cloud-based systems can automatically share information.

For processes that aren't (or simply can't be) Cloud-based, it's still possible to capture useful information. As discussed in chapter 7, paper documents can be scanned to create digital counterparts. Optical Character Recognition (OCR) can be used to extract text from scanned documents. Recorded audio can be digitised to audio files that can be played as needed or even sent to be transcribed, again extracting text that can be easily copied and pasted elsewhere, or at least providing an additional, searchable source of information.

Files that begin their life in a digital format will likely be a mine of hidden information. Most notably, media files from digital cameras typically contain a great deal of "metadata", or additional information, about the media. This metadata might be technical information such as the colour space of the file, or photographic information such as the shutter speed used, or it might even be information like the time and date and location the media was captured. Crucially, all of the data were created automatically without the photographer actively doing anything other than take a picture, and all of the data may be captured and put somewhere else, like a database or other system.

BOX 10.2 Digital Clutter

With the convenience of being able to keep everything ever recorded in a digital form, particularly when it comes to the Cloud, comes the problem of clutter. Information may not occupy physical space, but it

(Continued)

(Continued)

still has some form of representation. In a digital folder containing only a few files, it can be easier to sort through and find something specific, as well as "discover" items you didn't necessarily know about that become of interest. As more files are added, both finding specific things and discovery of interesting items becomes much harder.

This can, of course, be rectified by several things, like more sophisticated search processes that infer context better (such as how Google is able to—in theory at least—present the most relevant pages out of potentially millions), but also more considered, hierarchical organisation of files, making it easier to zero in on specific files. As Cloud storage and document management systems mature, we'll likely see greater development in this area, along with benefits like having things automatically categorised by their properties (for example, documents related to a specific scene might be recognised as such and filed away accordingly, becoming visible only when browsing or searching for documents related to that scene).

For now, though, the best approach is likely to be a well-defined, hierarchical folder structure, coupled with practices such as moving data and files into digital archives as needed, so there's always direct access to potentially relevant information only.

Organising Information

Though there are several ways to organise digital information on most systems, whether they be files on a computer, documents in Cloud storage, or even mobile apps on a mobile device, the most readily available is the "folder" metaphor. In the simplest terms, a digital folder acts like its real-world counterpart, as a container for things that can be individually labelled, and whose primary purpose is to reduce chaos by collecting similar files together. Folders are a very intuitive and straightforward way to allow users to organise files, both conceptually and visually.

Where the folder paradigm really shines is when there's the ability to put folders within other folders. With this seemingly innocuous improvement comes the ability to create "hierarchical" systems of data. A hierarchical system can be thought of as a tree, with each "branch" leading to further branches. Just as a book might contain chapters, with each of those chapters containing paragraphs, then sentences, and so on, a hierarchical structure

allows for very broad categorisation to present information in a way that "funnels" complexity, and gradually becomes more specific. For example, the highest level of a hierarchical structure might represent the entire production of a television show; this then has branches (or "sublevels") for each season, and then again for each episode. Then each episode might have its own hierarchy, with sequences, then scenes, then shots, and so on.

Hierarchical approaches to organisation of data have a great number of benefits. They're almost universally supported to some degree across different systems, and they're easy to establish. Furthermore, people seeing a hierarchical structure for the first time will usually be able to find what they need simply by browsing through the structure, assuming they have enough prior knowledge on the subject matter and that the structure matches their expectations.

BOX 10.3 Master-Detail Representations

There are a few approaches to presenting data, whether a collection of documents, or simply information stored in a database. Perhaps the most recognisable approach is the "master-detail" model. Most recognisable across mobile devices, where screen real estate is limited, the master-detail view presents either a "master" view of a list of items (such as a list of camera lenses), each of which may be individually accessed to display a screenful of "detail".

With this type of approach, it's possible to reduce the amount of information on a display at any given time, which can be critical for smaller displays. However, such an approach has other benefits, as it reduces the amount of information the viewer needs to process at one time, in much the same way as organising files into folders does. As the Cloud matures, there will likely be a shift from helping people get information into to the Cloud, to making processes that require using or finding that information more efficient. A reduction in the amount of information presented to people at any time will be a critical part of this, but there will need to be a careful balance struck between reducing the information presented and making people work too hard to get the information they need.

Hierarchical data structures do have some drawbacks, however. First and foremost is that an item can only really exist at one point in the hierarchy. Any data that are effectively shared or split between two different things need to be duplicated in order to be correctly categorised. Secondly, hierarchical structures should be rigidly defined. Shots belong to scenes, and so on. But for certain types of information, such well-defined categorisation isn't suitable. When defining concepts for a new production, for example, the information produced cannot be so clearly classified. Should a particular piece of concept art be tied to a specific scene or a character? Having to try to fit ideas into a predetermined framework in this way can break the flow of the creative process.

The popularity of systems such as Trello (trello.com), that offer looser, less formal data structures (with Trello, users simply create individual "cards" that can be freely moved between "lists") are a testament to the need to use a different approach on occasion. But other "taxonomies" (systems of classification) also exist. "Tagging" is one such example. With tagging, one or more labels ("tags") are applied to a piece of data. For example, a document relating to the safety considerations of the shoot of a particular scene might be tagged with things like: "safety", "scene 45", "stage B", "production management", "location", and so on.

With a system based on tags, it becomes possible to retrieve related information based on a particular topic. Looking at everything tagged with a particular character might yield a number of different documents or data points in one go that might otherwise have been split across multiple branches in a hierarchical system. Furthermore, it would be possible to zero in on more specific information by considering multiple tags, for example, looking at everything that contained the tags "set decoration", "opening sequence", and "finance".

Undoubtedly the biggest drawback to tags is that they aren't readily available, and they aren't very portable. Modern desktop operating systems have only recently started to provide the means to use tagging with documents, and in the Cloud there are perhaps even fewer options. Overall, the concept is not as familiar to people as with file and folder structures, and it will likely be many years before tagging of files becomes a common practice.

When transferring data between systems, it's likely that there will be some way to preserve a hierarchical structure, particularly with folders which are

well supported, but there's little chance that the same can be said for tags. Being free-form, it can also be difficult to determine in advance which tags might be suitable or even necessary for a particular piece of data, and so the incorporation of a widespread tagging system can mean that previously tagged information has to be updated to include new tags periodically, to ensure it stays relevant.

BOX 10.4 Reclassifying Data

As tempting as it might be to switch between different approaches to organising data, there's a point where doing so should be treated with caution. If you already have hundreds or thousands of files or records stored in a hierarchical system, it can be an extremely daunting task to attempt to introduce a tagging system without backtracking through all the previous data and painstakingly applying the appropriate tags to each.

Even where it's possible to devise a system of translation between systems, such as having files tagged based on their location within the hierarchical structure (so documents within an "approved scripts" folder might be converted to contain the tags "approved" and "script"), this will likely paint an incomplete picture later on and not provide the same benefits had the tagging system been used from the outset.

Due to their limitations, the best use for tags is within a closed system, where there's no concern that vital tagging information will be lost when importing or exporting data. This means that tracking systems and comprehensive production databases become good candidates for using tagging systems, as places where tags can be defined alongside other data being created, as well as being the place where people might make use of tags to quickly find particular things.

With the collaborative nature of the Cloud, tagging becomes a much more viable and attractive proposition. Rather than relying on someone to add applicable tags themselves at the point of creation, tagging information in the Cloud can be done in a more iterative way. Initial tags are added and then as other people edit and access particular things, they can add more tags. Such collaborative tagging can enrich the tracking process, whilst spreading the workload

amongst a high enough number of people as to not make it be a chore. Similar approaches have been demonstrated across a number of social media platforms, for example, where a person is able to tag other people's images.

As the Cloud grows and is used to store an increasing amount of information, it might become apparent that there's no single approach that will work well in every situation. Approaches that combine both tagging and hierarchical structures might prove superior to more traditional folder-like structures, as well as things like allowing a file to exist in multiple folders simultaneously. Tags might be used to help with searching for things, so searching for "costume" should find items with the corresponding tag applied, but search algorithms could be made to be more interpretive, so that a search for "costumes" would yield items tagged with "costume", as would "wardrobe", without anyone specifically adding those tags. One thing's for sure, though, the more data get uploaded to the Cloud, the more opportunities there are to analyse and summarise what's there.

BOX 10.5 Smart Folders, Smarter Tags

In addition to allowing users to create their own folder structure and copy or move files between them, some systems also allow for "smart" folders. These are special folders that don't directly store files, but instead have some rules or logic defined, and then display the files that match these rules. For example, a smart folder might be set up to show files created during the past week, that is an image or movie, and that contains "draft" in the file-name. Any new movie or image files that are created with the word "draft" would then show up in the folder and stay there for one week.

Smart folders can be an effective way to get around some of the limitations of traditional folder structures, and although the concept has not yet gained much traction with Cloud storage providers, it's possible that it's functionality that will start to appear in the near future.

Likewise, it should be possible to apply specific tags to things based on other properties, or triggered through specific events. Files that originate from a specific location could have predetermined tags applied, or tags could be applied based on the rules concerning the contents of the file, or if, for example, a specific person had accessed it.

Analysing Information

Once there's enough information available about something (or collection of things), it may become useful to perform some sort of analysis on it, whether to get summaries of different aspects of it, such as how many takes were recorded in a given week; perform comparisons, such as how this week's shooting compares to the previous week; and more complex analysis like identifying trends or making predictions, such as how much longer the shoot is likely to need.

Some of these things will be easier than others, but one thing is for sure: having information collected together in one place makes it easier to do. As more focused industry-standard tracking systems mature, there will likely be a greater possibility for more useful analysis to be available directly via those systems, without needing to dedicate significant resources based on specific requirements. Either way, it will be much easier to, for example, analyse costs for different things when there's a single place from which to export a spreadsheet of all relevant financial data.

PROGRESS TRACKING

Something every production, regardless of size, needs to track is progress. The complexities of film and video productions mean that they need to be broken down into smaller parts, though how finely the production gets sliced up will likely depend on the overall size of the production and how many people are involved. The smallest productions will likely only want to track individual scenes or sequences, whereas larger productions might need to track each potential shot and then divide those into an even greater number of subtasks to be tracked separately.

A number of things will help to streamline this process. First of all, consistency should be a key factor. If every shot in a production needs to be subdivided into smaller tasks, it should be the case that each shot largely has the same subset of tasks as for other shots with similar requirements. In the production of an animated film, for example, there might be fairly consistent requirements from shot to shot, such as needing to have animatics, backgrounds, ink and colour passes, and visual effects. Each of these tasks might have dependencies, and as such those dependencies and requirements should also be consistent across shots.

Each task (or subtask) should also have some way to identify its current status. On a spreadsheet, this might be done by placing crosses in various columns to show the task's progression to completion, whereas a database might instead represent this via a dropdown of different statuses. Whatever the particular approach used, it should be consistent so that this information can be filtered or summarised later as needed.

The Cloud provides one huge benefit when it comes to tracking. Rather than have a single person responsible for maintaining a list of tasks and ensuring the information is current, instead each individual can submit updates for their own task status. Instead of, for example, an animator sending an email to a producer that they've completed the animation of a particular shot, and the producer then having to update their system, the animator could simply access the spreadsheet or database directly and update the information themselves, making the process more immediate and less likely to be prone to errors (due to ambiguous or missed correspondence, for instance).

Errors could be further reduced by building in validation and logic into the system. For example, the system could be set up such that people can update statuses only for things they're listed as working on. Taken a step further, automation could be designed into the system such that if someone submits a file named a certain way, a corresponding status somewhere is updated automatically.

Where tasks are organised in a consistent way, it becomes much simpler to get a sense of the bigger picture. In most systems it would be reasonably simple to calculate the percentage of tasks that are complete, where those tasks all use the same field or column to relay this information. With the Cloud, the information is available immediately and constantly, so all someone has to do is access it to find out what the overall status is, which is much more preferable than having to request the information and have someone generate and then send back a report (though in some situations it can be useful to maintain such a buffer).

AUDITING

Less important perhaps than tracking progress, the need to audit updates can be important, particularly on larger productions. In the context of video and film production, auditing mainly serves two purposes: recording anything

that happens to the information (when it was accessed and by whom and what changes might have been made) and validating that the information meets any specific criteria for compliance or security requirements.

Most Cloud-based systems have some form of auditing built-in. For example, Google Sheets records all changes made to each spreadsheet, as well as when those changes were made and who made them (there's also the ability to restore a spreadsheet to the state it was at a particular point in time). Most databases will at least note when a specific record was modified (and who modified it), but some go as far as keeping records of every change that was made, in a similar manner to Google Sheets.

POPULAR CLOUD PRODUCTION TRACKING SERVICES

Google Sheets (docs.google.com)

> **Pricing:** free

> **Features:** formulae, charts, sharing, revision history, browser-based, mobile, API

Google Sheets has been around for quite some time, and as such represents a mature system for working collaboratively on spreadsheets. Changes are saved automatically, with each revision logged and able to be restored to become the current version. There is a robust set of options for sharing spreadsheets with others, and it's possible for multiple people to edit a spreadsheet simultaneously. Google Sheets is also unique compared to other Cloud-based spreadsheets in that it offers an API.

Apple iCloud Numbers (icloud.com)

> **Pricing:** free

> **Features:** formulae, charts, sharing, revision history, browser-based, mobile

Apple's offering for Cloud-based spreadsheets has roughly the same set of functionality as Google Sheets, although it's perhaps not as popular. Native desktop and mobile versions are also available for running on Apple devices.

Microsoft Excel Online (office.com)

Pricing: $7/user/month

Features: formulae, charts, sharing, revision history, browser-based, mobile

Although Microsoft's prominent spreadsheet application isn't free like the Google and Apple equivalents, it does come bundled with other applications in the "Office" suite, as well as 1 TB of Cloud storage and native mobile and desktop versions. In all other respects it is mostly equivalent to other online spreadsheet systems but does have the edge in terms of its formula and charting capabilities.

Google Cloud Datastore (cloud.google.com/datastore)

Pricing: free, $0.18/GB/month and $0.06/1,000 transactions

Features: managed NoSQL database, API

Google Cloud Datastore provides a means to store and retrieve any type of data in a scalable, non-relational way, although it can be accessed only via the API. It can be used for free up to certain limits, at which point it is charged out per usage.

Amazon DynamoDB (aws.amazon.com/dynamodb)

Pricing: free, $0.25/GB/month and from $0.0065/hour for transactions

Features: managed NoSQL database, API

Functionally identical to Google Cloud Datastore but with a slightly different pricing model. There's also a free version that can be used up to a certain limit.

Google Cloud SQL (cloud.google.com/sql)

Pricing: from $0.01/hour

Features: managed MySQL database, API

Google Cloud SQL provides a scalable relational database, with price based on usage and hardware configuration required. Using it means you don't need to worry about maintaining the hardware or software environment; however, there is no front-end, and as such requires technical resources to make the best use of it.

Microsoft Azure SQL Database (azure.microsoft.com)

> **Pricing:** from $5/month

> **Features:** managed SQL database

Microsoft's managed database is probably the most complicated to get started with and has all the same caveats as Google Cloud SQL in that it requires a front-end to be built specifically for whatever you need to do with it.

Amazon RDS (aws.amazon.com/rds)

> **Pricing:** from $0.017/hour

> **Features:** managed database, API

Amazon's managed relational database offering is unique in that it provides a number of different database technologies to choose from across a number of different hardware configurations.

Fieldbook (fieldbook.com)

> **Pricing:** free, $10/user/month

> **Features:** formulae, grouping, sharing, relational links, browser-based, mobile, API

At first glance, Fieldbook is similar to Google Sheets but with fewer features (there's no charting or revision history currently). However, the important distinction is that it allows for "linking" data between separate sheets, providing an easy way to create relationships between different things. There's also the ability to easily group and filter different things in an intuitive way. The only difference between the free and paid version is priority support and access permissions.

Airtable (airtable.com)

Pricing: free, from $12/user/month

Features: formulae, sharing, relational links, browser-based, mobile, API

Airtable provides the ability to create relational databases quickly and easily. There are a number of features for power users, such as calculated fields, and it's possible to generate forms for others to fill in. The main downside is that there are caps to the number of "rows" (records) each database can contain, which might be an issue if you've got a lot of data to work with.

Fusioo (fusioo.com)

Pricing: $12/user/month

Features: formulae, charts, sharing, relational links, browser-based

Like Airtable, Fusioo enables users to build relational databases with ease. Though lacking in some of the features Airtable has, such as an API or mobile version, it allows database designs (referred to as "apps") to be shared amongst the community to be used as starting points. While there are no published limits on the number of records allowed, there's a limit of 30 fields per database, which is probably insufficient for many cases.

Production Minds PMP (productionminds.com)

Pricing: $20/month (up to 4 users), $99/month (up to 10 users), $299/month (up to 20 users), $499/month (up to 40 users); additional storage costs apply

Features: scheduling, review and approval, reporting, archiving, browser-based

Targeted specifically to the pre-production phase, PMP aims to manage everything from script breakdown to casting and scheduling for shoots. However, it is lacking in advanced features like an API or any integrations, and as such is heavily reliant on import and export to spreadsheets.

Shotgun (shotgunsoftware.com)

Pricing: from $30/user/month

Features: scheduling, grouping, sharing, revision history, review and approval, relational links, permissions, browser-based, API, desktop review software

Primarily targeted to the visual effects industry, Shotgun has been gaining adoption amongst film and video production in recent months. It boasts a good number of customisation options, as well as integrations with several desktop applications. Limited functionality is also available via the "Shotgun Review" mobile application.

Ftrack (ftrack.com)

Pricing: from $25/user/month; additional storage costs apply

Features: scheduling, grouping, sharing, review and approval, relational links, permissions, browser-based, mobile, API

As with Shotgun, Ftrack is aimed primarily at the visual effects industry but is starting to target more of the production process. It also features an API and integrations, as well as automation through the use of "actions", customisable modules to perform certain tasks, and built-in support for time tracking.

11

Asset Management

"Human beings do things for a reason, even if sometimes it's the wrong reason."

—Tom Hanks

With the ability to store and track a large amount of information and files in the Cloud comes a greater need to impose clarity and standardisation to everything. A concept artist working with a pencil and sketchpad is responsible for keeping some form of filing system so he is able to locate particular pieces as requested, even if the details of the filing system are indecipherable to other people. Transitioning to a digital medium, the same artist might be concerned with following a particular naming convention so that artwork can be properly identified when sent to others in batch. Even so, the artist can otherwise organise everything on a laptop or desktop computer as he pleases.

The same artist working in a Cloud-based environment would likely have to follow many more protocols about where different files are stored, how metadata are recorded, and so on. The transition in giving up the ability to work in a more free-form way can be frustrating for people on all sides but ultimately lead to clearer communication and greater transparency between people and processes (it's also interesting to note that the proliferation of the

Cloud is also enabling a shift in the computing sphere as people are increasingly using mobile devices as their primary computer, a change which many are finding difficult to endure). The trade-off here means that artist can (in principle at least) spend less time fulfilling requests to see specific work—instead people can just get whatever they need directly.

Similar transitions are happening with other roles throughout productions. Where previously assistant directors were producing daily reports with pen and paper, this process become electronic, with them adopting spreadsheets or template forms that could instead be emailed. Soon, the reports will be stored on the Cloud rather than emailed out, and eventually the information will just be entered directly into a Cloud-based system.

With the expansion of these processes, the need for a dedicated "digital asset manager" becomes greater, someone to ensure that information is accounted for, and that it is organised in a coherent way. Where such a person is not available on a digital production, particularly on a large production, it can be much harder to ensure materials are easily located and accounted for, particularly in the long-term.

ORGANISATIONAL STRATEGIES

The nebulous nature of the Cloud can make it more challenging to manage digital assets in the long-term. Approaches that previously worked well, be they notepads or customised databases, might not fare so well in a Cloud-enabled production, where a vast amount of information is stored together and accessible by many people.

The following are some common approaches to digital asset management that have been found to work successfully in the more collaborative environment of the Cloud.

Breakdown of Scripted Productions

Although the most obvious way to break down a screenplay or teleplay is by scene, this might not be recommended (as far as digital asset management is concerned) early on in the production process. It's common for scripts to change right up until principal photography (or even past that point in some cases), with scenes added, removed, or re-ordered in the process. Although

there are conventions to minimise the resulting complexities of such changes, for example, adding new scenes with a prefix to prevent having to renumber others (so that a new "A22" scene would be inserted between scenes "21" and "22"), in practice this isn't always the case, particularly if the rewrites are significant.

What this means is that assets might be simply attributed to "scene 30" early on, but after a rewrite, the new scene 30 is actually a different scene. Depending on the system used for tracking digital assets, they might simply be listed under "scene 30" (or perhaps in a folder on a disk called "30") and now have no direct connection to the correct scene number. For these reasons, it can be beneficial to break down story elements into more encompassing "sequences" instead. A sequence can be thought of as a group of scenes that tells a specific part of the story, even if the shooting location may change a number of times within it. A good example is a "chase sequence" in an action movie, which might span a number of scenes and locations. In this way, people would know to look for information about a particular vehicle or prop, for example, within this sequence, rather than having to know which particular scene it was associated with at the time.

Categorisation

One of the most important things that should be done with any digital asset is to assign it to a category in some way. A digital photograph might be captured by set decoration, for example, and sent over with a filename to at least indicate the sequence it belongs to (or, as is often the case, some generic name such as "DSC_0423.JPG"), but for the sake of posterity one of the most helpful things that can be done is to identify a broad range of categories that the image could fall into (for example, does it relate to a specific prop or to the overall set?) and store it accordingly. Perhaps the simplest and most intuitive way to do this is through a series of folders, so that, for example, all images for props go into one folder and images for vehicles into another.

Subcategorisation should also be considered (for example, in the form of folders within folders), so that, for example, "props" might further be classified as "weapons", "furnishings", and so on. However, the danger here is in having too much dependence on categorising things such that there might be debate as to how a particular thing should be categorised. Should a kitchen knife be considered a "weapon" or a "utensil", for example? A good

FIGURE 11.1 Categories and Subcategories

rule of thumb is that if there's any doubt as to what something should be when trying to categorise it, it will likely be much harder to find in a given category later on.

BOX 11.1 Leading with Zeroes

How assets are named is extremely important to being able to identify what they are in a digital environment. It can take a lot longer to browse pages and pages of digital documents to find something specific compared to leafing through pages of printed reports, unless you have the ability to search for specific keywords, or otherwise know where to find something, in which case searching digitally becomes much faster than doing it physically. For more abstract files, such as digital images, there's no good interface to identify what it is other than to view it, unless it is named in such a way that the filename (or the context of the enclosing folders) provides identification as to the content.

For this reason, it can be important to establish "naming conventions" that should be used for specific types of files. For digital concept art, for example, it can be useful to include what the subject of the image is in the filename (such as "wine glass close up 1.jpg"), whereas for movie files for camera footage it might be useful to include the slate and take number (such as "101A-3B.mov"). Whatever conventions are devised, it can be important to agree on a system where numbers are "padded" with leading zeroes as appropriate.

(Continued)

(Continued)

What this means is, if something should have a number, such as for something that needs to be identified as belonging to a particular scene, instead of just numbering it as you'd write it down (such as "scene 4"), you make sure that there's always a specific number of digits (typically based on whatever the maximum number would be). So for a shoot with 120 scenes, for example, you'd want to make sure that all scenes have three digits, and that any with fewer have leading zeroes (so, for example, instead of "4", "72", and "102", you'd have "004", "072", and "124").

Why this can be important is so that when they are displayed in a sorted list, they appear in a way that makes sense. Consider the following list of scene numbers, as they would be sorted in most computer systems:

- ► 1
- ► 10
- ► 100
- ► 2
- ► 21

With three-digit padding, the list would sort in a more natural way:

- ► 001
- ► 002
- ► 010
- ► 021
- ► 100

Tagging

One of the problems with categorising items in this way is that there are occasions where it would be useful to associate something with multiple categories. For example, a single file might fit the categories of "set decoration", "photo", "reference", "tunnel sequence", "pipe", "weapon", and so on. Trying to convey all that information through a structure of categories and subcategories can become cluttered and ultimately defeat the purpose of doing so in the first place. In these situations, using "tags" can be a better fit.

Tags (or "keywords") are free-form words or short phrases to attribute something to an asset. The most important aspect to using tags is that any item can have multiple tags, and they do not need to conform to a particular order—all tags are considered equal. The strength of tags is when you need to find something later on, you can search for items "tagged with" a particular tag, for example, "weapon" and see everything with that tag, regardless of where it originates. It's also possible to search for things that match a set of tags, such as "yellow" and "clock".

With such a powerful approach come drawbacks, however. As tags are free-form, there's no easy way to enforce convention. You can't, for example, ensure that all photos are tagged as such (except where tagging is combined with some form of automation, that identifies key properties about something and adds tags automatically), meaning that whoever is responsible for adding tags to items remembers to do so, which is not as easy as, say, choosing which one of five folders to put a file into. Furthermore, it can be a very manual and time-consuming process to add the requisite tags in the first place, particularly if there's not someone dedicated to the task in the process. Finally, tags may be lost when moving data between systems. For example, tags on files created on the Windows operating system are lost when copying them to a Mac system (and vice versa), or if uploaded to Cloud Storage. That said, when tagging is first done within a primary Cloud storage system, or within a Cloud-based tracking system, the benefits persist for the duration the system is used, which is often long enough.

FIGURE 11.2 Categorisation through Tagging

BOX 11.2 Everything Is an Asset

As more aspects of the production process become rooted in the digital world somehow, more things can be thought of as digital assets (and thus, there become more things to track). It's easy to consider reference material that exists in a digital form as an asset, but what about reports saved as PDF files? Camera tests exist as digital media somewhere, as might things like table reads or hair and make-up tests. Many of these might have little long-term values, but then as discussed in chapter 13, if there's capacity to store something in the Cloud, it might be better to do so than not.

As the capacity to store assets increases, so does the importance of organising them in an effective way to ensure that people are able to find things as easily and quickly as possible. This can mean having strong organisational policies in place, such as by making use of clear categorisation, but it may also mean taking steps to ensure irrelevant assets don't clutter lists of results. One such approach is to "archive" older materials by moving them out of the main production workspace, or it may mean curating search systems to filter out certain items as time goes by (whilst still providing *some* means to find such items if they are really needed).

Version Control

One of the trickier problems of asset management is version control: the process of managing different versions of a particular item. This is perhaps most obviously applicable to the work that art departments do, which can undergo many iterations and changes on a single piece of concept art or costume. However, it extends to almost every facet of a production. A single "take", for instance, could be considered a version of a shot, and similarly the "final cut" of a production will likely represent only one of many, many versions of the work done by the editorial team.

Perhaps the most crucial thing to appreciate about version control on any creative endeavour is that all the interim versions are important to keep in the process of getting to the final ones. It can be helpful to compare changes between different versions of the same thing, and there might be occasions where a version that was previously thought to be inadequate proves to be

more desirable than chronologically newer ones as time goes by and sur-rounding context changes.

The Cloud loves to automatically version things. Cloud storage services such as Box (box.com), for example, will automatically track as files are changed, storing a history of each version of a file that was changed (along with the ability to view those at specific points in time). Some systems such as Google Docs (docs.google.com) even track changes made to a document as they happen, generating multiple versions, and allowing every revision to be viewed or reinstated at any time (in many systems, even the act of restor-ing a version itself constitutes making a new version, so you can restore older versions without fear of permanently losing any recent work). Many of the systems for review and approval (as discussed in chapter 12) allow for sophisticated comparison of different versions, such as viewing multiple versions side by side or allowing for switching between them in context.

Integrated Systems

The ultimate asset management system is the one that's fully integrated with every other aspect of the production. Such a system would allow artists to sub-mit each version of their work and have it tracked, reviewed, and approved throughout the production's duration. Others would be able to easily find their work and be confident that they're looking at the correct version. They could find any related materials as needed and build on it, completing the production with access to what they need and clear lines of communication. Even after the production wraps, assets can be easily located, gathered, and archived.

Although these seem like lofty ideals, many systems exist that are helping to make this a reality. SyncOnSet (synconset.com), for example, provides asset management functionality for the duration of a shoot, with breakdowns, inventory tracking, and reporting all integrated. 5th Kind (5thkind.com) extends this by allowing digital assets to be stored and tracked in the Cloud and then subsequently reviewed and approved in the same system.

MANAGING LOCAL ASSETS

In every production, even those that have fully committed to using the Cloud as much as possible, there's a need to manage "local" (or "offline") digital assets. This might be when working with external vendors, or in situations

FIGURE 11.3 Tracking References to Local Assets in the Cloud

where there's not a reliable Internet connection to facilitate transfer of files to and from the Cloud, or even where it just doesn't make sense to use Cloud storage (for example, for a high volume of data that's useful only to a single person). In any of these circumstances, it can make sense to just work with files outside of the Cloud environment.

However, there are still gains to be made by tracking references to the whereabouts of such material in the Cloud. For one thing, it provides some auditing of the existence of the material and allows for additional metadata to be tracked and collated. For another, it allows different versions to be tracked, along with notes about the differences between them.

Moreover, it gives rise to the ability to automate certain processes through the Cloud. For example, during the "turnover" process that visual effects teams must go through on effects-heavy productions, a large quantity of files (containing material, reference material, and metadata related to an individual shot) are requested from different sources, collected, and submitted to visual effects facilities in batches. This is a time-consuming process and one that is costly if errors are made (and is reasonably error-prone on account of how much manual work may be involved). But in a Cloud-enabled process, even one where the requisite files are not available in the Cloud, the references to the files can be, allowing the visual effects team to just build a shot list and have the system compile a list of corresponding assets required. More sophisticated workflows might also automate the process of requesting the transfer of materials or even retrieving and transferring the files as part of the turnover process.

FIGURE 11.4 Automating the Turnover Process with the Cloud

BOX 11.3 Version Control for Local Assets

One of the problems with using local assets is tracking them through multiple versions. One effective, albeit low-tech, approach is to identify the version of the file in the filename. So a third draft of a piece of concept art for a character might be "wolfman concept v03.jpg". This approach avoids ambiguity and can be used in tandem with a Cloud-based tracking system that would simply need to note the current version number for the file (or perhaps a list of all versions of the files with pertinent information about each one).

As the Cloud matures, the need to have local files at all will diminish. But for productions that aren't ready (or are unable) to take full advantage of the Cloud, some systems try to provide a bridge between traditional approaches and Cloud-based ones. For example, The Foundry's FLIX (thefoundry.co.uk/products/flix) allows management of locally created storyboard images, but allows them to be versioned and organised through in the Cloud, adding collaborative functionality to the process, but without requiring a dedicated digital asset manager to be involved.

MANAGING PHYSICAL ASSETS

In a similar way, it's possible to track references to physical assets in the Cloud too. This might be camera and lighting equipment or props or vehicles. These are all things that can be important to track not only for inventorying purposes

but also because they are frequently moved from location to location. Something like a camera, for example, can be important to keep a record of right through to post-production, where it might be useful to identify which footage was shot with a particular camera, as well as having easy access to other information about the camera, such as the model and accessories used.

Tracking physical assets is typically done by giving them a barcode (or QR code, which allows more information to be encoded), which can be scanned to easily find the relevant item in a tracking system, or even a dedicated inventorying system, such as GoCodes (gocodes.com). For more valuable assets, it might even be worth fitting a GPS tracker, which can continually broadcast the item's location.

12

Review and Approval

"It is our choices that show what we truly are, far more than our abilities."

—J. K. Rowling

One of the key factors of any production is decision-making. For the production of Pixar's *WALL-E* (2008), director Andrew Stanton claimed to have to make a decision every three and a half minutes. For directors and supervisors, reviewing work is both necessary and time-consuming. For everyone else, it's about the feedback they provide. There are a few crucial pieces to the process then. First there's the ability to collate and organise review sessions so they happen in an efficient manner. Then there's the presentation of the material itself, the recording of feedback, whether in the form of notes for further improvement, or an acknowledgment of approval. Finally, all that feedback needs to be relayed back to the appropriate people. Fortunately, the Cloud can make all of this effortless.

PRESENTATION

The biggest part of the review process, at least from a technological standpoint, is having the means to view something. Over the years this process has evolved from making prints of developed photographic negatives and

projecting in a screening room, through "dubbing" (making copies of) videotapes for playback on a monitor, to sending digital movie files for display on anything from a digital cinema projector to a mobile device. The range of options has certainly increased, but with it comes the problem of compatibility.

Not all devices for viewing digital media are alike. This year's iPhone might have a different colour profile, a different resolution, a different aspect ratio, and different playback capabilities from last year's, and that's for a single type of device by a single manufacturer. There are many different devices, and while there's a great deal of crossover between them, it's impossible to create a single movie file that will play back optimally on all of them.

The other issue is one of delivery. Though it's extraordinarily easy to make perfect copies of digital files, it can still be challenging to get them to the right people, or even more challenging to get them onto specific devices. It is relatively simple (although questionable from a security perspective) to email a copy of a movie as an attachment on an email, at least until you run into attachment size limits, spam filters, and so on. Then if the recipient wants to view it on a device that won't play the file you sent, you've got a problem. Even where things like FTP servers are used, the recipient still needs to get the file from the server onto their device.

With the Cloud, all of these issues become less of a problem. As will be discussed in chapter 13, the Cloud effectively provides a layer of abstraction that means you need only upload a digital video to an appropriate Cloud-based service, and the service will take care of ensuring it is correctly formatted for playback on the device used. It can be delivered directly to a range of different devices, specifically optimised for a particular device. Many Cloud-based services offer playback of video through a browser, mitigating many potential compatibility issues inherent in depending upon specific software for playback. Video can be streamed (played while being downloaded) or downloaded in its entirety and then played.

BOX 12.1 Streaming Media

The problem with video on the web is that the amount of data for video means it can take a long time to transfer across a typical Internet connection. This results in clicking a button to play a particular video

(Continued)

(Continued)

and then having to wait a long time until the video is downloaded and available to play. This can be time-consuming and frustrating.

As a result, another approach is possible, which is to "stream" the video. With streaming, the video can start playing while it is downloading. This makes for a better experience for playback as there are no long delays, but there are some drawbacks. First and foremost, the image quality can be sacrificed in order to ensure continuous playback. Second, because network conditions are not always consistent, a video might start to play smoothly but then become choppy as it can't maintain the same rate of data transfer. Finally, it might not be possible to skip backwards and forwards through a video smoothly, as there's typically an initial "buffering" period (where enough data are downloaded to be able to start playback) before playback can begin, and this buffering must take place again when changing the playback position.

As well as simplifying media playback, the Cloud provides innovative new possibilities for playback. Cospective's CineSync (cinesync.com), for example, allows for synchronised review, in that you can see exactly what other participants are seeing at the same time they see it, making it possible to discuss specific parts of a video live as you're watching it, with someone on the other side of the world.

ANNOTATION

There are many different ways to provide feedback. The most common is in the form of text, as comments or notes on an item. These can be generalised and short or long and detailed. One of the best things about textual feedback is that it can be copied and pasted into a number of different formats. Someone can add a comment to a particular image, and that comment could be included in an email (possibly alongside other comments) with a minimum amount of effort. There are many other benefits to having feedback recorded as text, not least of all that they're searchable and easily edited.

Unfortunately, text isn't always an ideal medium for conveying feedback. Sometimes it's more convenient, or even just quicker, to provide feedback audibly. Someone could be on-hand to record the audio feedback (or a system could capture this audio directly), but then it exists within a file that

can't as easily be distributed, edited, indexed, or searched, meaning people then have to listen to it in its entirety in order to get the message, or to transcribe it for others—all of which takes additional resources. Still, audio notes can convey emotion or context in a way that text can't always do.

A final form of feedback is through visual annotation. Sometimes, drawing a circle over part of an image or a frame from a movie can provide meaningful feedback that would be difficult to convey using text or audio alone. These can be done via low-tech means, such as snapping a photo of an image on a display and then using a mobile image editing app to add the annotation, but several reviewing systems have this functionality built-in.

REVIEW SESSIONS

With larger productions, there might be a lot of material for supervisors and directors that needs to be reviewed. There are only so many shots in a film, but there are many different ways to cut them together. Furthermore, other materials, such as concept art, may not appear in the finished production but will act as a "blueprint" providing aesthetic direction and having a more general impact on everything else. These materials will themselves undergo similar review processes to ensure they provide a clear direction. All of these shots, edits, and concepts will, therefore, undergo the iterative process of creation, presentation, refinement, and distribution.

Review sessions then typically have a dual purpose: first they provide a way to combine many materials and allow them to be reviewed in a streamlined way, thus ensuring everything that needs to be reviewed gets reviewed in an organised manner. The second is to collect feedback for everything reviewed and work out the implications of the feedback. Some items for review might get approved right then, and even though this might mean there's no more work to be done as a result, there still needs to be a record of this approval having happened for tracking purposes (in reality, though, the approvals process might be multi-layered, with several tiers of approvals being required before something is considered finished, such as from the art director and then the director; moreover, having something approved might mean that there's still the logistics of delivering the corresponding materials to have to deal with).

Organising review sessions can still be challenging, though. First, all the items to be included in the session need to be determined. Then an agreed

time and place must be set for the review to take place for all the partici-
pants. Finally, the items for review must be made available to the system
used to display it (where those materials are in a digital form). Feedback
must be collected and then forwarded to the people who need it. All of this
must also be tracked, particularly where there will be a lot of such reviews
taking place during a production. Each of these can be aided by the Cloud
in some way.

Cloud storage (as discussed in chapter 4) can be used to hold all the digital
materials, even grouping them together for specific sessions where possi-
ble. Any of the methods discussed in chapter 6 can help to coordinate the
actual meeting for the review session and ensure a suitable time and place
is decided. Display and playback of review items can be managed by one
or more of the Cloud-based systems discussed in this chapter, and feed-
back can be recorded and relayed using one or more of the communication
systems discussed in chapter 6. Everything can be tracked using one of the
services covered in chapter 10.

However, combining a number of different services in this way is not strictly
necessary. The review and approval process is so common across produc-
tions that a number of dedicated, Cloud-based services exist to streamline
the entire process.

FIGURE 12.1 Review Sessions with the Cloud

BOX 12.2 Ad-hoc Review Sessions

It's tempting to think that with the Cloud, such structured review sessions are redundant. With the Cloud, anyone can join an online review session at any time, from anywhere with an Internet connection. Technology certainly exists to enable everyone to review materials individually, as and when they're ready. Artists could submit their work to a central hub, and at the same time the people who would need to review it could be notified that it's ready and then just access the hub to review it when convenient.

In practice, though, that's almost never desirable. It's much less mentally taxing for supervisors to review things in bulk than on a per-item basis, and it's also easier for support staff to track that nothing has been missed when reviews are arranged around batches of items. In addition, there are usually several people who need to be present in a given review session, and there can be some discussion about various review items as opposed to just having a single person issuing a verdict. The difficulty of trying to schedule people's availability in this way, even if they don't need to be physically present, is high enough that it makes sense to try and schedule a single block of time and get as many items as possible reviewed in that time. In addition, often there will be materials that can't be reviewed adequately online, either due to bandwidth limitations, or due to needing a real-world context to view them (for example, to look at props or costumes or needing to watch shots in full quality in a screening room).

That said, there are situations that make precisely these kinds of "ad-hoc" review sessions desirable. An executive, for example, might not need (or want) to sit in on a review session with a director, or be involved with providing any direct feedback, but might still have a need to see certain materials to get a sense of how the overall production is going. For these types of situations, the Cloud can indeed provide many benefits, not least of all the ability to review items from anywhere they choose.

REVIEW AND APPROVAL IN THE CLOUD

With a single, centralised place to upload and organise digital media for review sessions, collect feedback, and then distribute that feedback as needed, the review and approval process becomes much easier and more

efficient for all involved. A surprising number of such Cloud-based systems already exist, covering a wide range of different needs and review scenarios.

PIX (pixsystem.com), for example, allows various types of files to be uploaded to a central repository, ready to share with others. Reviewers can then provide feedback directly via the system, with notifications generated automatically and sent to whoever needs them. This eliminates a lot of correspondence than would otherwise be needed, such as having to review materials and then resort to email to ask questions or provide feedback, along with the inherent possibility of confusion of which particular item is being referred to with such text-based communications.

Once the basic problems of gathering feedback have been overcome, other possibilities arise, solving problems that would prove challenging in more traditional review environments, but can be tackled in the connected environment the Cloud provides. For example, Screenlight (screenlight. tv) will automatically pause and log the point in a video being reviewed when the reviewer starts to type a note and tracks when a new version of a file is submitted, carrying across previous comments and sending notifications out.

Similarly, Wipster (wipster.io) provides an uncluttered interface for reviewing multiple video files, with all the commenting and visual annotation you might want to empower reviewers with, but without expecting them to learn a new, complicated system. In addition to allowing comments on specific frames and specific parts of those frames, there's also the option for reviewers to reply to each other's comments, making it less ambiguous and more conversational. Once feedback has been gathered, it can then be converted to a series of actionable items on a "to-do list" automatically.

Comparing different versions of media is something that can be rather complicated in more traditional setups, but with systems that have access to everything, and some understanding of how different files relate to each other, more possibilities emerge. Frame.io (frame.io), for example, allows two different versions of a shot to be played side-by-side as needed, so it's easier to determine the changes. Critique (critiquecloud.com) utilises a mobile app to allow media to be available offline, with any notes added while disconnected being submitted automatically the next time there's an Internet connection available.

Other systems go even further, allowing for structured review sessions to be created. For example, Shotgun (shotgunsoftware.com) allows for media to be organised into playlists, which can be shared with others in a similar manner to other systems, but these playlists can also be used to accompany a more traditional review structure, giving coordinators a convenient list of items included in the review with which to quickly add notes and look up related information, such as tasks still awaiting completion, or the notes from previous sessions. This can be completely independent from the system actually used to display the media, meaning that notes can be taken against videos being projected on a big screen from a hard disk drive.

The process doesn't end with approvals either. Systems such as Sony Ci (sonymcs.com) recognise this by enabling the media used for review to be easily consolidated into "mediaboxes", digital packages that can be transmitted to others. This allows recipients to have the full-quality, original media instead of (or in addition to) the web-viewable version.

Greater connectivity will allow for more possibilities in the future. With more of the media stored in the Cloud, and with systems becoming smarter about how all the media relates, it will be much easier to address common queries in review sessions, such as knowing how different versions compare to each other and whether previous notes have been adequately addressed, as well as seeing things in context—by being able to show adjacent shots within the current cut.

DIGITAL DAILIES

Over the last decade, film production has made a gradual transition from shooting on photographic film to shooting using digital cameras. Though there remains a source of contention as to whether or not this transition has been for the best, there are some indisputable benefits to shooting digital, chief amongst them their immediate availability for viewing and the ability to make perfect copies that have no degradation whatsoever.

The rise of digital capture formats for film and video has enabled the "dailies" (or "rushes") process of reviewing raw footage to be greatly streamlined. Traditionally, with a photographic film-based methodology, at the end of each shoot day the exposed film would be shipped off to a lab for processing overnight, with prints or DVDs couriered back to the set the

following morning. Key personnel would then view the output before the day's shoot and ensure everything was as expected, or make arrangements to redo anything that was not.

For the most part, this process has worked well, though the turnaround was so tightly scheduled that any issues could mean the receipt of the footage could be delayed by a significant amount of time. Additionally, it was rarely possible to get access to processed footage before the next shooting day, so the possibility of seeing something the same day it was shot (and with the best chance of being able to reshoot to address problems) was remote.

With the advent of digital photography, such delays became a relic of film-based production. As soon as something is shot using a digital format, it's available for viewing. Technically there might be some processing time required to decode a proprietary format or to otherwise copy or transcode footage to a format suitable for playback on specific devices, but such delays are comparatively insignificant, particularly where streamlined workflows have been established. Essentially once footage has been transferred from the camera and undergone whatever processing is needed, it can be displayed on a device. At that point, everyone can gather round and take a look. Traditionalists bemoan that this gives rise to less time shooting and more time spent in discussion in and around the "video village" viewing area. Whether this is indeed the case or not, there's a marked benefit of cost and time versus waiting for film to be developed.

Even with a digital dailies process there's room for improvement. The main issues with a typical digital dailies process are the lack of a formal way to track information and feedback and the dependence on being in a specific

FIGURE 12.2 Traditional Dailies Processing

FIGURE 12.3 Digital Dailies

location at a specific time to be able to view them. Naturally, these are areas where the Cloud can help.

With a Cloud-based digital dailies process, footage is uploaded to the Cloud as part of the transfer or backup process and can then almost immediately be made available for playback to a number of different devices across a number of geographic locations. This can be done in a very informal way, for example, using a Cloud storage system like Dropbox to store and grant access to the raw files, but for greater control and possibilities a more dedicated system can be used. For example, Prime Focus Technologies' Production Cloud (primefocustechnologies.com/dax-production-cloud) provides the means to upload footage to the Cloud, which can then be viewed via a browser, mobile device, or a dedicated set-top box. Footage uploaded is linked to corresponding scenes and takes, so it is readily searchable and organised. In addition, there's a whole host of review features, such as annotation, with the ability to export these to various non-linear editing formats, which can be convenient for editors who need quick access to this information.

The main obstacle to a completely Cloud-based digital dailies process is that Internet access tends to be limited on shooting locations. The volume of data generated each shoot day can run into the terabytes, which can take a very long time to upload on slower connections, particularly if the connections are unreliable and suffer from frequent disconnects. This means that the main draw of using the system in the first place—the immediacy of being able to view the footage—is lost whilst waiting for transfers to complete.

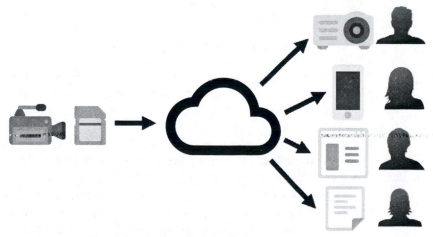

FIGURE 12.4 Cloud-based Digital Dailies

In these situations, it's likely that some combination of a traditional digital dailies process can be combined with a Cloud-based one. The traditional digital dailies process can be used to provide everyone on the set with quick access to the footage, and a Cloud-based approach can be done asynchronously, with people located remotely able to view the footage at a later date. Of course, in some shooting environments (such as at a television studio), there might be reliable and fast Internet access, in which case a Cloud-based approach might be both practical and suitable. Somewhat ironically, a Cloud-based approach might work well for shoots with photographic film, as the film processing lab might be able to offer Cloud-based dailies in tandem with processing the negative.

BOX 12.3 Transcoding

One of the most prominent issues that occurs when attempting to play video on different devices is that each device might have its own requirements for the specific format the video must be in. One device might support MPEG-compressed video, whilst another supports only Window Media Video. Then there's the need to try and deliver video that is appropriate to the hardware (such as the display resolution and audio capabilities), whilst maximising the overall quality and balancing the bandwidth of the connection to the device.

This can be particularly challenging due to the number of variables within the "transcoding" (taking media and changing the format so as to make it available on a particular device) process. For starters, there's the compression format, container format, and image resolution to consider, which will largely be dependent on what it needs to be viewed on. Then there's bit-rate, which controls the size of the resulting media by limiting how much information is stored, and then things like rate-factors, filters, and deblocking which can control the perceptual quality.

When there's a single person, for example, a Digital Imaging Technician, who is responsible for taking footage and transcoding it, this can be a tedious process, one that is both time-consuming and complicated. As such, it's best to target a limited set of output devices, for example, making one set of media that's optimised for an iPhone and another more appropriate for a laptop, and then settle on a set

(Continued)

(Continued)

of parameters that strike a good balance between turnaround time, size, and quality of the resulting files. These presets can then be reused throughout the production to make the process more automated and less of an obstacle.

This process is extremely limited as a result. It is undesirable to cater for different devices, as it impacts the overall turnaround time to actually do all the transcoding, as well as adding a period of experimentation to find suitable presets. Transcoding in the Cloud is a different matter. In the Cloud, transcoding can take advantage of a much larger pool of hardware, so transcoding for several different devices can be done in parallel. Furthermore, most Cloud transcoding services have created presets for numerous devices, so there's less of a need for experimentation of different formats. You simply submit some footage and then select which devices you need to view it on and let the service take care of the rest.

Services such as Brightcove's Zencoder (zencoder.com) allow you to upload video files to the Cloud and have them transcoded to various formats before transferring or downloading them from the service for use, which can be helpful in certain situations but is still limited by the time it takes to upload and download the files. Perhaps a better use for the technology is when it is combined with a dedicated Cloud-based review and approval system, in which case the files are being sent to the service which can then transcode files on demand, automatically making them available to a variety of devices.

POPULAR REVIEW AND APPROVAL SERVICES

PIX (pixsystem.com)

Pricing: undisclosed

Features: organise media into folders and playlists, text annotations, visual annotations, feedback notifications, watermarking, web-based, mobile

PIX is probably the most common review and approval system in use in the feature film industry. Endorsed for its simplicity and watermarking features, it provides a good way to get content to producers who may be in a different location to where the work is being produced. However, it lacks the ability to structure more complex coordinated review sessions.

CineSync (cinesync.com)

Pricing: from $99/month

Features: text annotations, visual annotations, feedback notifications, synchronised viewing

Another heavy hitter in the industry, CineSync's big sell is its ability to set up review sessions between multiple remote participants, with playback synchronised between them. It also provides a number of features for high-end production, such as support for DPX and EXR sequences, as well as stereoscopic footage and the ability to do synchronised colour manipulation.

Screenlight (screenlight.tv)

Pricing: free (single user, feature-limited), $9/user/month

Features: organise media into folders, text annotations, versioning, feedback notifications, web-based

Screenlight offers a very simple, streamlined interface for uploading and sharing media and requesting feedback. This simplicity is a double-edged sword, however, as the system is lacking some features that might be considered crucial in certain environments, such as the ability to add items to playlists, and a mobile version.

Wipster (wipster.io)

Pricing: from $15/user/month

Features: organise media into folders, text annotations, visual annotations, versioning, feedback notifications, web-based, mobile

Wipster provides a robust set of functionality for gathering feedback from others without requiring participants to learn a complicated system. It has some novel features, such as being able to reply to other comments in a conversational way, as well as the ability to export or print a checklist of follow-up items based on the comments.

Frame.io (frame.io)

Pricing: free (1 user, 2 GB), $15/month (1 user, 10 GB), $25/month (1 user, 25 GB), $50/month (5 users, 100 GB), $150/month (15 users, 400 GB)

Features: organise media into folders, text annotations, visual annotations, versioning, feedback notifications, web-based

Frame.io takes a similar approach to Wipster and Screenlight, seemingly incorporating the best parts of each and adding some unique features like being able to view two versions side-by-side. Its storage limits might be a bit of an issue for some situations, as might the lack of a mobile review app.

LookAt (lookat.io)

Pricing: free (1 user, 1 video limit), $12/month (1 user, 3 video limit), $30/month (1 user), $99/month (5 users)

Features: organise media into folders, text annotations, visual annotations, versioning, web-based

LookAt has feature parity with Frame.io, albeit with a different pricing structure. Another option to consider for people looking for a simple, streamlined experience.

Critique (critiquecloud.com)

Pricing: undisclosed

Features: organise media into folders and playlists, text annotations, visual annotations, web-based, mobile

Critique adds the ability to use playlists in addition to folders, providing a more flexible approach to organising media for review. Perhaps its most interesting feature is in its mobile application, which allows for media to be made available offline, with subsequent visual and text annotations transmitted back to the Cloud when an Internet connection is reestablished.

Sony Ci (sonymcs.com)

> **Pricing:** free (feature-limited), from $25/month

> **Features:** organise media into folders and playlists, text annotations, visual annotations, versioning, watermarking, web-based, mobile

Sony Ci offers a comprehensive package for managing media for review and approval, having just about every feature you could hope for in terms of media organisation and annotation capabilities. Though the service supports Aspera file transfer, it does have caps on the amount of media that can be uploaded and downloaded, so it might not be suitable for productions with a higher turnover of media. Whilst the cheaper packages limit proxy video to 540p, the more expensive ones allow for 1080p and have watermarking features.

SCRATCH Web (assimilateinc.com/products/scratch-web)

> **Pricing:** from $75/month

> **Features:** organise media into folders and playlists, text annotations, versioning, web-based

Assimilate Inc's SCRATCH Web provides a web-based counterpart to its SCRATCH workstation-based dailies system. Using an existing SCRATCH system (or the free SCRATCH player application), media can be uploaded to the Cloud for review with others. The service includes 20 GB of storage, which can be increased to 100 GB for a premium.

Production Cloud (primefocustechnologies.com/ dax-production-cloud)

> **Pricing:** undisclosed

> **Features:** organise media into folders and playlists, text annotations, watermarking, web-based, mobile, dedicated hardware

Production Cloud replaces a traditional dailies process with a Cloud-based approach, processing footage received from a shoot and making it available for viewing and annotation via a browser, mobile device, or dedicated

set-top box. As with many other review and approval systems, it's possible to export timecode-based annotations to a variety of non-linear editing systems. There's also a big emphasis on security, with two-factor authentication and watermarking available, as well as a secure method for allowing media to be viewed offline.

BIBLIOGRAPHY

Life of a Shot—Deconstructing the Pixar Process (WALL•E Special Features) https://www.youtube.com/watch?v=J_WCVQeuhP8

The Secrets of YIFY and High Quality and Small File Sizes Are Not So Secret after All . . . Encoding High Quality Low Bitrate Videos in Handbrake for Any Device https://ericolon.wordpress.com/2013/01/06/the-secrets-of-yify-and-high-quality-and-small-file-sizes-are-not-so-secret-after-all-encoding-high-quality-low-bitrate-videos-in-handbrake-for-any-device/

13

Distribution and Archive

"I've never made any film that I wouldn't go back and re-edit."
—Michael Mann

DISTRIBUTION IN THE CLOUD

Much has already been said about how the Cloud can enable convenient sharing of data, whether through communication or review of media, but there's another, more direct benefit in sharing—getting completed work to someone else, or to a great many people.

Sharing Information

During any kind of production, a lot of data are created. A sizeable amount of that data is just intermediary—the result of research and development, placeholders for work that is completed later, or just iterative versions on ideas, by-products of the creative process. But the rest of it can represent valuable data, pieces that will ultimately become part of a completed production. There's likely to be a lot of it, it's likely to come from many different places, and there will be a lot of people who will need parts of it. Completed storyboards might be needed by the director or cinematographer,

final edited footage would be needed by a colorist, a completed music video would be needed by a broadcaster.

As such, at a certain point the creative process gives way to logistics. With everything in the Cloud, the process can be simplified. People working on stereoscopic conversion of a feature film, for example, might need a lot of information about how each finished shot in the film was composed, which lens was used, and so on. Traditionally this type of information exchange would happen through complicated data dumps or, even worse, constant correspondence between different departments. With the Cloud, the stereo team could just be given access to the tracking systems or databases used by the respective teams to store this information in the first place. With some enforced consistency across different projects as to how this information is stored and displayed, the stereo team wouldn't even necessarily need to learn to navigate a new system each time.

Likewise, with people who need access to files and media rather than meta-data, a similar approach can be taken with Cloud Storage. Visual effects facilities, for example, might need access to a lot of media generated by the production crew during a shoot, from principal camera footage to reference images, LIDAR scans, or "witness" camera footage. For productions that already store this information in the Cloud, granting the facilities access to specific files and folders should be easier and faster than the alternative of making copies of the data from a server and then sending it to the vendor by putting it on an external drive and sending it via courier or uploading it via FTP or Aspera.

FIGURE 13.1 Data Stored in the Cloud

There are other situations where distributing media via the Cloud is an appealing prospect. In 2015, a major leak of DVD "screener" movies, intended for viewing by people voting on Academy Awards, meant that many movies ended up in the hands of pirates, including one that had not yet seen a general theatrical release. This re-ignited the debate to use digital screeners instead of physical DVDs, as they are thought to be more secure and less susceptible to being leaked in this way (as a bonus, they are also much cheaper to produce).

The technology to do this already exists and is available through the Cloud. GoScreening (goscreening.com) provides a way to send DVDs to the service, which will then encode and make them available for viewing in the Cloud. Prime Focus Technologies' SecureScreener (primefocus technologies.com/securescreener) takes this further by providing more options and security measures. That said, many creators feel this approach is anathema to their intended vision, as watching via a browser or mobile device is an inferior experience to watching on a big screen.

BOX 13.1 The Nuts & Bolts of Cloud Distribution

Part 1—Internet Transport Layer Protocols

The Transport layer of the Internet protocol suite (see chapter 2), defines how different computers communicate with each other. Within this layer, several different approaches (or "protocols") are defined, the most widely-used being the Transmission Control Protocol (TCP), followed by the User Datagram Protocol (UDP). Each of these is fundamentally different, and as such suit different purposes, but it is useful to know the characteristics of each.

TCP operates on the principle that the most important factor is reliability—that when data are sent from one device to another, that data get there intact. It works by making a connection (secure or otherwise) between the two devices and then allowing data to be sent via that connection, in much the same way as making a phone call. TCP provides both flow control (ensuring you don't send too much data in one go) and error-checking (resending data that did not get through). However, it can be relatively slow to send data, especially over large

(Continued)

(Continued)

distances, where latency (the delay between data being sent by one device and receiving an acknowledgment from the other) can get very large, like having the long pauses on a long-distance phone call while you wait for the other person to reply. As a result, it's practically useless for anything that needs real-time data transfer.

UDP on the other hand works by blindly sending out data without needing an established connection and assuming that the data will just reach the destination. There are no checks to make sure this happens (and as a result, no delays). If TCP is two people making a phone call, then UDP is two people standing at opposite ends of a busy street with megaphones. This results in faster data transmission than is possible with TCP but without any controls to verify the data are intact or to limit the transmission to the available bandwidth. In practice this means you can stream live data using UDP (the most common example being Voice over IP), but occasionally there'll be "packet loss" (such as the person you're talking to freezing for a split second or other video artifacts). Though many of the limitations of UDP can actually be resolved by designing the applications sending and receiving UDP-transmitted data to work around them, there are other limitations which are harder to solve, such as the fact that many network firewalls block UDP transmissions, and typically must be specifically configured to work with a particular application.

There have been some attempts to address the shortcomings of TCP compared to UDP. Most notably is the concept of buffering, whereby the application delays presenting data received to the user until enough of it is queued up so that any future intermittent transmission delays may be compensated for by grabbing data out of the buffer, giving the user an effectively seamless stream of data. There are several downsides to this, the most immediate being the initial delay between a user requesting data (like clicking play on a video) and it actually being presented (the video starts to play), and there might be situations where there's enough of a drop in the flow of data that the buffer gets completely used up and has to refill before continuing (the video stops part-way, and there's a delay before it resumes); but on the whole this provides a good work-around (at least for anything that doesn't need to be real-time, like a web application that responds directly to a user's input).

An alternative to either of these protocols (and a popular one in the film and television industry) is IBM's Aspera "FASP", a proprietary protocol which is functionally similar to TCP but with different mechanisms for error-correction and flow control. The result is the ability to send

(Continued)

(Continued)

data reliably but much faster than is possible over equivalent TCP con-
nections. In practice, while transfers using Aspera technology tend to
be both fast and reliable, there's a tendency for them to monopolise all
of the available network bandwidth, meaning that other network traffic
(such as opening web pages or receiving emails) will slow dramatically.
There's also a substantial cost implication to setting up an Aspera con-
nection, as it requires the purchase and administration of proprietary
client *and* server software.

Other iterations of UDP attempt to eliminate its shortcomings. Goo-
gle's Quick UDP Internet Connections (QUIC) is designed to bring the
benefits of UDP's faster data transfer to applications that currently use
TCP, though in practice the only significant benefits are seen by users
with slow connections. It's currently in an experimental form and is yet
to see widespread adoption outside of Google.

Broadcasting in the Cloud

There's a surprising lack of commercially-available options for people who
want to be able to broadcast a finished product to the masses, considering
how well the Cloud is suited for doing just that. If you then want to monetise
it, well there's even fewer options.

To take a finished digital video and make it publically viewable, there are
a few Cloud-based services, most significantly YouTube (youtube.com) or
Vimeo (vimeo.com). YouTube has the benefit of a much larger audience, but
the picture quality is somewhat lacking compared to Vimeo. With both ser-
vices, audiences can comment on the video (if the option is enabled), share
the link, or even "embed" (post a playable copy) on other sites.

If you want to actually make money from your finished product in the
Cloud, there are three options. The first, and most preferable option, is to
have a distribution agreement with a service like Netflix (netflix.com) or
iTunes (apple.com/itunes). This works in a similar way as having a distri-
bution deal with a television broadcaster or theatre chain, in that they're
extremely selective about what they'll include on their service and will likely
only deal with distribution companies directly.

Alternatively, you could turn to one of YouTube's monetisation options—which is to either allow YouTube to show adverts alongside your video, in which case they'll give you a (reportedly low) percentage of the profits, or you can gate access to the video behind a paywall, whereby you set a price and YouTube will charge viewers for access, either on a temporary "rental" basis, or for permanent access (the actual price for viewers will be different from your "suggested retail price" and will be set by Google). Vimeo has similar options for setting up paywalls, but there's no possibility to monetise through advertisements.

The third option is to use something like Distribber (distribber.com), an "aggregator" service that acts as a gateway to services such as iTunes and Netflix. These aggregator services charge a processing fee per video and then submit it to digital stores. They make no guarantees as to whether a video will be accepted by the services or not (and either way they keep part of the fee). As such it may be of questionable value to different types of productions.

When it comes to broadcasting live events, there are more options. Most of the popular services in this area such as Twitch (twitch.tv) cater to live coverage of televised gaming, but there are some that are less specific. Ustream (ustream.tv) will stream live videos to viewers across the Internet, though doing this for more than a few videos will cost money, with nothing built into the service to allow you to monetise your broadcasts, meaning you'd have to include your own advertisements as part of the stream if you plan to earn anything, something made easier by services such as Livestream (livestream.com), which allows for pre-roll advertisements, or advertisements inserted into the stream.

BOX 13.2 The Nuts & Bolts of the Cloud

Part 2—Peer-to-Peer Networking

Though (undeservedly) synonymous with piracy, peer-to-peer networks are a technology used to make file transmission faster. With a "server-client" model, one server is responsible for transmitting copies of a file to several "clients". If there are a lot of clients, all requesting the same file, the process can become very inefficient, as all the data transfers end up in a bottleneck at the server.

(Continued)

(Continued)

FIGURE 13.2 Transferring Data in a Server-Client Environment

With a peer-to-peer network, someone starts to download a file from a server as before. However, if additional clients request the same file, they instead download pieces of it from other clients instead. As more people download a specific file, there become more sources available for each person to download the file from, and so the process becomes more efficient with more popular files—in direct contrast to the server-client model.

There are some drawbacks to this approach, however. For one thing it can put undesirable strain on the clients' systems (and Internet connections), as they're effectively becoming servers in their own right. Moreover, there's additional overhead in tracking and synchronising which pieces of each file are available from which client. It's also difficult to allow "streaming" of media within this model, so files

FIGURE 13.3 Transferring Data in a Peer-to-Peer Environment

need to be downloaded in their entirety before they can be viewed. Even so, there are definite gains to be had with the technology in the right situations, with companies like Netflix reportedly interested in potential applications.

ARCHIVE IN THE CLOUD

Even before a production is completed, it's appropriate to think about organising and storing digital assets and related data for the long-term. It can be important to keep certain things both for posterity and for potential re-use later on. Once the production has completed, the production team might move on to other things, and as such it becomes much harder to sort through files and information in order to figure out what's needed.

Saving for the Future

The question of what to keep after a production is complete could just as easily be "what do you *need* to keep?" This in turn will depend on a variety of factors, such as how likely there is to be a sequel and the overall budget for the production. Though it may seem like there's little point keeping anything once a film is done, there's still the potential for some of it to be reused in the future for marketing materials (especially if the production becomes unexpectedly successful), and future technologies may also see your production getting new life.

History has shown how, for example, the proliferation of household DVD players ushered in a wave of "re-mastering" of old films and long-forgotten television series, with a great many forgotten titles finding a new audience, even for some that were not particularly successful the first time around. The re-mastering process was exactly without associated costs, but even so represented a relatively risk-free opportunity for the rights-holders to try and make some easy money on properties that were otherwise gathering dust.

In the fully digital, Cloud-enabled era we currently enjoy, such opportunities could come even easier with the proper planning. Consider the DVD "extras" that made for a great selling point for older titles, which could include outtakes, behind-the-scenes footage, concept art, and the like which previously had served little purpose once the production had wrapped. How fortunate for those productions that had archived some of those materials, to find that 20 or so years later, they had a new audience with a huge appetite for all of it.

More recently, we've seen the resurgence of stereoscopic 3D. Unlike the DVD re-mastering process, stereoscopic conversion (the process of taking something shot in conventional 2D and making it look as if it had been shot in 3D) is a costly and complex process, meaning it's not something many older productions will likely go through. Even so, those that are regarded highly enough to make the process seem financially worthwhile almost certainly benefit from having many of the original assets readily available. 2013's re-release of *Jurassic Park* in 3D was undoubtedly worth the cost of making it happen, but even so, that cost could have been greatly reduced had all the original visual effects elements been available (as it was, the majority of the film was treated in the same way as other in-camera footage; with elements painstakingly rotoscoped and 3D elements re-created after the fact).

That said, it's not easy to predict exactly what would be useful to keep for the future whilst a production is in motion. From a purely idealistic perspective, it seems reasonable to just attempt to keep absolutely everything. From a practical perspective, though, doing so is often impossible, as many elements are lost or otherwise discarded even before the cameras finish rolling. Furthermore, there's the other complicating factor: how to store whatever it is you want to keep.

Although the industry has been desperately seeking a standard for archiving different types of assets for the last decade, seemingly nothing has stuck. Still images are at least starting to seem to have some persistence—thanks to the web, it seems likely that even in 50 years' time there'll be a way to view a JPEG file, but once you start trying to store original RAW files that tend to be in a proprietary format, things become a little more complicated. Adobe's Digital Negative format has seemed a likely candidate, as have the visual effects and digital film mastering formats of DPX and EXR, but these are all yet to reach the critical mass that means absolutely everyone everywhere is using them.

Move away from simple still images, and things become even more complicated. Currently, the best way to archive a finished film is to encode each individual frame as a still image, as there's no established uncompressed movie format, and anything that is compressed as, say, an MP4 file simply suffers too much in terms of quality degradation (the MP4 file format itself lacks any sort of rigid definition, so the ability to play one MP4 file doesn't imply the ability to play *all* MP4 files). Then there are things like 3D assets, which are almost always tied to the software used to create them, and so there are no guarantees that it will be possible to read the data at some unspecified point in the future (indeed, there are so many disparate elements working in tandem on a typical visual effect shot that it can be challenging to exactly re-create them even a few months after they are archived).

Still, not archiving something due to worry that it won't be useful in the future doesn't make for a good archiving strategy, so if we take the attitude that action is preferable to inaction, then a sensible answer to the question of what should be kept might as well be "how much did it cost to make in the first place?", in conjunction with "how much will it cost to keep?"

The Cloud, of course, makes it easy to calculate the cost of keeping something. Whereas traditionally you'd have to consider a number of factors, the cost of Cloud storage depends only on two things: how much data do you want to store and how long you want to store it?

TABLE 13.1 Storage Cost Considerations

Traditional	Cloud
Size of storage media required	Amount of data
Purchase of storage media	Length of time to keep data
Expectancy of storage media	
Maintenance of storage media	
Future costs of replacement media	
Security of storage media	
Security of storage media location	
Backup strategy	

With this in mind, you might find that it becomes viable to keep things that you might otherwise discard. Storyboards, saved as JPEG images, for example, would probably amount to a few hundred megabytes at most, which is a lot less than what many Cloud storage providers give you for *free*. There's practically no reason *not* to keep data that's that small.

Digital Compression

Digital compression is a very involved and complicated topic. However, the basic concept is easy to grasp: you have some data in the form of files or metadata that occupy a specific amount of digital storage. Compression just reduces the amount of storage needed. There are a number of ways that can be done, but they fall into two categories: "lossless" compression and "lossy" compression.

Lossless compression uses mathematical principles to make the way data are organised more efficient and use less storage as a result. A common example of this is if you zip a file before emailing it. The zip file contains a copy of the original file, completely intact, but the size is smaller. Depending upon the type of data being compressed in this way, this can produce large reductions in the overall file sizes. For example, text files tend to compress extremely well compared to images or video files. The important thing about lossless compression is that no data are ever lost as a result of doing it (if you're wondering at this point why everything isn't just always compressed using lossless compression all the time, the reason is because there's significant overhead required to decompress files compressed in this way so that they can be viewed).

300 KB 12 KB

FIGURE 13.4 Lossless Compression

300 KB 12 KB

FIGURE 13.5 Lossy Compression

With lossy compression, some of the data are discarded in order to reduce file size. Though this can result in much, much smaller file sizes as a result, the process can't later be reversed to get the original file back. With lossy compression, the important factor is in deciding exactly which information is lost. Perhaps the most common example of this is the JPEG image format. With JPEG images, an algorithm removes detail in the image that are (in theory at least) imperceptible to the human eye. What this means is that, to the average person, there's no visible difference between the original version of an image and the JPEG-compressed one, but only at around 10% of the original file size (at higher levels of compression, this breaks down and visual compression artifacts are noticeable).

There are similar options for lossy compression for digital video, notably H.264 which is used throughout the web, as well as the new H.265 (or "High Efficiency Video Coder"), which affords greater reductions of file size at the same perceptual level of quality (H.265 is protected by a number of patents and stricter licensing than H.264, so its future adoption is uncertain at this point). As with JPEG compression, even though there might be no significant difference in quality to the average viewer, the loss of data means that any attempts to modify the content can cause severe distortion or artifacts. This is particularly the case when trying to colour-correct compressed video, for example.

Two conclusions can be drawn from this with regards to archiving. First, it almost always makes sense to use some form of lossless compression when archiving data, as this will reduce the amount of storage space needed and lower costs as a result (it should be noted, though, that such compression should be set up in a way that means you still are able to access files on an individual basis, as opposed to having to retrieve an entire archive and then extracting it to get to a single file).

Second, lossy compression should be used only if the alternative would be to just not archive a file at all. If there are several terabytes of out-takes that you don't consider being worth the expense to keep, it *might* be worth converting them to a smaller, lossy format and archiving that instead. Similarly, where original files are already lossy-compressed there's no benefit to converting them to a lossless format instead (recompressing or converting them to another lossy format can also lead to further visible degradation, so this should be avoided too).

BOX 13.3 Data Deduplication

One other way to reduce data storage needs is to "deduplicate" it. This process assumes that with a large enough set of files to archive, a significant proportion of them will be duplicates of each other. For example, if you need to archive everyone's email account, there's a good chance that many emails will have been sent to multiple people. With a deduplication system in this case, only one entire copy of the email needs to be archived, and the system just records a reference to the archived copy in place of making a new, complete copy.

Whether such a system will provide worthwhile benefits will largely depend on the type of data being archived. If most of the data are video or audio footage, and there's known to be only a single copy of each camera take, then there's unlikely to be any gains from such an approach, compared to, say, archiving terabytes of metadata, which would likely have significant repetition.

Long-Term Cloud Storage

Though it's certainly possible to use any of the Cloud Storage services covered in chapter 4 to archive (or back up) files and data, there are better options available if all the following points apply to your archival data:

▶ It will not need to be accessed frequently;

▶ When it does need to be accessed, it does not need to be available immediately.

With those points in mind, there are a few options for Cloud Storage of data that can be significantly less expensive than regular Cloud Storage.

Amazon Glacier (aws.amazon.com/glacier), for example, offers extremely cheap storage (less than one cent per gigabyte per month) with no limits on how much data can be stored. However, the service is designed so that withdrawals of data are kept to a minimum. Uploading data to the service is free, as is listing what's currently stored, but only a limited amount of data (5%) can be retrieved per month (at which point transfer fees will be applied), and you have to be prepared to wait several hours from the time you request it until it becomes available. If this approach is too inflexible for your requirements, you can try a more traditional service such as InfiniDisc (infinidisc.com), a tape-based system that allows you to retrieve data as and when you need it via the web or FTP, though it is far less cost-effective than Amazon's offering.

POPULAR DISTRIBUTION & ARCHIVE SERVICES

GoScreening (goscreening.com)

Pricing: free, $200/film

Features: DVD encoding, private screening sessions

GoScreening's main feature is that it will digitise and host private screenings from a DVD source. The service charges per viewing (although these have to be purchased in bulk beforehand). For an undisclosed fee there's also the option to enable watermarking and provide Blu-Ray or ProRes video instead of a DVD.

SecureScreener (primefocustechnologies.com/securescreener)

Pricing: undisclosed

Features: private screening sessions, watermarking, mobile

SecureScreener provides an enterprise-level service for getting screeners to viewers. A whole host of security features are included to prevent leaks or piracy, along with analytics capabilities and support for playback on mobile devices.

YouTube (youtube.com)

Pricing: free, $10/month (without advertisements)

Features: video upload, video sharing, video editing, video rentals, video
purchases, browser-based, mobile, API

YouTube is the largest video hosting site in the world. Primarily intended as a
way to allow anyone to publish a video online (either publically or privately),
it does offer some features to content creators to allow them to monetise
videos, through advertisements or video purchase and video rental options.
Though the service supports up to 4k video, it has been criticised for poor
visual quality, likely due to the high compression rates used. Its popularity
does mean it has the added benefit of being available on almost every device
with an Internet connection.

Vimeo (vimeo.com)

Pricing: free (feature-limited), from $10/month

Features: video upload, video sharing, video editing, video rentals,
video purchases, browser-based, mobile, API

Though not even close to the size of YouTube, Vimeo does several things
to differentiate itself from the larger service. First of all, there are no adver-
tisements anywhere on the site (for viewers or publishers). Second, the
compression quality of hosted videos is thought to be much better than
YouTube's. There are monetisation options for publishers in the form of
paywalls (and the service does a much better job of promoting the videos
using them than YouTube does). However, there is a limit on how much
video even the paid accounts can upload per week.

Ustream (ustream.tv)

Pricing: free (ad-supported), from $99/month

Features: live video broadcasting, browser-based, mobile, API

Ustream offers a convenient way to broadcast live video across the Inter-
net to browsers and mobile devices. The paid accounts have limits on
"viewer hours" or the length of a video multiplied by the number of

viewers. With longer broadcasts or larger audiences, the service can be very expensive.

Livestream (livestream.com)

Pricing: free (feature-limited), from $99/month

Features: live video broadcasting, browser-based, mobile, API

Livestream differentiates itself from other live broadcast services in a number of ways. First of all there are no limits on the length of broadcasts or the size of your audience. In addition, there's a selection of software and hardware products available to buy to help control the broadcasts.

Amazon Glacier (aws.amazon.com/glacier)

Pricing: $0.007/GB/month for storage, additional retrieval fees may apply

Features: unlimited cloud storage, API

Amazon Glacier is something of an alternative to tape backup systems used by IT departments across the world. Essentially you upload as much data as you want into the service, with the ultimate aim that probably won't need to access most of the data ever again. If you do need to retrieve data from the service in the future, be prepared for a wait time of several hours, along with retrieval fees from $0.01 per gigabyte. There is also a charge incurred for deleting data that's less than 90 days old.

InfiniDisc (infinidisc.com)

Pricing: from $0.04/GB/month

Features: cloud storage, API

InfiniDisc offers a Cloud-based tape backup system. You can store terabytes of data in the system, which then behaves like your own personal tape backup system, with you able to send and retrieve files as needed. The pricing structure is much more complicated than Glacier, but whichever way you calculate the costs of the service they will likely be much more expensive.

BIBLIOGRAPHY

After Oscar Piracy Studios Step Up Push for Digital Screeners https://variety.
 com/2016/film/news/oscar-piracy-digital-screeners-1201667493/
A QUIC Update on Google's Experimental Transport http://blog.chromium.org/
 2015/04/a-quic-update-on-googles-experimental.html
Aspera FASP Overview http://asperasoft.com/technology/transport/fasp
How to Get Your Indie Film onto iTunes & Netflix https://www.lightsfilmschool.
 com/blog/how-to-get-your-indie-film-onto-itunes-netflix/1817/
Jurassic Park 3D: A New Dimension for a Modern Classic https://library.creativecow.
 net/kaufman_debra/Jurassic-Park-3D-Conversion/1
Netflix Reportedly Looking into WebTorrent Technology to Stream Videos Faster
 http://www.techtimes.com/articles/116388/20151215/netflix-reportedly-looking-
 into-webtorrent-technology-to-stream-videos-faster.htm
QUIC, a Multiplexed Stream Transport over UDP https://www.chromium.org/quic
Transport Layer https://en.wikipedia.org/wiki/Transport_layer
UDP vs TCP http://gafferongames.com/networking-for-game-programmers/udp-
 vs-tcp/

14

Security
Considerations

"I steal from every movie ever made."
—Quentin Tarantino

As a rule of thumb, the larger the production, the more security-conscious it needs to be. The bigger the production is, the more of a target it is. Film productions like *World of Warcraft, The Avengers*, and *Star Wars: The Force Awakens* all had very strict security in place just to prevent any leaks relating to the story, let alone things like concept art or still images. It also goes without saying that on practically any size production, having the final version become leaked before its intended release date can be catastrophic.

When a large amount of production assets live in the Cloud, on servers somewhere else on the planet, it is natural to develop a sense of paranoia that any of it could fall into the wrong hands, either through accidental exposure or someone determined and malicious enough to attempt to access it without authorisation. There's probably enough to say about computer security, particularly when it comes to the Cloud to fill several books in their own right, but suffice it to say there's no reason anything stored in the Cloud shouldn't be at least as secure as anything stored on your own personal computer. Examples of other sectors that entrust their data to be secured in the Cloud include human resourcing, healthcare, and governments.

That's not to say that everything stored in the Cloud is automatically safe either. Most Cloud-based services make some assumption about the security of your data (some will assume you don't actually care about security all that much), and the best ones actually depend on establishing rules around who should have access to what.

Ultimately, security in the Cloud is defined by what your data are, how you get the data into the Cloud, what the provider does with the data once it's there, and how (and who) can get the data out again. If you can be confident in each of those steps, you can be confident that your data are secure.

SECURITY MEASURES

There are many security measures you can take when dealing with data in the Cloud, just as there are with local computer systems and hardcopy documents. None of these are specific to the Cloud, and any number of them may or may not be appropriate to your specific requirements. There may be cost implications with any of these, and it might be that some of them are simply not possible with a particular service provider. As with other security matters it's best to consult with an expert to audit to help identify areas that are vulnerable.

Encryption

The most obvious form of digital security is encryption. Put simply, it's the process of scrambling data so the data are unreadable without decryption. In computer terms, this usually involves having some form of digital key to access something that is encrypted. It's like someone sending a message in a locked box to someone else who already has the key to open it. There's no guarantee that the box won't be intercepted, but if it is, it will be extremely difficult to get at the message inside.

In terms of the Cloud, encryption performs two vital roles. First and foremost, it can ensure that data transferred between your browser and the service (or between a mobile application and the service) are encrypted. The most common example of this is browsing to a site using HTTPS (HTTP over TLS), which is typically displayed in the browser with a padlock icon (a green padlock in the case of websites with "Extended Validation Certificates", which indicates that the connection is both encrypted and provided

by a source with a verified identity). Most browsers provide additional information when clicking the padlock icon, so you can see exactly the level of protection offered.

The second role encryption performs is to protect stored data (also referred to as "at-rest" data), so that in the event that a service provider's server gets compromised, the data on that server are still protected. This is particularly important for Cloud storage services, as a data breach could allow someone to view users' actual files if they're not encrypted, but it's equally important to ensure the data stored in databases are encrypted, particularly where that data are sensitive, be it the screenplay from an unreleased film, or the contact details for the cast and crew (it's worth pointing out that databases that form part of a service, such as an online shot-tracking database, will not typically be encrypted themselves, but any backup copies *should* be encrypted).

Even where data are encrypted, it's not necessarily secure, as there are many forms of encryption, with some much more effective than others. Some are considered to be easily exploitable, for example, the Wireless Encryption Protocol (WEP) scheme for WiFi connections can be broken in a matter of minutes by someone who knows what they're doing, whereas the more modern WiFi Protected Access 2 (WPA2) scheme is considerably more secure.

BOX 14.1 App Transport Security

Sadly there's not as much transparency when using a mobile app to connect to the Cloud as when using a browser. As of the release of iOS 9 for Apple devices, Apple has been strongly encouraging app developers to make use of its App Transport Security (ATS) layer, which ensures a minimum level of security (via the use of HTTPS) for all network communication.

However, this effort has been undermined somewhat by advertisers such as Google who are advising developers to disable this feature in order to use their advertising services. Compounding the issue is that there's ultimately no way for the end-user to know if the app they're using has ATS enabled or not.

Access Restriction

Another conceptually simple form of digital security is limiting access to particular data based on who requests it. A user or group may be given permission (or not) to perform some action on the data (such as a file). This might be the ability to change (or create or remove) a subset of data, or it might just be the ability to view it.

This can work at multiple levels within a Cloud service. First there's file-system permissions, controlling which users on a server have access to which files (and the type of access they have). There might be network-level access rules (such as a firewall), dictating which type of data may be transferred in or out of the network (and limiting access based on specific IP addresses). Then there might be application-specific permissions, controlling which part of the application can be accessed by whom, as well as the possibility of having users set permissions for other users within the application itself.

Furthermore, the rules governing different kinds of access can themselves be multi-layered. An individual user might belong to a group, and so have permissions based on that group, but these be selectively overridden for the specific user (for example, a "Manager" group might not be able to see financial data, but a financial controller within the Manager group is specifically given permission to see it). In addition the rules might be *conditional*, so, for example, a given user might only be able to see items whose names begin with the letter B, or only if it's a Thursday, and so on.

BOX 14.2 Passwords

Everyone hates passwords. Either they are too difficult to remember or else too simple to break to be effective. Despite many attempts to try and find a better approach to providing a collection of letters (and sometimes numbers, and sometimes punctuation) to identify yourself, by and large we're stuck with them. And in a Cloud-enabled world, they are everywhere. Everything from online shopping to checking your calendar probably requires a password (even if you've opted to have it stored so you don't have to keep typing it in). It is, therefore,

(Continued)

(Continued)

extremely tempting to simply use the same password for everything, so that whenever you're asked for a password to something, the response comes easily and automatically.

Sadly, this is perhaps the worst thing you can possibly do, as far as your online security is concerned. Even if you're very careful never to reveal your password to anyone, even if you never even write it down, and even if it's 30 characters long with a mixture of letters, numbers, and punctuation, the chances are that eventually one of two things will happen: either you'll unknowingly provide your password to a site designed to collect passwords from people, or one of the sites you've previously entered your password will get compromised, and the database containing yours (and hundreds or thousands of others) will get stolen. Either of these two possibilities typically has the same outcome—some malicious person will then attempt to use the password (likely in combination with a registered email address) to access every worthwhile Internet account you might own, from social media to banking, to that one account which opens the door to every other account—email.

For this reason, it's essential that you try to have different passwords for every site. This might seem difficult or impractical but is actually remarkably simple if you use software such as 1Password (agilebits. com/onepassword) or KeePass (keepass.info) to track which passwords you use where (and indeed generate random passwords on your behalf if preferred) in a secure database (which itself is unlocked via a single password—but this is the only one you'll ever need to remember).

Digital Rights Management

Digital Rights Management (DRM) is a controversial method of controlling what can be done with a given piece of (presumably) copyrighted digital media. There are many examples of its use in everyday life, from preventing DVD copies being made, to preventing e-books being printed, and preventing music being played on more than a certain number of devices. From the consumers' standpoint there's arguably no benefit to DRM, and as such it has a tendency to become an inconvenience, and many forms of DRM (including those used for DVD and Blu-Ray) can be bypassed, but it remains in use nonetheless.

Still, it can be an additional method for protecting content, particularly in the short-term and when the aim is to avoid pre-release leaks. Distributing

a script that cannot be printed by anyone can be desirable in certain circumstances and having copies of videos that can be viewed only by people with a digital license can complement a solid security infrastructure.

Watermarking

A watermark is a graphic superimposed over a document (typically an image or video but can also be applied to document such as a screenplay). There are two types of watermarking commonly used, visible and invisible. With visible watermarks, the graphic can be clearly seen across the document (for example, on every page of a screenplay, or across every frame of a video) and tends to be in the form of text identifying the person it was sent to. Invisible watermarks (also referred to as "Forensic Watermarks") usually apply only to digital video or images and cannot be seen by the eye (but can be decoded via appropriate means), but are instead tagged in some way with a digital code. Forensic watermarks may be used when it would not be appropriate to obscure the image with a visible watermark, in situations where you don't want the recipient to know the file has been tagged, or even in combination with visible watermarks, if they carry more information than is possible to show in the visible watermark (such as the IP address of the person viewing it or the date and time the viewing was requested).

Unlike the other security measures, watermarking is not preventative. The mere presence of a watermark doesn't stop anyone looking your content, but it does allow any dissemination of material to be traced back to an originator. In the case of visible watermarks, it can act as a deterrent, however, as someone will be far less likely to leak an image if their name is stamped all over it.

Very occasionally a watermark is used merely to convey ownership (as in the case of watermarks proclaiming "Property of . . .") or when logistics prevent more individualised watermarks being used. Though this particular approach doesn't allow leaks to be traced back to a particular source, the rationale is that at least it prevents the proliferation of counterfeit copies.

Obfuscation

Obfuscation can be considered a "low-tech" security measure in comparison to the others mentioned and has been in use by the entertainment industry for many years, albeit with varying degrees of success. The idea is to disguise

important information about a production, so that if anything is accidentally leaked (such as someone finding a lost mobile phone with emails and other information about a production) it cannot be directly attributed to a particular production.

Most often this takes the form of code names for the production itself (both for the title and the production company's name), although in recent years these are of questionable value as the code name itself is often leaked as part of doing casting calls and so on (and because producers seem to enjoy using uniquely identifiable code names rather than more generic ones, a quick search on the Internet will usually reveal their true identities). However, this practice has also been extended to using code names for things like major character names and other identifying information associated with the production. Again, the benefits of this approach are somewhat dubious, as it can complicate and confuse matters for people who are actually working on the production, but it's still a popular practice.

Concealment

If you want to be really extreme about it, even the possibility that the stranger sitting next to you might be trying to get information about the production becomes a concern. A producer sitting on a plane may worry that other passengers will attempt to read a script over their shoulder, or a visual effects artist may take a bathroom break, allowing anyone who walks past a glimpse of some unannounced superhero on their monitor.

As paranoid as it may seem, there are ways to prevent these types of situations becoming an issue. The Filetrack (filetrack.com) document storage system, for example, runs in the Cloud but has a number of methods to limit exposure to any of the materials you might choose to store there. First of all, the browser window displaying a document or movie will "lock" itself after a certain amount of time, so if you leave your device unattended for a period of time, it's unlikely someone will be able to come along and snoop at what you were looking at. But perhaps the headline feature is its "scope view", whereby you can see only a small portion of the document on the screen at one time, or in the case of a mobile device, only the area you point at, as if you were reading with a flashlight in a dark room. This serves to conceal a document in its entirety (aside from the minuscule fragment you happen to be looking at).

BOX 14.3 Password Strength

Spend enough time signing up with different web-based services, and you'll become familiar with the different approaches to passwords they take. Some are content to let you choose any password you want, whilst others will impose certain restrictions ("you must use at least one number", for example), and sometimes have some really bizarre and self-defeating rules about how your password should be composed ("the password must be exactly 8 characters and not have any two of the same characters"). Almost all of them have some notion of what makes a "strong" password, and many of them will use a "password strength" meter to indicate this to you.

But tellingly, the exact same password will produce a different strength rating on different websites. There's much debate as to what makes a strong password, precisely because it depends on the method that is used to try and break them. A "dictionary attack", for example, goes through every word in a dictionary (or combination of words), and as such some sites enforce the inclusion of at least one number in a password precisely to avoid these types of attacks from being viable.

However, it does seem that the vast majority of articles on the subject reach the same conclusion—in general, the longer the password is, the better, as most attacks take longer with longer passwords. Coupled with this, you should try to maximise the "search space" of the password (or maximum number of possibilities attackers must check) by including at least one number, one symbol, and one uppercase letter. Do this, and there's a good chance your account won't be compromised even if a hacker breaches the system.

Hashed and Salted Passwords

Just as it's important to protect your own passwords, the sites you log on to have a measure of responsibility to protect your personal information and your password in particular. User passwords are commonly stored in a database and, ideally, the server hosting the database is secured to prevent access from attackers.

However, as countless high-profile incidents have demonstrated over the past few years, it is virtually impossible to prevent the most

(Continued)

(Continued)

dedicated hackers from gaining access to a system on the Internet, and when they do, they'll likely be headed directly for the database that stores user accounts and passwords. If you take the position that at some point, these data could fall into the wrong hands, then you must take steps to protect these data further. The most common solution is to "hash" passwords that are stored in the database. That is, when a user creates (or modifies) their password, the site doesn't actually store the password they provide, but an encrypted ("hashed") version of the password. Thus when the raw password data are viewed, the original password cannot be discerned.

There's a slight caveat to this which is that in recent years it's possible to use so-called "rainbow tables" (which list a large number of possible passwords and their equivalent hash based on the most popular hashing algorithms) to look up an original password based on its resulting hash. There's a solution to this, however, which is for the site to also add a "salt", or random sequence, of characters to the original password, with the aim of making the overall length of the string to be hashed sufficient to defeat rainbow tables (due to the sheer volume of data required, rainbow tables are limited to decoding hashes of strings up to a particular length). Salts can either be constant (the same string is appended to each password) or can be randomly generated and stored per account (the latter approach is considered safer as it prevents an attacker from attacking multiple accounts simultaneously).

The important part to this is that no-one else, not even the website owner, knows what your password is. The password is verified by repeating the operation (salting and hashing the password you provide when attempting to log in) and then comparing the result to the stored value. An exact match happens to mean you entered the correct password, but all the system really cares about is the salted and hashed end result, which, of course, bears no resemblance to the original password.

Time-based, One-time Passwords

A one-time password is a type of password that can be used to log in to a service only once, after which the password is rendered invalid. These are considered more secure than a regular password, because even if they are discovered somehow, for example, through negligence on the

(Continued)

user's part, or by monitoring an unsecured transmission, they cannot be used. They also tend to be randomly generated and thus more resistant to dictionary attacks and other password-cracking methods, and can be considered unique, so if another service that the same person uses gets compromised, it doesn't affect the site using the one-time password.

However, the challenge with implementing one-time passwords for use with web-based services is distributing them. In order to get the one-time passwords to the user you've got to regularly send new ones in a secure way (and guarantee the user has a record of them). Even if you do this in batches of passwords (which is considerably less secure than having one at a time), it's still difficult from a logistical point of view.

Time-based, one-time passwords (TOTP) are a way to overcome these issues whilst still getting the benefits of one-time passwords. With TOTP, one-time passwords are generated, but they are done so automatically based on an algorithm that uses a secret key (that is generated once and is generally hidden from the user) in combination with the current date and time. With this approach only the secret key needs to be secure, as the date and time (and in many cases the algorithm used to compute the codes) is public knowledge.

Two-factor Authentication

Two-factor authentication provides an additional layer of security to users by making them identify themselves by using something only they would know (as in, a password or personal identification number [PIN]), as well as something only they would have (as in a security key or credit card). Whilst this does not completely guarantee security, it provides a much greater degree of security than just using one form or the other (it's one thing to steal someone's credit card, or to guess or find out their PIN, but quite a feat to be able to do both) and in a way that doesn't inconvenience users too much.

That said, the nature of the web means that the second factor of two-factor authentication tends to be in the form of a hardware key that generates a unique code that can be input into the login screen. By definition, this code must be time based, or else it becomes little better than a second password, rendering the actual hardware part of it worthless.

(Continued)

(Continued)

So in reality, the devices will use some form of TOTP. And because hardware keys can be relatively costly to manufacture, and the thought of users carrying round a pocket full of hardware keys wherever they go is a little optimistic, the trend has been to have the codes generated on a mobile device which the user already owns, such as a smartphone.

Some implementations of this have a dedicated app that uses a proprietary algorithm to generate or request the codes, whilst others just have the site send an SMS message to the phone number registered for the user (this is not ideal, as SMS messages are not encrypted and vulnerable to being intercepted by a third-party). Increasingly, though, many implementations use the algorithm described by RFC 6238, which can be used in conjunction with a number of freely available mobile device apps (most notably, Google Authenticator [m.google.com/authenticator]), as this means they need to implement the service only into their own system and not have to spend resources creating corresponding apps for mobile devices.

There are some other caveats to using the RFC 6238 algorithm (which mainly boil down to the dependence of keeping clocks synchronised) that in practice mean there are fallback options to the system which can be considerably less secure (such as single-use backup codes that are not time-sensitive and which may have been saved somewhere in an insecure manner).

Additionally, although two-factor authentication methods will typically use codes generated on (or sent to) a mobile device, the use of TOTP itself does not necessarily qualify as two-factor authentication, unless the mobile device is completely separate from the service being unlocked. For example, if you use a banking app on a mobile phone, and the bank sends a TOTP code to that same phone, it is only one-factor—you just need access to the phone to unlock the account. Still none of this means using such an approach is completely worthless; just that it is not as secure as a purely two-factor one.

SECURITY RISKS

In addition to taking the proper precautions, it also pays to be aware of the risks and ways that security can be compromised. Ultimately, the Cloud does offload these concerns to the service provider, so you don't necessarily need to worry about them, but on the other hand, you need to be confident

that the service provider is both competent and can be trusted to have your best interests at heart. There are also certain circumstances where, despite the best efforts of the service provider, something can prevent security from being guaranteed.

Insecure Connections

Whilst most Internet-related security revolves around encrypting data, the reverse is true—not having data encrypted is a surefire way for others to gain access to the data. Use of public WiFi is a great example of this. When using a public WiFi connection, any other user on the same wireless network can see the data you're sending and receiving without much effort. And if you're sending sensitive information in a way that's not encrypted, such as when logging into a site, sending an email, or submitting credit card details on any site that isn't using a secure method like HTTPS (and often the only way to know for sure is to check if there's a padlock icon in the browser's address bar, despite what the site itself might be telling you), it's as if you're just speaking them out loud in a crowded room. Maybe no-one will intercept the data and it won't matter, but either way it's a big risk to take.

BOX 14.4 Man-in-the-Middle Attack

Even if a connection is encrypted, that doesn't guarantee it is secure. A so-called man-in-the-middle attack is one where someone silently acts as a go-between for the end-user and the web service. They intercept messages from the user and relay them to the service and do the same for messages going back from the server to the user. In this way, neither the server nor the end-user knows the messages are being intercepted. In this situation, the data would still be encrypted, however, under the right circumstances, the hacker would have the information to decrypt them.

There are ways to prevent this from happening by sites using the correct encryption protocols. Fortunately, modern browsers will provide feedback as to how secure they are (if there's a padlock, or a green padlock, the chances are you're protected).

Browser Hijacking

A popular way for hackers to intercept private data to and from websites is to attack the browser itself. Perhaps the most common way to do this is to fool users into installing malicious software (known as "malware") that modifies the browser settings in a number of ways. As well as having security implications, having such malware installed can lead to having advertisements inserted into web pages that don't normally display them, changing the user's home page to some other site, nagging the user to buy certain "antivirus" software, and generally slowing Internet access down to a crawl (whether intentionally or not).

Perhaps worst of all is the advice given to users to avoid this happening is not particularly helpful. Microsoft, for example, previously advised users to "avoid disreputable websites" and "be careful what you download and install onto your computer". In practice, you should make sure not to install any plugins or extensions unless you know exactly what they're for and make sure your browser's home page is set to a page you can trust (or just a blank page). Then if you suspect there might be an issue with your browser (such as experiencing any of the symptoms listed previously), you should check the corresponding settings in your browser, in particular what the home page is set to, and which extensions and plugins are installed. As a last resort, most browsers have a "reset" option somewhere to restore everything to working order (whilst still preserving other important information).

Router Hijacking

A tactic that has been discovered more recently involves compromising a router (a device responsible for sending and receiving data between a local network, such as a WiFi network, and the Internet). Because many routers are set up to allow them to be configured from across the network (via the Internet), strictly speaking anyone could log in to the router and change the configuration—something which can result in all traffic being routed through another server controlled by a hacker, for example (or as with browser hijacking, to insert advertisements into web pages). They have to know the router's password for this to work, but given that a significant proportion of users don't change the default passwords on their router this can be a simple task. Even for those who are savvy enough to change the password to something less likely to be cracked, they might still be susceptible to exploits in the router's software.

This can be especially problematic, as many people will get their routers from their Internet service provider, who might not go to enough trouble to ensure their users' routers are secure. Regardless, there are some steps you can take to ensure you are better protected from these types of attacks. First of all, you should ensure that the ability to administer the router from outside the network is disabled. Second, you should ensure you change the default password to something secure. Next (as with everything else), make sure your router's firmware is kept up-to-date. Finally, where possible, disable features like uPNP (Universal Plug-and-Play) and WPS (WiFi Protected Setup) that can be used to give attackers greater access to your network.

BOX 14.5 Virtual Private Networks

One reliable way to secure Internet communication is to use a virtual private network (VPN). A VPN provides a secure link to another network, typically across the Internet. It is a common way to allow access to a network at an office whilst elsewhere (or as a way to connect separate offices together). Even outside of a corporate environment, however, there are many benefits to using a VPN.

Because all communication via a VPN is secure, the act of using a VPN effectively provides greater security when using one to browse the Internet. Because of this, there are many services (such as privateinternetaccess.com) available that offer a VPN to an Internet proxy, providing a way to securely access the Internet, even when on public WiFi. Such services are relatively cheap, at around $50 per year or so, but they should be weighed on their individual merits, particularly in regards to their policy on privacy and how they might impact your bandwidth (there are numerous "free" VPN services, but for the most part these should be avoided, as there's a tendency for people running such free services to snoop on their users).

Social Engineering

In comparison to the other approaches, social engineering is a decidedly low-tech approach. Rather than trying to break encryption or access protected systems, social engineering attacks the human element in a security

system, attempting to obtain information that can then be used to gain access to a computer system or an individual's account.

Though there are many techniques that can be used as part of a social engineering scam, the most well-known is probably "phishing". With phishing, the target is tricked into thinking they need to access a particular account, but in attempting to do so, they inadvertently log into a fraudulent site that captures their login credentials, allowing the attacker to use them and pose as the actual user. Commonly this is done by sending a "spoof" email to random people, pretending to be a legitimate message from the service being targeted, but with links that direct the user to the fraudulent site.

Many other approaches are also used. Complex schemes use a chain of different scams to get more and more information about a person until there's enough available to pass enough identification checks and gain access to a particular service. In one high-profile case in 2014, a much sought-after Twitter account was stolen from its owner through a series of social engineering scams (and which was notable as the hacker explained exactly how he'd done it), designed to first gain the last four digits of the victim's credit card, information which was subsequently used to gain control of the victim's email account. From there it would be possible to do untold amount of damage, but the attacker instead contacted the victim and offered to undo the damage in exchange for the Twitter account.

Perhaps the most worrying aspect to social engineering is that there's not much that can be done to prevent its effectiveness. Better training, sure, and more judicious security policies (more widespread use of security measures such as two-factor authentication would help), but ultimately people are infallible, and as such make easy targets.

BOX 14.6 How to Hack into Someone's Account

The first thing to bear in mind is that unless you already know someone's password, simply guessing it on a website's login screen is not going to get you very far. The vast majority of websites have a multitude

(Continued)

(Continued)

of measures in place to ensure you can't just keep trying password for a particular user's account. Even for those who have somehow managed to not have any checks in place, the nature of the Internet means it would still be a laborious process, as there's the inherent delay between submitting a password and then getting a response back, so attempting to burn through thousands of password combinations is going to take a very long time, and (one would hope) draw attention from the website's owners. So in order to break into someone's account, you will actually need to know what their password is before you try logging on.

So first you're going to have to gain access to the system that stores the passwords, and download the list of passwords so you can get at the one you're after. To do that, you'll have to find a way in. Commonly this is done by exploiting a known vulnerability, which is feasible if the company running the website doesn't bother keeping their software up-to-date. One of the most widespread of these is the "Heartbleed" bug, first discovered in 2014, and estimated to have affected 17% of secure web servers at that time. As of September 2015, an estimated 200,000 devices were still vulnerable. Even if that particular exploit doesn't work, you can make use of an "Exploit Kit" to try and identify known exploits for a particular server.

Once you've gained unrestricted access to a server, assuming you can't now just add yourself as an administrator with full permissions, you can instead download databases which include (amongst other things) usernames and passwords. Maybe at this point you'll get lucky and discover that all the passwords are stored in plain text (as is the case for the various sites tracked at plaintextoffenders.com), and you can just look up the one you want. Even though this seems implausible, this was certainly the case for UK retail giant Tesco as of 2012—gain unrestricted access to their system and you'd find yourself in possession of the passwords of potentially millions of users (perhaps worst of all, they didn't acknowledge, at least not publicly, that this was even a cause for concern).

But assuming the site has taken proper precautions and hashed stored passwords, you've now got to crack the encryption. At this point you can grab a rainbow table (for example, from http://project-rainbowcrack.com/table.htm) and use that to cross-reference the password from the stored hash. In cases where the hash was also "salted", the rainbow table approach won't work. But if you know what the salt is for a given user account (as these are typically randomly generated per user and stored in the database alongside the username), the best

(Continued)

chance of success is a brute force attack. According to the GRC Search Space calculator (grc.com/haystack.htm), for a randomly generated, eight-character password containing a mixture of mixed-case letters, numbers, and symbols, this could be done in under 19 hours with regular hardware, or just over a minute with dedicated equipment. Had the password have been just three digits longer, the process would take somewhere between 1 year and 10 months and 1,828 years.

BIBLIOGRAPHY

Browser Hijacking: How to Help Avoid It and Undo Damage http://web.archive.org/web/20070509161151/http://www.microsoft.com/athome/security/online/browser_hijacking.mspx

Check Chrome's Connection to a Site https://support.google.com/chrome/answer/95617?p=ui_security_indicator&rd=1

Cloud Bound: Advice from Organizations in Outsourcing Relationships http://www-01.ibm.com/common/ssi/cgi-bin/ssialias?subtype=XB&infotype=PM&appname=CHQE_SO_SO_USEN&htmlfid=SOE12347USEN&attachment=SOE12347USEN.PDF#

Clouds Are More Secure Than Traditional IT Systems—and Here's Why http://searchcloudcomputing.techtarget.com/opinion/Clouds-are-more-secure-than-traditional-IT-systems-and-heres-why

Cracking Salted MD5 with Hashcat http://robinverton.de/blog/2012/08/26/cracking-salted-md5-with-hashcat/

DRM https://www.eff.org/issues/drm

Federal Cloud Computing Strategy https://www.whitehouse.gov/sites/default/files/omb/assets/egov_docs/federal-cloud-computing-strategy.pdf

Google Tells iOS 9 App Devs: Switch off HTTPS If You Want That Sweet Sweet Ad Money from Us http://www.theregister.co.uk/2015/08/27/google_apple_ads/

Hackers Hijack 300,000-Plus Wireless Routers, Make Malicious Changes http://arstechnica.com/security/2014/03/hackers-hijack-300000-plus-wireless-routers-make-malicious-changes/

How Big Is Your Haystack? https://www.grc.com/haystack.htm

How I Became a Password Cracker http://arstechnica.com/security/2013/03/how-i-became-a-password-cracker/

Lessons in Website Security Anti-Patterns by Tesco http://www.troyhunt.com/2012/07/lessons-in-website-security-anti.html

Rare Twitter Username 'Stolen' http://www.bbc.com/news/technology-25963662

Thought Heartbleed Was Dead? Nope—Hundreds of Thousands of Things Still Vulnerable to Attack http://www.theregister.co.uk/2015/09/15/still_200k_iot_heartbleed_vulns/

Three Companies That Transformed Their Businesses Using Cloud Computing http://www.forbes.com/sites/ibm/2014/11/03/three-companies-that-transformed-their-businesses-using-cloud-computing/

TOTP for 1Password Users https://blog.agilebits.com/2015/01/26/totp-for-1password-users/

Two Factor Auth List https://twofactorauth.org/

Welcome to the Internet of Compromised Things http://blog.codinghorror.com/welcome-to-the-internet-of-compromised-things/

A Year Later the Vast Majority of Large Corporations Have Not Fully Remediated the Computer Bug, a New Study Shows http://fortune.com/2015/04/07/heartbleed-anniversary-vulnerable/

Your Password Is Too Damn Short http://blog.codinghorror.com/your-password-is-too-damn-short/

15

Automation

"I do not like to repeat successes, I like to go on to other things."
—Walt Disney

If there's one thing every production needs more of, it's automation. There is a great deal of repeatable work being done continuously throughout the lifetime of a production, whether it is administrative tasks or specific routines that a particular department follows. A great many of these are carried out manually, over and over again:

▶ Call sheets for the next shoot day are sent out at the end of a shoot day;

▶ Footage from the previous day's shoot is gathered together for review;

▶ Cast members are notified about a last-minute script change;

▶ A location manager checks the weather forecast for changes;

▶ An editorial assistant requisitions a copy of an edited sequence;

▶ An accountant produces a daily budget report.

Any of these can potentially benefit from some automation. There are varying degrees with which this could take place; for example, you could have an email template that you use to send out a stock email every day, or you could have the email be sent out automatically at a certain time every day, or you could have the content of the email change based on different factors *and* be sent automatically when a particular event occurs. Each of these options is possible in one way or another, but the Cloud can make it easier to get them to work for you.

BOX 15.1 The Paradox of Automation

There's an inherent risk with depending on too much automation. The "paradox of automation" posits that, as *some* degree of human interaction is always required in an automated system, it becomes more critical the more that system is automated. Effectively, you remove the amount of work a person has to do, but in doing so you are building greater dependency on the part that isn't automated.

Consider processing screenplay page changes. A less automated process might have someone compare two screenplays for changes, produce pages for each of those pages, and then send them out to people who need them. A more automated system might just have someone provide a before and after script and then work out the changes and send out the changed pages to people on a saved list. Though such a system is clearly more efficient, it does mean that the few parts that involve humans are more critical. If either of the scripts provided are wrong, for example, by the time someone notices, the changed pages would have already been sent out to potentially dozens of people.

NOTIFICATIONS

The simplest and most common form of automation you can expect from the Cloud is through notifications. An event occurs and some notification is produced as a result. The event can be anything, like uploading a file to Cloud storage, and there are many options for generating notifications, such as pop-up messages, emails (which in turn can trigger other notifications),

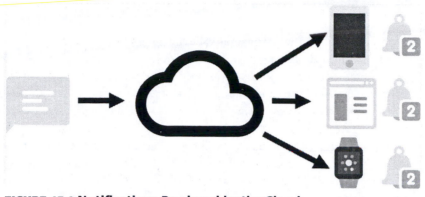

FIGURE 15.1 Notifications Produced by the Cloud

or alerts on mobile devices. With the Cloud, multiple notification types can be produced for a single event, and they can span all of your connected devices. They can range from the subtle (notification on a smart-watch) to the attention-grabbing (automated phone calls), depending on how everything is set up.

BOX 15.2 Push Notifications

One of the key technologies that have helped shape mobile computing is push notifications. Push technology, which allows services to "push" data to a remote device (as opposed to the remote device explicitly requesting the data), has been available in various forms for several years, but it's on the Cloud where it really shines. Push notification in particular allows user-authorised services to send updates to mobile devices, computers, and browsers, which are then displayed to the user, giving them the choice to acknowledge, ignore or, in some cases, act on them.

Push notifications can be used for a variety of different situations which range from companies letting their users know about special offers or time-sensitive information to more specific, relevant information—for example, to let them know that a file has been received or an important task is due.

INTEGRATION

Hundreds of automatically-generated emails might be good for letting people know things have happened, but they aren't necessarily going to help them actually do any of those things any faster. That's where integrations between different services and systems come in. For example, because Gmail is integrated with Google Drive, you can add email attachments directly from Google Drive without having to save it locally first. It might not seem like much, but given that you can do interactions like this dozens of times a day, the time savings quickly adds up.

Although some of the services covered throughout this book try to offer an end-to-end ecosystem, a platform that you can use from start to finish (write your script in our product A, then break it down in our product B, and so on), history seems to indicate that the truly successful ones are those that are open to the idea that you might want to make use of third-party products to do at least part of what you need to do.

Some of them will accommodate this in an almost begrudging way, for example, by providing rudimentary import and export functionality. However, there are many that go a lot further, offering an Application Programming Interface (API) that allows some of its key functions to be controlled by another application or system. These APIs *potentially* offer incredible access and flexibility, although they can require you to have the technical resources and time to properly utilise them. Some services take this a step further, offering an API and some working integrations with other products that are already made. For example, Autodesk's Shotgun (shotgunsoftware. com) comes with integrations with products such as Adobe Photoshop (adobe.com), and Slack (slack.com) features integrations with numerous Cloud-based services like Dropbox (dropbox.com).

FIGURE 15.2 Using an API to Send Data Between Services

AD-HOC INTEGRATION

All of this is just the beginning, of course. Where the Cloud really starts to go from providing convenience to becoming indispensable is when you connect different services together. Consider a location scout uploading some photos to Dropbox. You could already be subscribed to the shared folder they're in, so they'll automatically download to a folder on your hard drive. But in addition, you could set it up so any photos added to that folder are automatically posted into a Slack channel for everyone to review, and you have a specific section in an Evernote notebook you want to keep track of things like that, so in they go for future reference. Oh, and these photos are actually really important, so you also need to receive a text message when they arrive.

All of this is possible via the APIs that each of the services provide, allowing data to be chained between them. But not everyone has either the time or expertise to actually make use of these APIs, and even where working integrations exist, they might not work in exactly the way you want them to. This is where services like Zapier (zapier.com) and IFTTT (ifttt.com) step in.

These services allow users to create "ad-hoc" integrations between supported services in a very streamlined way. The technical aspects of the various third-party services' APIs are abstracted to a very high degree so users don't need

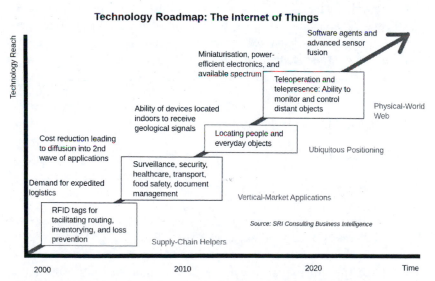

FIGURE 15.3 Technology Roadmap for the Internet of Things

to know anything about them, and are just presented with a simple interface to connect any two services together (with one service providing a "trigger" and the other an "action"), allowing for some customisation options specific to those services. For example, you could have Google Calendar provide the trigger and configure it to fire at the start of any event containing the word "casting" and then have the resulting action be to post a message to the "Casting" channel in Slack with notes from the calendar event.

BOX 15.3 The Internet of Things

It's not just computers and mobile devices that can connect to the Internet. A number of "things" are Internet-enabled in some way, leading to the growth of the so-called Internet of Things. Popularised perhaps by "smart" light bulbs that can change colour based on the time of day, the weather, or just about any metric you can think of downloading from the Internet, the concept can apply to what's already a multitude of different things, from radiators to refrigerators.

It's not just a gimmick, though. Various sources predict at least 20 billion devices connected to the Internet by 2020, both in the form of different types of sensors that are able to collect data and mechanisms to actually do things. The driver for this right now is home automation (hence the abundance of smart thermostats and smart kettles), but no doubt this will gradually expand into other areas. By 2020 we might begin to see smart cameras or even smart clapper boards.

POPULAR AUTOMATION SERVICES

IFTTT (ifttt.com)

Pricing: free

Features: customisable trigger actions based on events from over 250 different services and devices

IFTTT (IF This, Then That) provides a well-rounded set of supported services (or "channels"), although aside from popular web services like Slack

and Box, most of the channels are for hardware devices such as smart thermostats. IFTTT's integrations ("recipes") are triggered every 15 minutes.

Zapier (zapier.com)

> **Pricing:** free (feature-limited), $20/month ("Basic"), $50/month ("Business"), $75/month ("Business Plus"), $125/month ("Infrastructure")

> **Features:** customisable trigger actions based on events from over 500 different services and devices, multi-step automation

Zapier's main selling point is the huge number of integrations it offers, and many of these are for business-related services such as QuickBooks Online and GoToMeeting. However, the service is remarkably expensive compared to IFTTT, costing $1 per month per integration ("zap"), with caps on how many times zaps can be triggered each month. Zapier's zaps are triggered every 15 minutes unless you shell out for a "Business" or better package, in which case they are triggered every 5 minutes.

We Wired Web (wewiredweb.com)

> **Pricing:** $10/month ("Basic"), $20/month ("Plus"), $50/month ("Pro")

> **Features:** customisable trigger actions based on events from over 150 different services and devices

We Wired Web has fewer integrations but makes up for this by providing a little more control (and complexity) to users. Though functionally similar to Zapier and IFTTT, it uses a "wiring diagram" metaphor to allow the more technically-inclined to dive in and make changes to functionality.

BIBLIOGRAPHY

Designing Smart Notifications https://medium.com/@intercom/designing-smart-notifications-36336b9c58fb#.6kto6kpyn

The Internet of Things Is Everywhere, But It Doesn't Rule Yet http://www.wired.com/2015/12/this-year-was-almost-the-year-of-the-internet-of-things/

16

Crowdsourcing

"If you're lucky enough to do well, it's your responsibility to send the elevator back down."

—Kevin Spacey

CROWDED CLOUDS

One of the interesting features of the Cloud that hasn't been mentioned so far, is that as well as being able to reach out through the Internet across the world to others, there's the potential to receive some form of data not just from a select few scattered about the globe, but from hundreds or even hundreds of thousands of people.

This can seem daunting, or even undesirable, at first glance; after all, there's little need for input from so many strangers for what's ostensibly a creative endeavour. However, for a few select situations, the act of "crowdsourcing", or getting some form of involvement from other people, can be extremely beneficial.

CROWDFUNDING

Consider large-scale cash lotteries—everyone spends a small amount of money for the chance to win a huge amount of money. The odds are massively stacked against every individual, of course, but on the other hand the risk is small enough (at least in the short-term) that it doesn't really matter. Spending a dollar for the possibility of a return of millions of dollars doesn't sound like a bad deal, statistical probability notwithstanding. However, when participants inevitably lose, they're unlikely to derive much satisfaction at the prospect of having made someone else a millionaire.

Now consider that same large-scale, low-risk contribution to something that does have a more positive outcome—funding a production. Traditionally, productions are funded by a small number of parties each contributing a large part of the budget, with the hope of getting a high enough return on investment on its eventual sale to be worthwhile. But with "crowdfunding", instead a large number of people each contribute a much smaller amount of money, but typically don't expect anything in return.

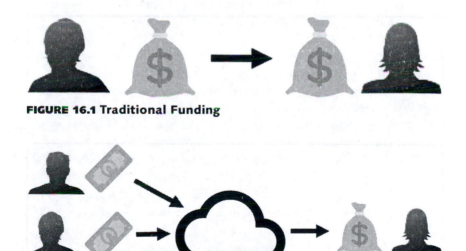

FIGURE 16.1 Traditional Funding

FIGURE 16.2 Crowdfunding

If you're rolling your eyes at this point, consider that in 2014, $16 billion dollars was raised through crowdfunding, of which $1.97 billion was directed towards film and the performing arts. The World Bank expects the overall value of crowdfunding to increase to $90 billion by 2020, effectively tripling the value of venture capital globally. Crowdfunding has been used to raise an estimated $6 million from approximately 90,000 "backers" for the production of *Veronica Mars* (2014) and just over $6 million from approximately 50,000 backers for the production of a new series of *Mystery Science Theater 3000*. Perhaps even more crucially, it's likely that neither of those projects would have ever been greenlit via more traditional means.

Clearly with a crowdfunded approach, there are vastly different considerations to be made. On one hand, with each individual contribution being so small, there's no-one who can claim a stake in the production and start making demands or assuming some form of creative control. However, at the same time, few of the contributors will likely be happy to simply hand over a sum of money and walk away, even if it's a comparatively insignificant amount, which means you have to provide them with something in exchange, be it a forum to voice their ideas and opinions, or some regular feedback to give them an insight into how things are going.

Not having external involvement is not always a good thing, however. There are a great many stories of high-profile crowdfunded projects that secured a lot of money in funding (to the tune of millions of dollars in some cases) but that subsequently went off the rails in terms of their development, having been unable to manage its funds or schedule correctly. There's also the problem of distribution to consider—it's one matter to raise money to shoot a film but quite another to get it out in front of paying people.

For these reasons, it seems that the optimal approach, at least for the time being, is to use crowdfunding first as a way to prove to a studio or television station that there's significant interest in a project, and second as a way to jump-start the marketing process by generating excitement about a project. That's unless you're trying to raise funds for a low-budget production, in which case a successful crowdfunding campaign can mean all the difference in the funding of the production and support in getting it made (2013's Academy Award for Best Documentary Short Subject went to *Inocente*, having been crowdfunded to the tune of $52,527, and after raising $406,237 on Kickstarter, 2016's *Anomalisa* was nominated for Best Animated Feature Film).

There are plenty of challenges associated with raising money through crowdfunding, however. First and foremost is attracting enough attention to be viable. Crowdfunding depends on a significant number of people willing to give you even a small amount of money on the promise that you'll use it to make something they'd be interested in seeing. To do that you have to either have a million followers on Twitter or you need to do some marketing to raise awareness for a project before you even start asking for money.

Furthermore, you need to have some way of handling the logistics of crowdfunding. Potential funders need a way to actually give you their money in a convenient and secure way, and there need to be enough controls in place in the process to ensure that both you and they are protected in the exchange. Then there needs to be a way for funders to receive things like progress reports, but also for them to be able to communicate, if not with the production directly, then at least with each other.

Fortunately several platforms already exist to make this as simple as possible. Sites like Kickstarter (kickstarter.com) and IndieGoGo (indiegogo.com) allow producers to easily create a project page that has the details of a proposed production, along with a deadline date and a minimum target to meet by then in order for the project to be viable. People can then "back" projects for any amount they choose, either having discovered it on the site directly or being referred there from somewhere else. The sites themselves handle all the logistics of managing backers' pledges, providing any technical support with regards to using the site. Meanwhile, there's an easy way for producers to get analytics data about the backers, as well as provide regular "updates" to backers on the project, and provide the ability for the backers to comment and discuss each of the updates. In return for all this, the sites take a small percentage of the total amount funded if the campaign is successful in reaching its funding goal (if unsuccessful, typically the campaign ends without backers being charged, though this depends on the specific project).

There are some additional steps producers can take to make their pitch more appealing to potential backers. It's common for campaigns to offer various "rewards" to backers should the funding be successful. These are usually tiered (backing for a higher amount of money qualifies the backer for a better reward), and can be, for example, a credit or acknowledgment somewhere (not necessarily on-screen, but typically on an accompanying website), a copy of the production to watch once complete, the opportunity to meet key people from the production, some memorabilia (such

as a signed prop), or even an invitation to an event (such as a screening). Rewards like this can be a good way to encourage people to pledge a higher amount than they would otherwise.

BOX 16.1 Tips for Running a Successful
 Crowdfunding Campaign

The following is a list of things that the most successful crowdfunding campaigns seem to have in common, as well as potential pitfalls to avoid when pitching a project:

▶ Set expectations clearly. Don't let backers think that they'll be contributing more than they actually will be, and don't give the impression that the production will be finished sooner than is realistic.

▶ Give backers a voice. Conversely, make sure backers have a way to be able to express their opinions and feel like they are valued (something which becomes much harder with more backers).

▶ Beware offering physical rewards. Physical rewards require shipping and come with a whole lot of logistical issues to deal with. Some successful crowdfunded projects failed in the long-term due to the cost of providing such rewards.

▶ Build interest before the campaign starts. Ultimately the success of the campaign will be due to a large extent on people actually finding out about it. Once a campaign starts, success may lead to a "virtuous circle" effect whereby the success of the campaign actually draws in more interest and attention, but there's no doubt you should aim to start off strong, as a project seen to be floundering will likely drive people away.

▶ Show that you've got what it takes. Many backers are cynical, particularly those who have previously backed projects that were mismanaged or ultimately failed in some way. Outline your plans as clearly as possible and describe the experience of everyone involved to instil confidence.

▶ Explain why crowdfunding is necessary. If a studio isn't prepared to back your production, why should anyone else?

(Continued)

(Continued)

> ▶ Provide regular updates. Even though just running a campaign can be hard work, regular updates reassure backers (and potential backers) that you haven't thrown in the towel. This should continue in some form even after the campaign has ended, as it can leave backers with the confidence to back any future campaigns you run.
>
> ▶ Know that timing is everything. Campaigns that launch during summer months tend to attract fewer backers.
>
> ▶ Hire a crowdfunding support person. For bigger campaigns, dealing with the crowdfunding process and related issues can be extremely time-consuming. It's best to hire someone (or multiple people as needed) to help keep the campaign running and possibly keep everything going smoothly even after the campaign ends.

CREATIVE CROWDSOURCING

The concept of outsourcing is not new. If some work is needed but a production needs expertise they don't have or (more often) they need to do it for less money, outsourcing becomes a viable option. With the Cloud, outsourcing in this way becomes even easier, provided you're willing to forgo some secrecy.

Various sites act as agents for creatives available for work, and several different approaches are used. With the most familiar, as used on sites such as Freelancer (freelancer.com), you provide a brief about some work that needs doing, and then receive bids from available freelancers willing to do the work, or alternatively browse through the profiles of freelancers available to do work. This is a relatively intuitive and quick process, with the downside that there's perhaps some risk involved. Although most reputable crowdsourcing services provide ways to prevent people taking money and not delivering the work (or conversely, protect freelancers from having submitted the work and then not getting paid), there's still no guarantee that the quality of work will be to the standard required.

That's where the "contest" approach comes in. Rather than selecting from submitted proposals and hoping that the final work submitted will be

sufficient, some services instead allow holding a contest. An organisation submits a brief as before, but this time freelancers will do the work on spec and submit finished work in the hope they are selected as the winner. The organisation then has several finished options to choose between, from which they select one to be the "winner" of the contest. The winner then gets paid for the work, and everyone else goes away empty-handed.

It's a system that's undoubtedly skewed in favour of the organisation requesting the work; the majority of freelancers "competing" to get paid still end up doing the work. Indeed, AIGA, the professional association for design, strongly discourages professional designers from participating in work where there's a risk of not getting paid. Still, if what you're looking for is low-cost work of adequate quality, this could be a viable approach.

Services like this exist for practically every creative endeavour. Crowd Studio (crowdstudio.com) provides a way to get bespoke music and audio for projects, whilst Tongal (tongal.com) provides videography. Numerous sites exist for sourcing 2D design for logos, branding, and so on, and still others exist for translating content, and most of them are readily accessible and inexpensive.

BOX 16.2 Coworking

The flip side of being a lone freelancer connected via the Cloud in order to do work is that you lose some of the benefits of working in an environment with other people, such as having a sense of community or being around others to bounce ideas off or just socialise. As an increasing number of people are working outside of a traditional office, so too has there been a rise in the number of people looking to reconnect to some extent with a working environment.

"Coworking" groups are intended to cater to those needs. These can be informal groups of people who work for different organisations but work out of a single location (such as one person's home or a cafe). In this way, each member gets the social connection they're otherwise missing but with a greater degree of flexibility (if you don't get on with a particular group, you can just leave).

(Continued)

(Continued)

> There are also more formal variations of this, whereby companies such as WeWork (wework.com) rent out shared office space to people coming from a variety of different organisations. Although these tend to be expensive compared to having a single company leasing space for all its employees, they prove popular due to the accessibility, security, and psychological benefits they provide.

MICROTASKING

The options for getting important tasks done through crowdsourcing as discussed so far are referred to as "macrotasking", whereby a small number of people are selected from potentially hundreds in order to carry out the work. The opposite is also possible—sourcing hundreds of people to perform numerous basic manual tasks—and is referred to as "microtasking".

Microtasks can range from things like looking at images of receipts and working out which company each of them was from to fact-checking data from a spreadsheet. They are things that are too complicated or too impractical to be able to get a computer to do but that a person can do without much effort. When faced with having to get a significant number of microtasks done in a specific timeframe, you can either hire someone to spend time completing them all or you can turn to the Cloud.

Services such as Amazon's Mechanical Turk (mturk.com) aim to make this process as accessible as possible. Anyone with Internet access can opt to be a worker on the services (though having specific skills, or having been a worker for a certain period of time, allows them to be able to apply for a greater variety of work), and anyone can submit "Human Intelligence Tasks" (HITs) that they need doing. Requesters submit a short brief about what's needed, an allotted time to complete each task, any qualifications that workers should have, and then a budget for getting the work done.

There are numerous applications for this approach. It can be an easy way to get reams of data verified in a particular way (or, for example, dealing with duplication issues in data). It's possible to get images classified and categorised (for example, from a pool of 5,000 images, determine whether the main character is wearing a blue dress or a red one). It can even be used for research purposes (for example, to see if people prefer one particular

piece of music over another). If you really wanted, you could conduct test screenings in this way (though you'd probably want set up the request such that workers would need to sign an NDA first).

The headline benefit of this system is that it is cheaper perhaps than any other approach. Workers typically earn around $1–$1.50 per hour doing the work, which is notably lower than the minimum wage (a fact that has caused these services to be heavily criticised), although that amount increases slightly for workers who are more "recognised", having performed more tasks successfully for the service in the past.

The other benefit is the time it takes to complete the work. By splitting the tasks up amongst potentially hundreds of people, you can get them all to work in parallel, which means it will get done a lot faster than one person doing them all in sequence (and when you consider that person will not work 24 hours a day).

BOX 16.3 Physical Microtasking

All of the microtasking approaches covered so far involve manipulating data of some sort, whether in the form of a video file or a spreadsheet of data to check. However, there are also options for crowdsourcing things that need to be done offline, like collecting packages or booking a hotel reservation over the phone.

Services like TaskRabbit (taskrabbit.com) follow a similar model to Mechanical Turk but instead allow people to be recruited to perform one-off physical tasks. These can involve, for example, waiting in line, running errands, cleaning, or doing some research. Likewise, Uber (uber.com) uses crowdsourcing to provide private transportation services to people.

CROWD VOTING

The final aspect of crowdsourcing is crowd voting. Put simply, crowd voting is getting a large number of people to vote on a topic. This approach has been popularised by sites like Yelp (yelp.com) and TripAdvisor (tripadvisor.com), which collate and aggregate user-submitted reviews for local business

and travel destinations respectively. More subtle implementations can also be seen across numerous commerce-based sites where users submit ratings and reviews for products. Perhaps even more prominently, crowd voting is put to use on a number of high-profile televised performance competitions such as *The Voice* (nbc.com/the-voice), wherein viewers collectively get to vote on who they want to win.

As useful as crowd voting might be, there's not actually any easy way to tap into that sort of power unless you have your own established, large community to draw upon as needed (unless you just happen to be making the next series of a hugely popular TV series or a sequel to a blockbuster with a large fanbase). The alternative is to leverage something like Mechanical Turk, and pay people to vote on various topics, or else get people to take part in an online survey somewhere.

BOX 16.4 The Wisdom of the Crowd

A novel experiment taking place in the Cloud is "A melody written by a crowd" (crowdsound.net). Visitors to the site are offered the opportunity to help in the creation of an entire melody, written note by note, using votes to determine what each note should be, with each note in the sequence based on 50 submitted votes on a number of options.

Following on from this, the site aims to run another experiment, "Lyrics Project", whereby a similar setup will allow visitors to vote on each word used as lyrics for a pre-composed melody. With both experiments, the idea is to create something not only unique but also based on a diverse range of input, something that might considered extraordinarily difficult to accomplish any other way.

POPULAR CROWDSOURCING SERVICES

Kickstarter (kickstarter.com)

> **Pricing:** 5% of funds collected (additional payment processing fees apply)

> **Features:** allows creation of crowdfunding campaign, payments processing, analytics, producers may post updates, backers may post comments

Kickstarter is probably the most popular crowdfunding platform. Originally conceived as a way for entrepreneurs to pitch ideas to potential backers, it is now used across a variety of different creative projects to gain funding at different stages of the project's lifecycle. A key feature of Kickstarter is that payment is taken from backers only in the event that the funding meets the predetermined target, so failed campaigns represent less risk to potential backers.

IndieGoGo (indiegogo.com)

Pricing: 5% of funds collected (additional payment processing fees apply)

Features: allows creation of crowdfunding campaign, payments processing, analytics, producers may post updates, backers may post comments, pre-campaign pages, fulfilment support

Though not as popular as Kickstarter, IndieGoGo has a lot going for it. It caters for phases before and after a crowdfunding campaign, allowing producers to use the site to start generating awareness and hype for an upcoming crowdfunding campaign. It also offers post-campaign support, providing services for manufacture and distribution of physical rewards as well as a place to sell merchandise. Unlike Kickstarter, IndieGoGo (somewhat controversially) allows campaigns the option to keep pledged funding even when a target is not met.

Freelancer (freelancer.com)

Pricing: up to 10% of fees for freelancers, up to 3% of fees for employers, up to $200/month subscription cost

Features: advertise projects, post contests

Probably the biggest website for sourcing freelancers (across a multitude of industries), prospective employers have a lot of options including the ability to hire freelancers to work at an hourly rate or a fixed price for a particular project. Alternatively, employers can post contests whereby finished work is submitted with the employer selecting a winner to claim the budgeted amount.

In addition, employers can optionally require freelancers to sign an NDA, though this requires subscription to the "premium" service at $200 per

month, and also hire a recruiter to vet freelancers who apply for the work for an additional fee.

DesignCrowd (designcrowd.com)

Pricing: $50 per contest

Features: advertise projects, post contests

DesignCrowd provides crowdsourced graphic design work. Similar in concept to Freelancer, except with a focus on hiring designers and a more straightforward fee scheme (the site takes a cut of the money paid to free-lancers, so from the employer's perspective it's a case of setting an overall budget).

Tongal (tongal.com)

Pricing: undisclosed

Features: post contests

Tongal focuses on providing videography content. The contests consist of up to three phases. First the employer submits a brief, to which the Tongal community submits ideas. The employer selects a number of these ideas, which are each awarded part of the budget. Next the Tongal community creates pitches based on one of the selected ideas, from which the employer chooses a shortlist of winners (each of which are awarded another part of the overall budget). These winners then each produce a video from which a winner is selected and receives the rest of the budgeted amount.

NeedaJingle (needajingle.com)

Pricing: from $89 per contest for employers, 10% of fees for freelancers

Features: post contests

NeedaJingle takes the same approach as other crowdsourcing sites, but is centered on the creation of music, such as crowdsourcing a soundtrack for a production, or even just a short tune for a commercial.

Crowd Studio (crowdstudio.com)

Pricing: from $89 per contest for employers, 10% of fees for freelancers

Features: advertise projects, post contests

Similar to NeedaJingle, Crowd Studio targets audio creation, though it caters for all types of audio production, including sound effects and voice over in addition to music. The service also offers a "music shop" where you can license tracks for a production. Buyer beware, though: at the time of writing there seemed to have been no activity on the site for over a year.

CastingWords (castingwords.com)

Pricing: from $1/minute

Features: audio transcription

CastingWords uses crowdsourcing to perform audio transcription. You submit an audio file to the service and get a document back with the time-stamped transcription. Guaranteed turnaround times and non-English language transcriptions of content are available at higher rates. The service leverages crowdsourcing by having people register to do the work, and the work is then subsequently reviewed by others.

Amazon Mechanical Turk (mturk.com)

Pricing: 20% of overall expenditure, additional costs for more qualified workers or validation

Features: request crowdsourced work, API

Mechanical Turk is perhaps the most significant service in place for getting microtasks completed. With a pool of around half a million workers (many of whom dedicate a significant proportion of their time to the service), work may be completed quickly and relatively inexpensively. The requester decides the pricing structure for each assignment, though setting a higher price will tend encourage the work to be completed faster. In addition, other constraints, such as worker location, some level of qualification, or ensuring, for example, that they sign an NDA, may also be placed on the assignment.

Although individual workers maintain some anonymity from the request-ers, it's possible to block specific workers (who are identified only by a code) or provide a monetary bonus. Requesters using the service must be based in the US, although individual workers can be located elsewhere.

BIBLIOGRAPHY

AIGA Position on Spec Work http://www.aiga.org/position-spec-work/

Anatomy of a HIT https://mturk01.wordpress.com/anatomy-of-a-hit/

Bring Back Mystery Science Theater 3000 https://www.kickstarter.com/projects/mst3k/bringbackmst3k

Crowdfunding: The New Venture Capital? http://worthpointeinvest.com/crowd funding-the-new-venture-capital/

The First Kickstarter Film to Win an Oscar Takes Home Crowdsourced Gold http://www.wired.com/2013/02/kickstarter-first-oscar/

Global Crowdfunding Market to Reach $34.4B in 2015, Predicts Massolution's 2015CF Industry Report http://www.crowdsourcing.org/editorial/global-crowd funding-market-to-reach-344b-in-2015-predicts-massolutions-2015cf-industry-report/45376

List of Crowdsourcing Projects https://en.wikipedia.org/wiki/List_of_crowdsourcing_projects

Our Do's and Don'ts of Kickstarter https://thepip.com/en-gb/2013/09/our-dos-and-donts-of-kickstarter/

Trends Show Crowdfunding to Surpass VC in 2016 https://www.crowdfunder.com/blog/trends-show-crowdfunding-to-surpass-vc-in-2016/

The Veronica Mars Movie Project https://www.kickstarter.com/projects/559914737/the-veronica-mars-movie-project/

17

Potential

"Technology is nothing. What's important is that you have a faith in people, that they're basically good and smart, and if you give them tools, they'll do wonderful things with them."

—Steve Jobs

THE FUTURE OF PRODUCTION IN THE CLOUD

So now you're fully invested in the Cloud as far as your productions are concerned. Key materials like concept art and the screenplay are kept online, having undergone numerous review stages with each version and corresponding notes logged for future reference. Copies are securely distributed with watermarking to those who need it. A production crew has been assembled through various Cloud-based services, and the Cloud-based casting call is complete. A schedule has been finalised, with every cast and crew member having accurate and up-to-date information that relates specifically to what they're doing and where they need to be. Managers are able to stay on top of where everyone is and what they're doing thanks to mobile devices running Cloud-powered apps feeding this information back to them. Footage is captured, logged, and processed, and everything is tracked in the Cloud, giving everyone immediate access to the information.

Production becomes post-production, with every version of every frame of the picture tracked and distributed as needed. Everything goes smoothly.

What next?

For film and video productions that use the Cloud, the fantasy doesn't need to end there. Many businesses are betting their futures on the Cloud, both in terms of their own technical infrastructure as well as in terms of the services they provide. As a result, there's a massive financial investment in Cloud technology underway. Whilst some Cloud-based services will doubtless fail in some way, others will flourish, and users will reap the benefits of gradually reducing costs and ever more sophisticated technology. With that in mind, there are a few potential developments to look forward to in the coming years.

Faster Everything

Speed is something that can really hold back the Cloud. With greater utilisation of the Cloud, the bottleneck for the end-user increasingly becomes the bandwidth of their Internet connection. As demand for faster speeds increases, Internet Service Providers will likely find new ways to give their customers improvements to bandwidth, both in terms of home and office connections, as well as through cellular connection.

The next generation of cellular communication is estimated to allow for around 1 gigabit per second of data throughput, which is more than 3 times faster than the current 4G specification, though it has been theorised that the new system has the potential to be 800 times faster than that. As a bonus, 5G connections are likely to be more reliable, making mobile devices less dependent on WiFi connections.

Development continues on broadband Internet connections, as technologies such as "Fibre to the Cabinet" and "Fibre to the Premises" gain traction and promise greater speeds to homes and offices but require replacing legacy cabling and will take time to roll out everywhere. But new protocols like "G.fast" may also offer additional benefits over existing infrastructure in the interim.

With the availability of faster Internet connections, Cloud services will be able to provide more benefits, not just in being able to transfer files more

quickly, but also being able to pack more functionality into applications that are served across the Internet. Simultaneously, advances in data compression and new web technology will also mean that fewer data will need to be transferred in the first place, again providing speed benefits. Polaris, a technology developed by MIT and Harvard researchers, reportedly reduces the time for web pages to load by up to 34%, will be released some time in 2016, at which point other sites will be free to make use of it.

More Services

As the Cloud gains popularity, more services that have previously ignored or avoided it will gradually succumb and offer their own Cloud-based services. Companies that are already invested in Cloud technology will continue to refine and iterate their products and may produce new products based on needs. All of this will result in new ways to do things and greater choice of how to do them.

Better Interoperability

Given the complexities and ever-changing nature of video and film productions, it's unlikely that there'll be a single service that will be able to provide a complete, end-to-end approach by providing everything the production might need from budgeting and scheduling all the way through to post-production and distribution, at least not any time soon. What does seem likely, however, is that there'll be greater integration between different services, so a script breakdown done through one system can be easily and automatically read into another. Most Cloud-based services offer some form of API where appropriate, so it's always possible that even if a particular service doesn't directly integrate with another one, someone, somewhere could build and publish a third-party integration. With the rise of ad-hoc integration systems, it could become easier than ever to take two different Cloud-based services and simply plug them together.

Ubiquitous Access

Mobile devices are becoming more powerful, and as they do, people tend to use them where they'd previously been using desktop computers. Though many Cloud-based services have support for mobile devices, not all of them do and the support can be somewhat limited. Over time, we'll likely see greater support, as well as new uses for mobile devices in the context of

these services, for example, taking advantage of built-in cameras and location tracking. All of this will lead to people wanting to access different services whilst on the move, from different locations and at different times.

This may extend to other areas too. In early 2016 a new system dubbed "Screening Room", that promised delivery of new movies to a set-top box in the home, on the day of their theatrical release, gained the backing of several prominent directors, many of whom had previously come out against such systems (the fact that Screening Room promises to pay significant royalties to theatres for each viewing might have helped).

Reduced Costs

As the technology gets more efficient and sees a greater number of people using it, the costs will reduce. Simultaneously, associated hardware costs will also drop, and there will be more competition between different systems, which should also serve to drive costs down. This should then make Cloud-based services more attractive than more traditional approaches in many cases, causing them to see even greater adoption.

More Power

All previous developments should mean that the services grow in terms of their feature set and capabilities. Ease of integration should allow different data processing services to be leased to other systems. For example, one company could set up a video transcription service that another company is able to leverage for its own service (such as digital dailies), meaning that its own customers gain all the benefits without the company having to commit considerable resources to researching and developing the technology themselves.

Google is doing just that with its Prediction API (cloud.google.com/prediction). Companies can use the API to buy "predictions" using Google's own neural networks, about things like what a user is likely to do in a given day based on past interactions, or determine whether posted comments have a positive or negative tone. Similarly, Microsoft's Project Oxford (projectoxford.ai) has a tantalising set of APIs in development, covering everything from face recognition to spell checking and video stabilisation. Potentially any company could leverage these and use them to enrich their own services.

Innovation

Even across unrelated fields, new approaches to solving problems can serve as inspiration to others or become established workflows. For example, x.ai is developing a Cloud-based "personal assistant" that can be copied on emails to help with scheduling meetings. The twist is that the personal assistant is a "web robot" that uses natural language routines, meaning participants can send messages in a completely conversational tone, without needing to use specific keywords, and the assistant will send replies and manage the calendar directly.

Developments like this can lead to many companies adopting similar approaches to their own systems. Imagine if, when you need to send a file to someone, instead of logging into your Cloud storage system and granting access and emailing the recipient a link, you could just send an email to a virtual assistant (or speak into a phone) and have them take care of it for you.

With an increasing amount of video being stored in the Cloud, sophisticated analysis becomes possible. Autodesk Video Lens (autodeskresearch. com/publications/videolens), for example, demonstrates this by analysing footage from numerous baseball games, and then allowing interesting footage to be surfaced based on a number of different parameters, such as finding video featuring the lowest pitches hit for a home run. What's particularly interesting about this is that it's indicative of a shift from finding things based on keywords and metadata to analysis of its content. It's not a huge stretch to imagine that in a few years' time, an editor might be able to search for a video of "close up of leading lady looking down" rather than "101AA-2B".

Aggregation of large amounts of data will likely become important. The core concept of Project Portfolio Management, which is being able to analyse the progress of a number of projects at a strategic level, might extend to other aspects of the production process and be used to gain insight into processes that are efficient or cost-effective, or that translate to increased critical reception or box office sales.

Services might offer "benchmarking" features, whereby aspects of your process can be compared with those of other productions, potentially highlighting areas that could be improved in some way. For example, a service

might be able to tell you that you're shooting less usable footage on an average day than a similar-sized production or that you're spending above average on catering at a particular location.

Information will become more context-aware. With an increased use of Cloud-based services comes an increase in data, which in turn leads to different things competing for attention. Getting notifications when someone uploads an important file is great, but a flood of notifications about people uploading files that are less important can lead to people becoming overwhelmed and just not using them at all. In the future we'll hopefully see a move towards being notified about just the things you actually care about, as well as perhaps the various services being more intelligent about how and when they send you information or ask you to make choices.

The motion picture industry may have difficulty keeping up with the pace of developments in information technology, but the promise of a Cloud-powered future will mean they no longer have to.

BIBLIOGRAPHY

Cloudy with a Chance of Pitfalls: Future of VFX and Animation Pipelines http://wiki-fx.net/pages/bars-2014-stephane-deverly/

Gigabit Speeds over Telephone Wires Get Closer Thanks to New G.fast Standard http://www.pcworld.com/article/2856532/gigabit-speeds-over-telephone-wires-get-closer-thanks-to-new-gfast-standard.html

How Will the 5G Network Change the World? http://www.bbc.co.uk/news/technology-30224853

http://www.popsci.com/mit-developed-tool-to-make-webpages-load-34-percent-faster

The Silver Screen Moves to the Cloud http://finance.yahoo.com/news/silver-screen-moves-cloud-143000184.html

Steven Spielberg, J.J. Abrams, Peter Jackson Backing Sean Parker's Bold Home Movie Plan https://variety.com/2016/film/news/steven-spielberg-j-j-abrams-peter-jackson-sean-parker-screening-room-12017283

Index